INDEX CARDS

Moyra Davey

INDEX CARDS

edited by Nicolas Linnert

A NEW DIRECTIONS
PAPERBOOK ORIGINAL

Manufactured in the United States of America
First published as New Directions Paperbook 1478 in 2020

Library of Congress Cataloging-in-Publication Data
Names: Davey, Moyra, 1958– author.
Title: Index cards / Moyra Davey.
Description: New York : New Directions Publishing, 2020.
Identifiers: LCCN 2020004648 | ISBN 9780811229517 (paperback) |
ISBN 9780811229524 (ebook)
Subjects: LCSH: Davey, Moyra, 1958–
Classification: LCC TR140.D364 A5 2020 | DDC 770—dc23
LC record available at https://lccn.loc.gov/2020004648

2 4 6 8 10 9 7 5 3

New Directions Books are published for James Laughlin
by New Directions Publishing Corporation
80 Eighth Avenue, New York 10011

CONTENTS

FIFTY MINUTES

The Fridge

I had a houseguest once who told me that all of his cooking was about managing his fridge. I don't remember the man's name, but I did retain from him that expression, and even though I don't cook per se . . . [*narrator forgets her lines, begins again from the top*], I think of a fridge as something that needs to be managed. A well-stocked fridge always triggers a certain atavistic, metabolic anxiety, like that of the Neanderthal after the kill, faced with the task of needing to either ingest or preserve a massive abundance of food before spoilage sets in.

I get an unmistakable pleasure out of seeing . . . [*long pause; narrator again forgets her lines; off-screen voice tells her to wait five seconds and start over*] the contents of the fridge diminish, out of seeing the spaces between the food items get larger and better defined. This emptying out reminds me of the carcasses being eaten away by maggots in Peter Greenaway's film *A Zed and Two Noughts*. He uses time-lapse photography to show an animal carcass wither away before our eyes until all that's left is clean white bone. That is my aim with the fridge: to be able to open it and see as much of its clean, white, empty walls as possible.

Once every ten days or so the fridge fills up with food and the Sisyphean cycle of ordering and chewing our way through it all begins anew. This rodentlike behavior is my metaphor for domestic survival: digging our way out, either from the contents of the fridge, or from the dust and grit and hair that clog the place; or sloughing our way through the never-ending, proliferating piles of paper, clothing, and toys.

Recently I read about a writer getting rid of four thousand books and hundreds of CDs, and emptying three closets full of clothes, and it made me think of how much we pad our lives with this stuff.

Books

I feel a little towards my books as I do towards the fridge, that I have to manage these as well, prioritize, determine which book is likely to give me the thing I need most at a given moment. But unlike with the fridge, I like to be surrounded by an excess of books, and to not even have a clear idea of what I own, to feel as though there's a limitless store waiting to be tapped, and that I can be surprised by what I find.

I spend most of my time trolling through a half a dozen or so books, all the while imagining there's another one out there I should be reading instead, if I could only just put my finger on it. Often I find the spark where I least expect it, in a book I may have been reading casually, lazily, wondering why I am even bothering to read it. Sometimes I persist with a book, even just through inertia, and it can happen that the writing will suddenly open itself up to me.

[*Narrator has been roaming through Pete's Barn, a giant junk store in upstate New York, speaking into the camera mic. She asks: "Do I remind you of Geraldine Chaplin in* Nashville?"]

[*Short interlude in which narrator is seen blowing dust from her books*]

Analysis

["*Shhhhh." Narrator attempts to silence others in the room, who chime in, "shhhhh."*]

I started my analysis when I lived in Brooklyn. I'd take the L train to Union Square and then the 6 to 86th Street. From there it was a short walk to my analyst's office on Madison Avenue. As I approached Dr. Y's building I'd scan the sidewalks for his small, compact frame, since he often arrived for my appointment just before I did. Once I spotted him in profile walking down the avenue—he was holding a paper bag just under his chin and putting food in his mouth. Another time, even more unsettling since I wasn't even in his neighborhood, we found ourselves eye to eye, a mere ten feet apart, me standing on the Uptown platform at

Grand Central, and him staring out at me from the window of the express train.

But if I happened to catch sight of him anywhere near his building, rather than enter the lobby and risk having to ride up in the elevator together, I'd circle the block. These near encounters were enough to throw into question the entire analysis, and to ratchet up the level of self-consciousness to a nearly unbearable degree. I also felt conspicuous walking past his doorman five days a week at exactly the same hour.

Once I had crossed the threshold into the waiting room I would take a seat on the couch, or if someone already happened to be there I'd sit in the black-and-gold Harvard chair and wait for the moment when Dr. Y would appear to welcome me into his office. It was all very ritualistic and formal.

Money-Time

We negotiated a fee of eight dollars a session, based on my income at the time. The fee is meant to compensate the analyst for his time, but in my case it was purely symbolic. In fact, I was paying for his time with my time by my willingness to come four-five times a week and be a control case in the final stages of his training. I knew almost nothing about my shrink, other than that he was a psychiatrist training to become a psychoanalyst at one of New York's more conservative institutes.

[*Dust motes fly around a corner bookshelf.*]

Vivian Gornick

Late last night, coming home on the subway, I was reading Natalia Ginzburg, but in a quite distracted way, even having trouble keeping the characters straight, when slowly, something about the writing began to dawn on me.

I had picked up Ginzburg's novel *Voices in the Evening* subsequent to reading a short article by Vivian Gornick titled "Reading in an Age of Uncertainty," published a few months after September 11th in the *LA Times*. Gornick's essay is a brief analysis

of the writing of three postwar European writers: Ginzburg, Elizabeth Bowen, and Anna Akhmatova, and why it is she finds solace in reading these authors in the weeks and months after the attacks.

As Gornick explains, all three authors have lived through terrible times: war, bombings, murder, ongoing persecution, and censure. Their writing, she notes, shares certain qualities of detachment, and a lack of sentimentality. It recounts events in a cool, matter-of-fact way. It does not emote. Gornick writes:

"What unites all these works is a severe absence of sentiment—and even of inner motion. A remarkable stillness suffuses the prose in each; a stillness beyond pain, fear or agitation. It is as though, in each case, the writer feels herself standing at the end of history—eyes dry, sentences cold and pure—staring hard, without longing or fantasy or regret, into the is-ness of what is."

Gornick's essay then shifts from literary analysis into the present moment: the bewilderment and shock of New Yorkers in the weeks following September 11th. She recounts an anecdote, of trying to cross Broadway somewhere in the Seventies. The light changes before she can get all the way across, and from the median she does what she says all New Yorkers do: she peers down the Avenue to see if there's a break in the traffic that will allow her to run the light. But there is no traffic. The street is virtually empty, and the thought begins to cross her mind that the scene looks like a Berenice Abbott photograph from the 1930s. But Gornick cannot allow herself to complete the thought because it is too painful and disturbing. She realizes that to even entertain that thought presupposes a temporal relationship to the city that is no longer available to her. Gornick continues:

"The light changed, and I remained standing on the island; unable to step off the sidewalk into a thought whose origin was rooted in an equanimity that now seemed lost forever: the one I used to think was my birthright. That night I realized what it is that's been draining away throughout this sad, stunned lovely season: It's nostalgia. And then I realized that it was this that was at the heart of Ginzburg, Bowen and Akhmatova. It wasn't sentiment that was missing from them, it was nostalgia."

Dr. Y

After I moved from Brooklyn to Hoboken my travel time to and from Dr. Y's office increased to about an hour and fifteen minutes each way. I'd catch a four o'clock bus to the Port Authority and then either walk across on 42nd to Grand Central, or I'd take the C up the West Side and walk through the park.

Dr. Y had a nice aquiline face that reminded me of Pierre Trudeau's when Trudeau was young—well, when he was about fifty or fifty-five. I registered this visual impression of my analyst in the preliminary consultations that eventually led to the analysis proper, to lying down on the couch, at which point I ceased to look at him. Upon entering his office, I both removed my glasses and averted my gaze, and his face soon faded into an ageless abstraction, a gentle, pleasing blur.

All of his movements and gestures, from the way he stood in the hallway to signal that my time had come, to his walking ahead of me into his office so as to position himself, sentinel-like, by the doorway as I entered, to the careful shutting and locking of the door with a flimsy little hook crudely and inexpertly screwed into the molding, to his calling me Ms. Davey rather than by my first name, were choreographed and ritualized.

This highly mannered behavior suggested to me that he was performing the role of the analyst, and that he was incapable of any spontaneity or originality. What I was supposed to be doing on the couch was figuring out all the reasons his behavior made me so uncomfortable. But in fact I am not a very analytical person and over and over I balked at doing my job on the couch. I couldn't bring myself to talk about him and all the things that annoyed me—his clothes, his shoes, his thinning hair, his shortness, his priggish, by-the-book manner. I found it ridiculous and absurd that I too was expected to participate in this codified, preordained script.

Nostalgia

For Vivian Gornick in post-9/11 New York, daydreaming about the city stretching backwards in time is a cause for anxiety, a

reminder that historical continuity and the promise of a future are no longer things we can take for granted.

In critical circles, nostalgia has a negative, even decadent connotation. But the etymology of the word uncovers other meanings. It comes from the Greek *nostos*, a return home, and *algos*, pain. According to Jane Gallop, after "homesickness" and "melancholy regret" in the dictionary there is a third definition of nostalgia, which is "unsatisfied desire." And that is what the word has always implied to me: unconsummated desire kept alive by private forays into the cultural spaces of memory.

I am told nostalgia is the intellectual's guilty pleasure. Cynthia Ozick, writing about Sebald's novel *The Emigrants*, would seem to agree: "I admit to being disconcerted by a grieving that has been made beautiful. Grief, absence, loss, longing, wandering, exile, homesickness — these have been made millennially, sadly beautiful since the Odyssey. . . . Nostalgia is itself a lovely and piercing word, and even more so is the German *Heimwey*, 'home-ache.'"

Asked in an interview in 1982 if he felt nostalgia "for the clarity of the classical age," Michel Foucault replied:

"I know very well that it is our own invention. But it's quite good to have this kind of nostalgia, just as it's good to have a good relationship with your own childhood if you have children. It's a good thing to have nostalgia toward some periods on the condition that it's a way to have a thoughtful and positive relation to your own present."

[*Narrator reads "pleasure" instead of "present," then corrects herself.*]

In *The Future of Nostalgia* Svetlana Boym identifies two tendencies: restorative and reflective nostalgia. The first is principally linked to place, and, with its emphasis on *nostos*, home, can easily become a breeding ground for oppressive and intolerant nationalisms. Reflective nostalgia, on the other hand, has a "utopian dimension." It is not about "rebuilding the mythical place called home [but about] perpetually deferring the homecoming itself."

Here is a personal example of reflective nostalgia: As I write and think about this abstraction, nostalgia, a particular landscape always presents itself. It involves a summer day, a park in Montreal, '60s-era architecture, my mother, and a scene from an An-

tonioni film. But I can't say more than that. To do so would be to kill off the memory and all the generative power it holds in my imagination. I keep it perpetually in reserve, with the fantasy that someday I may land there, in what is by now a fictional mirage of time and place.

Eavesdropping

Dr. Y's office contained one floor-to-ceiling bookshelf on the far wall, and on my very first day I recognized the bright yellow dust jacket of Joel Kovel's *The Age of Desire*, a book I happen to own two copies of. A few years later a second set of custom-made shelves went up on the wall parallel to the couch. These remained empty for some time and then eventually began to fill up with books, the titles of which I was at pains to decipher, but could never quite make out from my nearsighted position on the couch. I read a fair amount on psychoanalysis in those days and sometimes tried to introduce ideas from my reading into the analysis. But these attempts to connect on any sort of theoretical level with my shrink invariably backfired. I would mispronounce names, and then feel embarrassed, or my queries and remarks would simply go unacknowledged. The most Dr. Y would concede was that my reading was my way of trying to get closer to him. What he wanted was the unfiltered version of events, my childhood for instance, something I did not have a good relationship with and did not relish talking about.

Lost & Found

I rehearse "lost and found" almost daily. Sometimes it's an actual object but it can be a line or two I've read and only dimly recall. I rack my brain, flipping through books, magazines, newspapers trying to retrace my steps. Often the thing I'm searching for is of dubious significance, but I persuade myself that the flow of life cannot go on until I have located the object. The search can be for something of very recent vintage, or it can cut across deep time into a twenty-year archive of negatives. The ritual is about

creating a lacuna, a pocket of time into which I will disappear. When I find the object, the relief is palpable.

Lost and found is a ritual of redemption. If I find the thing, then I am a worthy person. I have been granted a reprieve. I have relief when I find something, but it's a shallow, superficial relief. I know this ritual is a rehearsal for all the inevitable, bigger losses. I think, if I can only find X, then I am holding back the floodwaters, I am in control.

This compulsion to "lose" and find things is not so different from the drives and habits of collectors. In thinking about the cyclical nature of collecting, Baudrillard, in *The System of Objects*, invokes the *fort/da* game that Freud witnessed in his young nephew and interpreted as a way to stave off anxiety over the mother's absence.

Baudrillard: "[T]he object stands for our own death, symbolically transcended. . . . [B]y integrating it within a series based on the repeated cyclical game of making it absent and then recalling it from out of that absence—we reach an accommodation with the anguish-laden fact of lack, of literal death. . . . [W]e will continue to enact this mourning for our own person through the intercession of objects, and this allows us, albeit regressively, to live out our lives."

Natalia Ginzburg

On the subway, halfway into reading *Voices in the Evening*, I began to recognize the specific quality Vivian Gornick had been describing. There's no psychologizing. We have to infer the complexity of a life from a handful of very selective and superficial details. And mixed in with all of Ginzburg's appealingly idiosyncratic detail and anecdote, you'll come upon something of the utmost seriousness. But it's all treated in exactly the same artless way, with no sentimentality whatsoever about time passing, people growing old and dying, even being murdered by the Fascists. Before, during and after the war, it's all the same, recounted in the same slightly absurd, flat voice. This is the absence of nostalgia that Vivian Gornick is talking about.

The Couch

I was constantly irritated by the look of Dr. Y's couch, a bed really, with a Mexican fabric covering it and a pillow with a small white hanky laid on top. Nailed to the wall directly over the couch was a South American fringed rug. I hated this arrangement of bed and covers and rugs because it struck me as a rather artless mock-up of Freud's couch, and served to reinforce my idea that my shrink was an amateur, someone doing a poor job of imitating an analyst. I was also convinced that I was his only analytic patient, the only person desperate and meek enough to submit to such a draconian schedule as the one he imposed.

I would lie on his couch and spend a good deal of my time thinking of ways to get up, either to sit upright on the couch, or to move to a chair, or simply to walk out. But I felt as though I'd been nailed there, stricken in this supine position a little like in a dream when you're inexplicably paralyzed and can't move your limbs.

Fear

I found myself thinking often of Natalia Ginzburg in the weeks and months after September 11th. Especially a passage from one of her essays titled "The Son of Man" in which the image of a shattered house, a home reduced to rubble by bombs becomes the central metaphor for a loss of wholeness, for the ability to ever trust again in the stability of material things, in the continuity of lives. Ginzburg writes: "Behind the serene vases of flowers, behind the teapots, the rugs and the waxed floors, is the other, the true face of the house, the horrible face of the crumbled house. . . . Even if we have lamps on the table again, vases of flowers and portraits of our loved ones, we have no more faith in such things, not since we had to abandon them in haste or hunt for them in vain amid the rubble."

I would lie awake at night in my bedroom on the eleventh floor overlooking the city, listening to the roar of jet planes, and think of Ginzburg's crumbling houses and sleepy children

wrenched from their beds and "frantically dressed in the dark of night." Every morning for a long time I would leap from my bed and foolishly scrutinize the skyline to see if the Empire State Building was still standing.

It's summer of 2002 and extremely hot. I am waiting on the subway platform, having glanced at the headlines on the news-stand, all bad, dire warnings about the inevitability of future attacks on the city. I board a suffocatingly hot subway car and make my way through the moving train until I reach a car that is so cold it could be a meat locker. These extremes of temperature are so excessive, so unnatural, they reinforce the sense that things are way out of whack and could crack at any moment.

I dialed my shrink's number, but it was busy and I didn't call back. Almost a year later I still found myself sitting at the kitchen table staring at his number in my address book. And I would just sit there frozen to the spot, working my way into a small fix over whether to call or not to call.

But instead of calling I told myself all the reasons I shouldn't call, and the reasons why I never wanted to see him again. Over the course of some time I talked myself out of it: I did my work, I did yoga, I got on the subway. I walked into a food store and noticed that there were plenty of things I'd like to eat.

Pregnancy

I carried on with the analysis for five and half years, going from five to four to three, [*narrator forgets her lines, starts again*] and then after I'd had a baby, to two days a week. In the beginning I liked going five days a week. It was a novelty, and I had the time. But more and more, as the years wore on and out of necessity I began to cut back, there was a lot of tense exchange around the issue of frequency of visits.

One such discussion took place in my ninth month of preg-nancy, a few weeks before Christmas and my due date. I sug-gested to my analyst that wasn't it a bit unseemly, me in my state lying here like this, not to mention the treacheries of navigating

icy sidewalks and blizzards to make my way to the East Side from Hoboken.

Sidestepping the issue of travel and convenience, as he nearly always did, Dr. Y came up with the idea of "arranging for [me] a chair." Somehow the image of him hoisting furniture and re-arranging his office in order to stage this thronelike commode in the middle of the room was too much, and I simply insisted that we stop and resume again after I'd had the baby. Which we did, and I managed to sustain the analysis for another couple of years, though it became increasingly difficult with a small child.

Hollis Frampton

In 1971 Hollis Frampton made a film called "[nostalgia]." It's a sort of leave-taking of photography. Frampton burns his photographs on a hot plate, and always out of synch with the disintegrating image on the screen is a voice-over describing the circumstances of the making of each picture.

The narrator recounts the motivations, and usually the short-comings and regrets associated with each image. The tone is melancholic and self-deprecating.

On one level [nostalgia] is permeated by a sense of regret over things never said, amends not made, a sense of failure and real loss for the moments and people no longer in Frampton's life. But towards the end of the film there's a twist, and one of the chief moments of regret turns out to be a bit of a charade. Frampton's nostalgia (and he spells it with a small *n*) is real, but it is also wrapped in distancing irony and wit.

The film ends on a strange note of terror, with the narrator saying: "I think I shall never dare to make another photograph again."

Vulture/Kite

In *Leonardo da Vinci and a Memory of His Childhood* Freud inter-prets an early memory of Leonardo's, of being in his cradle and

having a vulture swoop down and bat its tail between his lips. I think this is where Freud concludes that Leonardo was gay. But it turns out there's been a mistranslation from the Italian, that it wasn't a vulture at all, but a kite. I remember telling Dr. Y about this mistake and saying to him that I thought it seriously discredited psychoanalysis. He was dumbfounded that I'd take such an extreme position.

Rereading the case study now, I can see it probably makes no difference to Freud's interpretation that it was a kite rather than a vulture. But at the time I was quite literal-minded and convinced it was just another nail in the coffin for psychoanalysis.

The Fundamental Rule

I remember very few details of my verbal exchanges with Dr. Y. An exception was a rather stupefying moment towards the end of my analysis that had to do with Freud's Fundamental Rule, the idea that you have to say everything that comes to consciousness, every horrible, hideous thought that crosses your mind while on the couch. Ever obedient and fearful of authority, I had been endeavoring to follow this rule, with all the pain and self-loathing one can imagine might come with this burden of disclosure. One day a discussion of the basic premise of the Rule ensued and Dr. Y, in a moment of uncharacteristic straightforwardness, breezily informed me that of course I had never been *obliged* to follow the Rule. No one was *forcing* me. Rather, he suggested, my servile adherence to the Rule said something about my character. This rule had been tormenting me for over five years. Dr. Y's interjection left me feeling relieved and duped in equal measure.

Hubris

[*This section of the video is unnarrated. A radio in the background is tuned to NPR moments before Patrick Fitzgerald's much-anticipated press conference on the grand jury investigation of the leaked identity of CIA operative Valerie Plame and the indictment of White House ad-*

viser I. Lewis "Scooter" Libby: "I'm Patrick Fitzgerald, I'm the United States Attorney in Chicago. . . ."]

Work

Frampton said that the "nostalgia" of the title of his film had to do with the "wounds of returning," of reconstructing "the lumps [he] took" in those days before he'd made a name for himself as an artist. Some of the struggles Frampton talks about in [*nostalgia*] are uncomfortably familiar to me from the days when I was just starting out. For instance, having an idea for a picture, but eventually feeling a kind of inertia about the whole thing, and after some time and effort, chalking it up to failure.

On the weekend I took some pictures of J's 45s in dim light. And I tried to photograph the glare on an LP on the turntable, and the dust that had collected on the needle. I take far fewer pictures now, but it can still happen that I'll get that sense of heightened absorption and suspended time that comes with the first idea and the notion of a latent image.

The End

The end occurred soon after that revelatory moment about the Fundamental Rule. One early October day in the sixth year, shortly after the August break, Dr. Y imparted that he was anxious to return to the minimum four-day-a-week schedule as mandated by his particular school of psychoanalysis. I was no longer living in Hoboken but had moved to Washington Heights, and this he surmised would make it much easier for me to resume coming again four times a week. But at that point something in me snapped. It was the realization that this man, who'd been listening to me talk about the conflicts in my life for over five years now, could also realistically expect me to show up here four days a week. That was my last day of analysis. I said goodbye and shook his hand (still not looking at his face), and walked out and bought a bar of soap on Madison Avenue.

The City

Yet, if I have any feeling of nostalgia toward New York City, it is mapped through my trajectory to and from Dr. Y's office on the East Side. My daily travel was like a circle drawn around the heart of the city. The solidity and sometimes glamor of Manhattan became like the ballast, the reassuring counterweight for the muck that spewed forth in the confines of that small, decorous office.

And here I will add a final note: while I have few positive memories of my analysis, I have to admit to the possibility that it helped me, that it gave me something I needed. Despite all the irksome formalities, Dr. Y was generous and kind, and he still occasionally makes an appearance in my dreams in that guise.

The Fridge

I began writing this collection of thoughts in June 2003, and didn't look at it again until the fall. By then the August 14th blackout had happened on the East Coast and many of us here relived some of the apocalyptic fears of September 11th. I also spent that summer reading Peter Handke. I wanted to write this without ever saying "I feel" or "I felt," with Handke and Natalia Ginzburg as my models, but I have not succeeded. I have used those expressions, or variations of them, at least ten times.

Had I been honest, I would have told about how I let the milk freeze at the back so it will last longer, and about how I bark at my child if he stands too long in front with the door open, or about how my biggest fights with the man I live with have to do with his propensity to cook in large quantities and stuff the fridge with leftover food. I would have told about how proprietary and controlling is my relation to the fridge, and about how the food it contains brings out my most anxious and miserly tendencies, as though by fixating on the process of consumption and replenishment I can control my destiny.

Fifty Minutes is a work of autofiction.

(2006)

TRANSIT OF VENUS

7/27/10
Begin to doubt the Wet. Why would I want this stuff made public?
An old stumble: exposing the abject.
This temptation goes way back.

Girl with aqua nail polish concentrated on her iridescent, magenta phone, three strands of fat pearls wrapped around her wrist. Long dark hair hides her face. (subway)

Lay down. Thoughts of jumping off GWB. Wake early for tax appointment, less pain and mood is restored. Leonard Cohen: 'mood is all'

MOOD
IS
ALL

Write to Jane:
We are *all* trying to fix something.

'A disappointed woman should try to construct happiness out of a set of materials within her reach.'
William Godwin

Ellipses
Slow disclosure
Stream of consciousness
Obsession/neurosis
Non sequitur

A woman in a fuchsia hoodie writes with a small pencil stub and rubs out as much as she writes. Barney: she is doing college schedules. Around her neck, a silver chain and name pendant in script, might read "Maria."
(subway)

Walking down Oxford Street with C. into raking, late afternoon sunlight. I say "Gary Winogrand light." C. walks and talks fast, sometimes leaving me behind.

To Soho to buy Grace Jones for J.
John Soane house:

ALAS
POOR
FANNY

10/15/11
Pee into the river. Rosie waits. Cinematic dreams.

Epic dreams of college days and brutalist architecture. Read this morning about Penn State coach fired in connection to locker-room rapes: "slapping sex sounds coming from the shower."

Wake at 6. Watch sky turn from blue-black to white/rose.

Roland Barthes: "Il ne faut pas viser la chose." Write about the thing that is to the side.

Use sleep as a structure for Walser/Genet? The way RW uses the walk to structure his storytelling.

Crying in the AM over misplaced negs.

The body breaking down. Peeing behind cars.

Babette Mangolte: "Sync sound is only for television and interviews. For film the sound should be reinvented."

LB: "I write these notes not even I can decipher. It is only in the moment of writing that they have meaning."

June 5. Transit of Venus.

Train to Rhinecliff, watching the foam on the Hudson, the sun setting.

Robert Walser: "Must a man always be seeking experience, writing about it?"

Hervé Guibert calls the clear film "white death."

"Now (instead of reading) I take a photo-book and I look at the photographs, and it soothes me."
—Hervé Guibert

Cut *Prisoner of Love* in half. Read it at night, though much of the time I have no idea what I'm reading: hierarchies and internecine rivalries among the Arab states and tribes plague the Fedayeen. I don't know the history, yet I keep on reading for the flashes of Genet embedded in all this.

"Under Hendrijke's skirts, under the fur-edged coats, under the painter's extravagant robe, the bodies are performing their functions: they digest, they are warm, they are heavy, they smell, they shit."

"A painter is nothing more than an eye going from an object to the canvas."
—Jean Genet, *What Remains of a Rembrandt Torn into Four Equal Pieces and Flushed down the Toilet*. (two above quotes)

Structure video around books:
Rembrandt
Robert Frank
Money in books
Susan's books
Cut books
K. reading

Kevin Ayers: "I think the clever people are the ones who do as little as possible."
NYT, 2/21/13

<div align="right">(2014)</div>

NOTES ON PHOTOGRAPHY & ACCIDENT

For a long time I've had a document on my desktop called "Photography & Accident." It contains passages from Walter Benjamin's "Short History of Photography," Susan Sontag's *On Photography*, and Janet Malcolm's *Diana & Nikon*. All of the quotes hover around the idea that accident is the lifeblood of photography.

Walter Benjamin: "The viewer [of the photograph] feels an irresistible compulsion to seek the tiny spark of accident, the here and now."

Susan Sontag: "Most photographers have always had an almost superstitious confidence in the lucky accident."

Janet Malcolm: "All the canonical works of photography retain some trace of the medium's underlying, life-giving, accident-proneness."

Add to these exceptional writers on photography Roland Barthes and his notion of the *punctum*: that "cast of the dice ... that accident which pricks" (*Camera Lucida*).

Benjamin's masterpiece is from 1931, Sontag and Malcolm were publishing their superlative prose in the mid-1970s in the *New York Review of Books* and the *New Yorker* respectively, Barthes's *Camera Lucida* appeared in 1980. I have long been drawn to these writers, and I am fascinated by the ways their thinking overlaps. Some instances are well known, as in the homage paid by Sontag to Benjamin and Barthes, but other connections are more buried: Sontag's references to the photograph as "memento mori" and "inventory of mortality" before *Camera Lucida;* Sontag and Malcolm circling around the same material in the '70s (accident, surrealism, the vitality of the snapshot versus formalism) and coming to remarkably similar conclusions about "the enigma of photography."

The notion of accident has had many meanings, from "decisive moment" to "photographing to see what something will look like photographed." But is this an anachronism for contemporary work, decades after the ethos of the street?

Roberta Smith, writing in the *New York Times,* has aptly char-

acterized recent trends in image making (very large, staged color photographs) as "the Pre-Raphaelite painting of our day." The problem, to state it baldly, is one of stilt coupled with bloat. Absent from these oversized tableaux is the inherently surrealist, contingent, "found" quality of the vernacular photograph, the quality my quartet of writers so eloquently identifies and holds so dear. My goal is to reclaim this critical history of ideas in relation to contemporary photographs, and to understand how the notion of accident might still be relevant.

And I have another motive as well: I want to make some photographs, but I want them to take seed in words.

Being

July 2006. In the hospital, on steroids, I have the feeling for perhaps the first time in my life that I can simply "be." I no longer have to push myself to do anything, to prove anything. I can just sit on the bed and be.

Writers

Why these particular writers and critics now? I admit to an acolyte's devotion to Malcolm, to a thirst for everything she writes. There's a thrill to reading her that comes from the moments when her writing breaks ever so subtly with the decorum of journalistic worldliness to hint at something personal, painful even, about Malcolm herself.

Malcolm generally operates at a metadiscursive level — in some ways it's her signature as a writer — but I'm thinking here of instances that are more localized, of remarks almost having the quality of a Freudian slip, that crop up in the essays and give the reader pause. A small aside, perhaps having to do with aging or the unhappiness of artists, or families, or childhood, will unexpectedly open up a window of emotional life onto what had otherwise been a fairly hermetic discursive field. It is tempting to call these *punctum* moments, small ruptures in the *studium* (Barthes's term for the aspect of a photograph that gets taken

for granted, doesn't surprise) of Malcolm's flawless, expository prose. For Barthes the *punctum* could not be willed, and while Malcolm's interjections are clearly not accidents; they have a strong unconscious quality. Her view of the world is profoundly and understatedly psychoanalytic. I love to read her because of this, and it reminds me of why I could never read Nabokov: he had an utter disdain for Freud and psychoanalysis. Malcolm's perceptions thrill because they signal "truth" in the way that strange, eccentric details nearly always do.

A *punctum* moment comes in Benjamin's "Short History of Photography" when he describes, and shows, an early studio portrait of Karl Dauthendey and his betrothed. This woman, Benjamin tells us, would "one day [be found] shortly after the birth of their sixth child ... in the bedroom of [Dauthendey's] Moscow house with arteries slashed."[1] Prefiguring Barthes and his scrutiny of images of condemned men ("he is dead and he is going to die"), Benjamin notes the "irresistible urge to search such a picture for the tiny spark of accident," the contingency or sign that might allow us to read in the photographic record of this woman a foretelling of her tragic end. It's very eccentric, the way Benjamin includes this biographical information in a text on photography, and contemporary readers of this poignant aside cannot but speculate as to Benjamin's emotional state at the time he was composing his essay. We know of his suicide at the French/Spanish border in 1940, but we also learn from Sontag's essay "Under the Sign of Saturn" that Benjamin contemplated suicide more than once, beginning in 1931, the year "Short History" was published. (Later I google "Dauthendey" and find a genealogy that tells me his wife's name was Anna Olswang, and that her suicide was the result of postpartum depression.)

I read Benjamin over and over, sometimes getting it, sometimes not. I identify mostly with his nostalgia, which seemed

1 In her book *The Miracle of Analogy*, Kaja Silverman directs our attention to new historical evidence: "As André Gunthert has recently pointed out, the photograph was taken two years after Olswang's death, and shows Danthendey with the woman who would become his second wife" (p. 146).

to ebb and flow, depending on which part of his temperament prevailed. At times it was the Marxist side that dominated, when he was under the sway of Brecht and spoke of mechanical reproduction as a liberation from aura. But Benjamin was also, as Sontag points out, a melancholic collector who sought out beauty and authenticity, and who wrote lovingly of the earliest auratic photographs, the long, drawn out exposures that preceded the mass hucksterism and popularization of the medium.

I confess to never having had a handle on Sontag's *On Photography*. It's teeming with insight, and contains exhilarating passages but I've always had trouble keeping the essays straight in my mind. William Gass, reviewing the book in the *NYT* when it came out in 1977, sheds some light on her method: "Sontag's ideas are grouped more nearly like a gang of keys upon a ring than a run of onions on a string." A perfect description of *On Photography*'s epigrammatic structure, where ideas, indented with dingbats, accumulate, and indeed follow one another with a sort of loose, fragmentary randomness. I never connected on an emotional level with Sontag; nonetheless I'm awed by her avant-gardism and erudition.

Sontag's book prefigured Barthes's. Sontag and Barthes were friends, and I wonder how much *On Photography*, especially its ideas about death and the photograph as memento mori, might have been generative to his thinking in *Camera Lucida*.

Blocked

Writer's block has a legitimacy. There's nothing comparable for artists, no common designation for similar stoppage, and with this symbolic deficiency comes a shame implying a failure of the will, lassitude, impotence. I may as well admit it. I'm blocked. I take pictures of the same dusty surfaces, the cherry wood bedside table with its thin coating of linen dust, a color that I know doesn't reproduce well. It will have that plummy magenta look that I always find a bit sickening. A week later I pick up the film: no transformation. My ratio these days is perhaps one usable frame for every five or ten rolls of film.

I think of Robert Frank's contact sheets for *The Americans*, his incredible ratios of productivity.

I think of filmmaker Nina Fonoroff beginning to shoot *The Accursed Mazurka* after a long hiatus, emitting a howl as the first feet of film run through her Bolex. Release, expenditure, risk, surrender.

I think of Janet Malcolm, apropos of Edward Weston: "One gets the impression he didn't enjoy himself very much. What artist does?"

Ampersand

The ampersand between *Photography & Accident* is to remind me of Virginia Woolf, who made regular use of the symbol, writing for instance of her habit of "reading with pen & notebook." There is a *flânerie* of reading that can be linked to the *flânerie* of a certain kind of photographing. Both involve drift, but also purpose, when they become enterprises of absorption and collecting. Walter Benjamin's *Arcades* project was a superlative *flânerie*, a long, digressive list of notes and citations. It was a surrealist-inspired collection, but with a nihilist twist, what Hannah Arendt called "a refusal of empathy." The historical quotes were intended to stand alone, a tacit protest and stark witness to Benjamin's despair over what was taking place in Europe in the late 1920s and '30s.

Benjamin and Virginia Woolf were contemporaries. They committed suicide within six months of each other in 1940–41, at the height of personal hopelessness and Nazi terror.

Reading

Reading is a favorite activity, and I often ponder its phenomenology. As I write this essay, the reading I do for it is a mitigated pleasure. Sometimes it feels like a literal ingestion, a bulimic gobbling up of words as though they were fast food. At other times I read and take notes in a desultory, halting, profoundly unsatisfying way. And my eyes hurt.

I remember Lynne Sharon Schwartz in her book *Ruined by*

Reading, writing of letting Cagean principles of chance and randomness determine her reading. I've never read John Cage, but since I'm writing about accident I determine that now is the time and begin with a book I find on the shelves called *Notations*, a collection of several hundred pages of composers' musical scores, and notations on these notations. I open the book at random. Someone has written: "I mix chance and choice somewhat scandalously." I copy this phrase into a notebook, a perfect encapsulation of my own desire for contingency within a structure. I decide to allow chance elements, the *flânerie*, as it were, of daily life, to find their way into this essay.

Notes

Roland Barthes spoke of his love of, his addiction almost, to note-taking. He had a system of notebooks and note cards, and Latinate names to designate different stages of note-taking: *notula* was the single word or two quickly recorded in a slim notebook; *nota*, the later and fuller transcription of this thought onto an index card. When away from his desk he used spring-activated ballpoint pens that required no fumbling with a cap, and wore jackets with pockets that would accommodate these tools. He maintained friends who would not question his habit of stopping, mid-walk, mid-sentence, to quickly note a thought.

Barthes: "When a certain amount of time's gone by without any note-taking, without my having taken out my notebook, I notice a certain feeling of frustration and aridity. And so each time I get back to note-taking (*notatio*) it's like a drug, a refuge, a security. I'd say that the activity of *notatio* is like a mothering. I return to *notatio* as to a mother who protects me. Note-taking gives me a form of security" (*La préparation du roman*, 1979).

Reading and thinking about note-taking gives me a form of security, a thrill even, so I will indulge myself a little further and add here advice from Benjamin's list, "The Writer's Technique in Thirteen Theses":

"Item #4. Avoid haphazard writing materials. A pedantic ad-

herence to certain papers, pens, inks is beneficial. No luxury, but an abundance of these utensils is indispensable.

"Item #5. Let no thought pass incognito, and keep your notebook as strictly as the authorities keep their register of aliens." ("One-Way Street," 1928)

Hannah Arendt on Benjamin: "Nothing was more characteristic of him in the thirties than the little notebooks with black covers which he always carried with him and in which he tirelessly entered in the form of quotations what daily living and reading netted him in the way of 'pearls' and 'coral.'"

Diaries

September 10, 2006. The *New York Times* prints excerpts from Sontag's diaries of 1958 to 1967. I marvel at the immediacy and intimacy of her notes and lists, and the quirky way formal typesetting reproduces and transforms the idiosyncrasies of her punctuation and abbreviation; at her using the word "queer" to describe herself in 1959, her talk of lovers, orgasm, depression, drinking, Rilke, writing, and her seven-year-old son. The tone of these diaries is so radically different from anything I've ever read by her. It's a revelation and makes me rethink many of my assumptions about Sontag.

A Barthes Reader, edited by Sontag, begins and ends with essays on the diary. "Deliberation," published the year before Barthes died, is a melancholic meditation on his ambivalence over that form. He finds pleasure in the spontaneity of recording an entry, but ultimately expresses irritation with the "verbless sentences" and the "pose" of the diary voice. He feels that everything he writes is merely reproducing the voice of all the diaries that have come before.

Vision

I'm working haltingly on this essay while simultaneously undergoing treatment for optic neuritis in my left eye. My doctors

are kind people who especially want to help me because I am a photographer; my ophthalmologist collects Leicas and is always eager to discuss optics and lenses and uses the terminology of f-stops and "shutting down" to describe the darkened sight in my affected eye. I don't tell my doctors that my production of photographs has dwindled to a trickle, that I've grown melancholic and ambivalent about photography. After all, one of the motivations for this essay has been to try to rekindle a desire to make images.

I have a resistance to engaging my true topic, "photography & accident," and instead find myself inexorably drawn to thinking about writing. As I struggle to write about photography, I remember how much easier it seemed to write about reading and writing, and how much I love to read about both these subjects. I begin to wonder if it's not just the modernist paradigm kicking in, that a metadiscourse is always more satisfying: painting about painting, photographs about photography, and writing about writing. I can always be engaged by discipline- or medium-specific metaproductions.

Words, Pictures

Sontag: "A photograph could also be described as a quotation, making a book of photographs like a book of quotations." And Barthes speculated that the haiku and the photograph have the same *noeme*, the same essence. What each reveals, unequivocally, is the "that has been."

Light Writing

This is the Greek origin of the word "photography," and Eduardo Cadava reminds us that Henry Fox Talbot, author of *The Pencil of Nature*, used the expression "words of light" to describe his first photographs. In *Camera Lucida* Barthes gives us a possible Latin equivalent for "photograph": *imago lucis opera expressa*, an image "expressed (like the juice of a lemon) by the action of light."

Automatic Writing

Sontag: "[A photograph] is a trace, something directly stenciled off the real, like a footprint or a death mask. . . . [A] photograph is never less than the registering of an emanation."

Barthes, invoking Sontag: "[F]rom the real body, which was there, proceed radiations, which ultimately touch me . . . like the delayed rays of a star."

As indexes or imprints, photographs constitute an unmediated transcription of the flow of the real onto a two-dimensional plane. In her essay "The Photographic Conditions of Surrealism" (1981), Rosalind Krauss recast photography as a form of automatism or automatic writing.

Martha Rosler

I am immersed in reading works by and about my four authors, trying to think through this notion of accident and what it could possibly mean in relation to contemporary practices. There is an archaic ring to "accident," somehow associated with the "truth" claims of the photograph, a notion of authenticity long ago debunked by critics such as Allan Sekula and Martha Rosler. Rosler published her seminal, brutal critique of documentary photography ("in, around, and afterthoughts") in 1981, and, ironically, I think the subsequent decline in the medium can be attributed at least in part to a super-valuation, not to mention a convenient distortion, of her argument. Rosler's essay portrays documentary as an untenable practice: to look at and record the real world, unmediated, is to run the very high risk of victimizing a second time those already victimized by social injustice. This was the message that filtered down and out, widely, from that influential essay and touched a generation of artists. One possible response to Rosler's argument would have been to create instead a world of one's own. Much of the staged, directed, and patently constructed work of the '80s and after, whether it's of a critical nature or not, is underpinned by Rosler's critique.

Wolfgang Tillmans

Wolfgang Tillmans's work is at P.S.1: a major exhibition of mostly enormous, framed photographs, very abstract and painterly, gestural. They are images of flares and light leaks, giant swaths of color spilling across the paper like thrown paint. They are nothing if not a testament to the possibilities of accident, yet I am filled with boredom and disappointment, skeptical about Tillmans's choice to produce these works on such a massive scale, and to give up his usual, unpretentious method of tacking pictures to the wall with Scotch tape. I walk quickly through the galleries; a little later I look at the catalogue in the bookstore, in which everything is reduced to a thumbnail, little smudges of color. Without the grand scale of the originals, the images make almost no impression. I think: this is the true indictment of Tillmans's current works. Only their massiveness of scale and the technical mastery of manipulating gigantic sheets of color paper in the dark make any claim on our attention. There's accident, but it's the accident of a Pollock drip — it's not the idiom of the photograph.

The Book

Writing about William Eggleston's now legendary first showing of color photographs at MoMA in 1976, Malcolm notes how weak an impression they make on the wall. The catalogue, however, is another story: its hip design gives his work the avant-garde look of modern art "that eluded it in the museum."

Photographs have been embedded in books almost from day one, beginning with Talbot's *The Pencil of Nature*, and they continue to be happy companions. I'm convinced that reproducibility in book form is part of the vocabulary of the photograph.

Reproduction and Type

There is a seduction to the editorial use of photographs: surround almost any image with type and it takes on an allure, an

authority, provokes a desire it might otherwise not have. What is this appeal, exactly? The seduction of language, of the symbolic? Is it that, as Benjamin and Brecht speculated, photographs are more at home with, even in need of, words?

In one of the grad programs where I teach, students are required to write a thesis about their work and process. I notice that their photographs become vastly more interesting to me after I read what they've written about them; I like seeing their images shrunken and recontextualized, embedded in paragraphs of descriptive text.

Malcolm: "The dullest, most inept and inconsequential snapshot, when isolated, framed (on a wall or by the margins of a book), and paid attention to, takes on all the uncanny significance, fascination, and beauty of R. Mutt's fountain . . ."

Fragments

I'm drawn to fragmentary forms, to lists, diaries, notebooks, and letters. Even just reading the word "diary" elicits a frisson, a touch of promise. It's the concreteness of these forms, the clarity of their address, that appeals and brings to mind Virginia Woolf's dictum about writing, that "to know whom to write for is to know how to write." I am similarly drawn to fragments of an artist's oeuvre, a single image in a magazine or brochure. I tear these out and hold onto them. No doubt I also like the miniaturization, and the possibility of possessing the thing.

Taped to the wall above my desk is a Thomas Hirshhorn print of Emma Kunz's geometric shapes, stolen for me from his last show by my friend, filmmaker Jennifer Montgomery, and beside it is a page torn out of *Afterimage*, with a Gabriel Orozco photo (*Coins in Window*) reproduced in black and white.

In a pencil jar is a six-inch nail, also pinched from the Hirshhorn show by Jennifer, and embedded between it and the pens and pencils is a tiny reproduction of an Andrea Gohl window, an image I saw in an Allen Frame show at Art in General a few years ago. Frame is an artist I discovered in Nan Goldin's curated

show *Witnesses: Against Our Vanishing* in 1989 at Artists Space, a show that included many other loved artists, such as David Wojnarowicz and Peter Hujar. Frame made color diptychs of Kodachrome snapshots with handwritten captions in the margins. They seemed to be images of friends and lovers, and reminded me of Larry Clark's *Tulsa*.

All of these images, the ones at hand and the ones remembered, become part of a psychic landscape; they feed a fantasy, have what Sontag calls a "talismanic" quality.

Found

Sontag: "Photographs are, of course, artifacts. But their appeal is that they also seem, in a world littered with photographic relics, to have the status of found objects."

"A painting is commissioned or bought; a photograph is found (in albums and drawers), cut out (of newspapers and magazines), or easily taken oneself."

The space of reverie opened up by images I come across in a group show or in a magazine is often squelched by an encounter with the larger body of larger works from which these have been extracted. So much of what we see in galleries is responding to the imperative to overproduce, overenlarge, overconsume, and for artists with ascending and funded careers this trajectory can seem all but unavoidable. As Roberta Smith points out, the primary meaning of these works is often: "I made this because I can."

One of the rare instances where large-scale photography seems to be justified is Hannah Wilke's *Intra-Venus* series. Here there's a reason for the massive size: these pictures of Wilke's delicate body rendered monstrous and bloated by cancer treatments are meant to be an affront, in-your-face, a gutsy cry of rage and defiance. I saw some of them recently at P.S.1. They were a little warped and fraying around the edges, not precious or commercial looking, or well preserved. Probably not very saleable or collectible.

Consumption

"The final reason for the need to photograph everything lies in the very logic of consumption itself. To consume means to burn, to use up—and, therefore, the need to be replenished. As we make images and consume them, we need still more images; and still more" (Susan Sontag).

Periodically, but infrequently enough to be surprised by what I find, I go through boxes of photographs and contact sheets made as long as twenty-eight years ago. My latest foray into the archive was sparked by a need to find specific negatives for a piece that never went beyond the contact sheet stage. In my memory the negs were 35mm color. When I finally uncovered them, they were medium format, black and white, and fewer than I imagined. Nonetheless, I was very happy to find them; I am always happy and reassured when I "find" something that has been "lost." And in the process of searching, I flipped through hundreds of contact sheets of my baby, wondering how I could possibly have taken so many pictures of him in the first few years of his life (a veritable compulsion is how it strikes me now). Still, these were the images I wanted to look at, pore over, scrutinize.

Dipping into the archive is always an interesting, if sometimes unsettling, proposition. It often begins with anxiety, with the fear that the thing you want won't surface. But ultimately the process is a little like tapping into the unconscious, and can bring with it the ambivalent gratification of rediscovering forgotten selves.

Rather than making new pictures, why can't I just recycle some of these old ones? Claim "found" photographs from among my boxes? And have this gesture signify "resistance to further production/consumption"?

Love

In the essay "Diana and Nikon," Malcolm quotes Lisette Model on the attraction of the snapshot: "We are all so overwhelmed by culture that it is a relief to see something which is done directly,

without any intention of being good or bad, done only because one wants to do it."

And Barthes, in one of many emotive passages in *Camera Lucida*, speaking of the pathos of the photograph, and of the particular direction his investigation of its essence will take, says: "I was like that friend who had turned to Photography only because it allowed him to photograph his son."

I remember Sheryl C., a beautiful young lesbian woman at the University of California, San Diego, who enrolled in photography classes so that she could take pictures of all the girls she had crushes on.

Thomas Hirshhorn writes unabashedly of love in relation to his literary and artistic heroes (and I love him for this), including Emma Kunz (1892–1963), whose "healing images" he featured abundantly in his installation at Gladstone Gallery in 2005:

"I want to take the beauty of her work superficially to make use of it as pictorial energy in a three-dimensional display where questions of decoration, formalism, superficiality are confronted to pictures of war, human violence and wounds."

I love these words and I love Jennifer for her nerviness, for pinching the Kunz print I coveted but didn't have the guts to steal myself. I picture her on that cold winter day in her long coat and platform heels, like one of Robert Altman's women, moving stealthily and placidly through the frigid glass and concrete spaces of Gladstone in Chelsea.

Sitting through MFA admissions committees, looking at slides or electronic images and listening to the candidates' statements being read aloud, I am struck by these 20-to-30-year-olds' declarations of love for photography. I remember my own love of B&W photography at that age, the seduction of materials, the finishes and textures of special papers, the toners that could be added to further alter warmth or coolness. A simple appreciation of materials becomes taboo.

Zoe Leonard later brought a love and estimation of the old-fashioned gelatin silver print into the postmodern equation, at a time, in the early '90s, when it was thought most uncouth to do so. Her work represented a bridge between old-school pho-

tography and the concept-driven practices of the post-Pictures generation, i.e. appropriation and staged photography.

October 4

Page count: 23. Typeface 16-pt bold. I have been reading and writing these notes in a meandering, aleatory fashion, but it is becoming increasingly clear that I must address directly what Benjamin, Sontag, and Malcolm meant by accident and their valuation of it in relation to photography. I go back to the books to reread my opening quotes in context.

Walter Benjamin

Benjamin's essay is a love letter to the earliest practitioners, the first portraitists, and then to subsequent generations of document producers: Eugène Atget, August Sander, and Karl Blossfeld. Benjamin had an uncanny eye for everything that would prove enduring in photographic history, and famously railed against the arty and fashionable, the "creative" — in particular, Albert Renger-Patzsch, author of *The World Is Beautiful*.

For Benjamin, "the tiny spark of accident" is a little like the *punctum*, the detail that escaped the photographer's notice but reaches out to the viewer, decades or centuries later, collapsing time, making the viewer feel contemporaneous with the image.[2] He includes in his essay, recently retranslated as "Little History of Photography," David Octavius Hill's *Newhaven Fishwife*, and writes of "an unruly desire to know what her name was, the woman who was alive there, who even now is still real." I find this a strikingly Barthesian remark, this way of speaking about desire in relation to the photograph. And looking at the reproduction you know exactly what Benjamin is talking about: you have the uncanny sense that the photograph could be a contemporary one

2 In the new translation, "accident" is rendered as "contingency," perhaps another indicator of the term's downgrading in the contemporary photographic lexicon.

of a stage actress in nineteenth-century dress.

Benjamin's tribute to Atget, an artist all but ignored in his own lifetime, but who photographed the Parisian arcades, those architectural structures that figured so emblematically in Benjamin's thought and oeuvre in the last decade of his life, is especially moving. It is almost as though Benjamin sees in Atget's undervalued life and work, and in the lonely, poverty-afflicted circumstances of his death, a mirror of his own struggles and unrewarded work, his own life beset by cruel accidents of history, that would end in conditions even more fraught than his subject's.

For Benjamin accident is the tiny mark of destiny, the ability of the camera to signal a moment of historical truth. In a strong allusion to mounting Fascist violence in Europe, to city streets becoming more and more perilous to citizens such as himself, Benjamin writes: "It is no accident that Atget's photographs have been likened to those of a crime scene. . . . Every passerby a culprit." He follows with a series of rhetorical questions, a call to photographers to make their works literate, to be eyewitnesses, to pin down meaning with inscription.

But "Little History of Photography" then concludes in classic Benjaminian fashion, with a gesture away from the revolutionary engagement demanded of photographs, back to the melancholic tone that opened the essay, to "the photographs [that] emerge beautiful and unapproachable, from the darkness of our grandfathers' day."

Benjamin and Barthes

Sit at glass-topped table. Copy passages from Benjamin, Barthes. Begin to see new connections.

Benjamin: "For the reader is at all times ready to become a writer. . . . [C]onsumers into producers, readers or spectators into collaborators" ("The Author As Producer").

Barthes: "The Text decants the work from its consumption and gathers it up as play, activity, production, practice" ("From Work to Text").

For Benjamin the art photograph quickly became a fetish;

he was interested in photographs whose aesthetic qualities were secondary, a by-product of some other intention or drive. At the end of *Camera Lucida*, Barthes declares that photography as art is worthless to him because it's not mad. Only an original, mad work will pitch the viewer right back into what he calls "the very letter of Time," the wound of Time, the sense of loss that in turn produces for Barthes a "photographic *ecstasy*." This ecstasy reminds me of the *bliss* of Barthes's *writerly* Text, which, like the *punctum*, also "cuts," "chooses," "imposes . . . loss." It is also the Text that blurs the distinction between writer and reader.

There are some remarkable affinities between Barthes's decrees in the 1970s and Benjamin's pronouncements in his trio of related works from the early-to-mid-1930s ("Author As Producer," "The Work of Art in the Age of Mechanical Reproduction," "Little History") that touch on the revolutionary power of the photographic image. In the days of escalating Fascism in Europe, Benjamin felt that what photographs urgently needed was text to ground them, and he advocated Brechtian acts of "unmasking and construction," urged writers to become photographers and readers to become writers.

Though conceived at very different historical moments, and under very different circumstances, these prescriptions from Benjamin are nonetheless very close in spirit to Barthes's own manifesto texts that call for collapsing the distinctions between writers and readers, producers and consumers.

To illustrate this collapsing of roles, both writers make analogies to models of musical production. For Benjamin it is the concert that "eliminate[s] the antithesis between performers and listeners"; for Barthes the conflation of roles signals a period in musical history when "'playing' and 'listening' formed a scarcely differentiated activity."

October 7

Meet up with friends in the East Village. Walk over to St. Marks and look at enormous Annie Leibovitz coffee-table book for her show about to open at the Brooklyn Museum: shocking pho-

tographs of Susan Sontag, her longtime companion, very ill, in hospital, and on a stretcher being transported by ambulance plane. Photographs and video stills of Sontag dead, almost unrecognizable.

Next day, read article online from Friday *Times* on the Leibovitz show and book in which Sontag is described as "a private person" and Leibovitz is quoted as saying:

"If [Sontag] was alive, of course this work wouldn't be published. It's such a totally different story that she is dead. I mean, she would champion this work."

Walk the dog and think of the strangeness of this intensely voyeuristic, almost freakish book that chronicles fifteen years of Leibovitz's commercial work and her private life with Sontag. I think of Sontag's razor-sharp criticism, her withering critique of Diane Arbus; think especially of Sontag's last book, *Regarding the Pain of Others*, an account of the relationship between victimization and photography, and wonder at the terrible irony of these final images of her corpse.

Dust and vacuum bedroom where I work on the bed. Within days every surface is again covered in powdery white dust.

Sontag and Accident

I am struck more than ever by Sontag's prescience.

She mentions accident more than once, including this passage on photography's privileged relation to surrealism: "Surrealism lies at the heart of the photographic enterprise ... has always courted accidents, welcomed the uninvited.... What could be more surreal than an object which virtually produces itself, and with a minimum of effort?" (I wonder what debt Rosalind Krauss's essay on the surrealists and photography might owe to Sontag, and go back to Krauss and look over her footnotes. No mention of Sontag.)

For Sontag it is the unmanipulated photograph that is inherently surreal and comes about "through a loose co-operation (quasi-magical, quasi-accidental) between photographer and

subject." It does not require elaborate means or technical inge-
nuity; in fact the opposite is true: it is artifice that kills off what's
interesting and vital in a photograph. Artiness squelches: "The
less doctored, the less patently crafted, the more naïve, the better
a photograph is likely to be."

Malcolm and Aging

For Barthes accident is the detail that wounds; the *punctum* is
also the wound of Time that every photograph embodies. Janet
Malcolm's essay "Pink Roses" in *Diana & Nikon*, a review of
Andrew Bush's photographs of a home inhabited by a group of
aging aristocrats, is also about the wounds of time. Three-quar-
ters of the way into a fairly straightforward review, Malcolm
writes:

"But [the photographs] ultimately tell a story more personal
and painful (and universal) than the narrative of the 'European
aristocratic lifestyle' at bay. With a precocity resembling that of
Muriel Spark, who wrote her masterpiece *Memento Mori* when
she was half the age of her characters, Bush delicately but with
a devastating accuracy probes the world of old age. Led by the
camera's bland inquisitiveness, the young visitor penetrates to
the heart of the matter of being at the end of one's life and get-
ting through the day as best one can."

I find this writing "devastating," and google Malcolm to know
her birth date: 1934, in Prague, which means she was 56 when she
wrote her review, and was thinking about aging. Now she would
be 72. I think of all the accidents of fate and history involved
with these writers: Benjamin's persecution and suicide at age 48;
Woolf's at 59. Barthes hit by a truck at 64, Sontag succumbing
to a third bout of cancer at age 71. She railed against "quality
of life" and fought for the very slim chance of a cure. Of the
four, only Janet Malcolm, the daughter of a Jewish psychiatrist
whose family left Czechoslovakia in 1939, the year the Germans
invaded, is still alive.

Robert Louis Stevenson: "[Death] outdoes all other accidents

because it is the last of them."

Psychoanalysis

Nineteen thirty-nine was also the year of Freud's suicide in London following his flight from Nazi-occupied Vienna the previous year. Unlike Benjamin, who was forced to abandon his cherished library when he left Paris, Freud had been allowed to bring his collection of antiquities with him to England. But by then he was in unbearable pain from cancer of the jaw, and induced his own death by morphine with a physician's assistance.

Janet Malcolm has written extensively on psychoanalysis. In some ways she is at her most dazzling when she uses psychoanalysis as a lens through which to view the world, as in this passage from the essay "Diana and Nikon," on the irascible documentarian Chauncey Hare:

"Hare takes the camera's capacity for aimless vision as his starting point and works with it somewhat the way a psychoanalyst works with free association. He enters the universe of the undesired detail and adopts an expectant attitude, waiting for the cluttered surface to crack and yield to interpretation."

Here Malcolm puts her own artful spin on Benjamin's famous allusion to the camera's ability "with its devices of slow motion and enlargement" to reveal hidden and unseen truths:

"It is through photography that we first discover the existence of [the] optical unconscious, just as we discover the instinctual unconscious through psychoanalysis."

October 10

First Interferon injection. Pictures of dust motes in sunlight after shaking out bedspread; picture of large weed growing by the West Side Highway. I've broken the ice, am taking pictures again. I risk something, but what, exactly? I am overcoming my resistance to committing further images to the world, new negatives to the archive. Think again of Nina's long howl as she took

the plunge.

October 13

For Sontag and Malcolm accident is the vitality of the snapshot, to which they oppose the turgidity and pretentiousness of art. For Barthes accident is wholly subjective; it is what interpolates him into any given photograph.

It's becoming clear to me that my own relation to accident is also extremely subjective, that accident is to be located outside the frame somehow, in the way we apprehend images. I shun the formal encounter via the institutions of galleries and museums, and gravitate to books and journals.

Lost

As I'm writing I start to remember, or think I remember, reading that Benjamin (or was it Barthes?) wrote about clocks in photographs, the idea of a picture recording the exact moment of its taking. I flip through books, hoping I've made a mark. But the thing I was looking to find remains lost. I feel unlucky.

I am developing new coping mechanisms for lost words and lost negatives, as here for instance: compensate by describing the episode instead. Where something is lost, redirect energy, follow the *dérive*, the chance and flow of what life tosses us, and make something new instead.

Remember that I'm often struck by certain passages of descriptive writing, writing that is not about driving home a point but about providing detail, background, setting the scene (it's tempting to call this the *studium* of writing). It has a "something from nothing" quality: a pleasurable experience has been had, and no one has paid a price. Remember that writing does not have to be torture.

October 15

Read. Read something else. Go back to the first thing and see how it is changed.

Writing

"Every writer has to reach and is constantly aware of how basically it comes from inside; . . . whereas for the photographer, the world is really there" (Sontag, "Photography within the Humanities").

Writing seems like the ultimate magic trick, of making something from nothing. Perhaps I still "write" like a photographer— I go out into the world of other people's writing and take snapshots. These "word-pictures," like Benjamin's "pearls and coral," have Sontag's "talismanic" quality, and from them I can make something.

October 25

Increase Interferon. Dream-filled, restless sleep. Prompted by Sontag's diary, read Rilke, who said: "Love the questions."

Transformation

In an interview in *Afterimage* in 1999 Jennifer Montgomery describes the initial attraction film had for her, that it was a medium that could bring together writing, performance, and the visual, all in one work. And then came the discovery of film language:

"We always used to talk about whether the film had been transformed or not. You would get some footage back [from the lab], and it wouldn't be successful because it wouldn't have become something other than just the image and the text. . . . [It wouldn't have] gotten constructed to the point where it had a life of its own."

This "life of its own" is film language, "the thing we don't count on . . . the language of the unexpected."

Jennifer's comments remind me of Gary Winogrand's famous statement about why he took pictures. In her essay "Certain-

ties and Possibilities," Janet Malcolm cites a longer version of the well-known quote in which Winogrand is responding to this query from a student: "What is it, say, in a picture that makes it interesting instead of dead? What makes a picture alive instead of dead?"

Winogrand gives the example of a Robert Frank photograph of a gas station: "[It's] the photographer's understanding of possibilities.... When he took that photograph he couldn't possibly know—he just could not know—that it would work, that it would be a photograph. He knew he probably had a chance. In other words, he cannot know what that's going to look like as a photograph.... That's really what photography—still photography—is about. In the simplest sentence, I photograph to find out what something will look like photographed."

This "not knowing" has, for the better part of two centuries, been an integral part of working with emulsions and celluloid. Even with a Polaroid you had to wait a minute or two. Not to be too mystical about it, but the delay, the waiting and the anticipation, were all part of a process that embraced accident and contingency.

And this phenomenon of latency, while not exactly eliminated from digital work, has been diminished. A fundamental principle of the photographic process has been altered by the introduction of previsualization, by the little screens that allow us to compose, rearrange, jettison. The next step is often the larger screen of the computer monitor and the tools of digital enhancement. As per Roberta Smith, many of the pictures produced by this method are fundamentally no different from the gaudy mid-nineteenth-century pictorialist tableaux of Henry Peach Robinson and F. Holland Day.

Tod Papageorge

Tod Papageorge has been teaching at Yale for a long time—he's one of the archetypal street photographers of the '70s, and while my photography teachers all talked about him thirty years ago, I never knew his work. Now he has two books coming out, and an

interview recently appeared in *Bomb*.

"Bomb: Are the mistakes that your students are prone to now the same mistakes that students were prone to when you were teaching back in the '60s?

"TP: No. I think that, in general—and this includes a lot of what I see in Chelsea even more than what I see from students at Yale—there's a failure to understand how much richer in surprise and creative possibility the world is for photographers in comparison to their imagination. This is an understanding that an earlier generation of students, and photographers, accepted as a first principle. Now ideas are paramount, and the computer and Photoshop are seen as the engines to stage and digitally coax those ideas into a physical form—typically a very large form. This process is synthetic, and the results, for me, are often emotionally synthetic too. Sure, things have to change, but photography-as-illustration, even sublime illustration, seems to me an uninteresting direction for the medium to be tracking now, particularly at such a difficult time in the general American culture."

October 28

Insane mood swings.

Virginia Woolf

In 1926 Woolf wrote an essay called "The Cinema," about how primitive the art form still was, and about its clumsy attempts to poach on great works of literature such as *Anna Karenina*. Woolf contrasts the experience of reading, of knowing Anna "almost entirely by the inside of her mind" with film's rendering of an actress's "teeth, her pearls and her velvet ... her [falling] into the arms of a gentleman in uniform [as] they kiss with enormous succulence." With her usual discernment, Woolf locates cinema's potential not in its parasitic relationship to the novel but in an "accidental scene [taking place in the background]—the gardener mowing the lawn."

She begins to glimpse film language in what was probably a hair in the gate of *Dr. Caligari*: "a shadow shaped like a tadpole [that] suddenly appeared at one corner of the screen. It swelled to an immense size, quivered, bulged, and sank back again into nonentity." This monstrous, hoary apparition signifies fear in a way that no facial expressions or words spoken by actors could ever approach, and Woolf speculates that it is in this sort of formal, materialist device, apprehended by accident, that the future of cinema lies.

There are some obvious parallels between Woolf's send-up of hokey film adaptations and what's going on today with photographers who work with Hollywood actors and sets. I know that photography has to evolve, and that for some artists it makes no sense to produce a photograph that is not self-acknowledging "as a construction," but I still stubbornly cling to those artists, like Francesca Woodman, who did it without dusting the hairs from the gate.

A picture like *Three Kinds of Melon in Four Kinds of Light*, from 1976, capers around the problematics, à la John Berger (*Ways of Seeing*), of objectifying the naked female body. Woodman cranked this stuff out with effortless verve and wit. Jason Simon introduced me to her work in the late '80s via a catalogue with poor-quality reproductions that he found in a secondhand-book store. I was blown away by this young artist, born the same year I was, dead at twenty-two in 1981, a suicide.

Openness

I make it to Chelsea. There's nothing in particular I've come to see; mostly, I've had a pressing feeling that it's been way too long since I made the effort, that I'm out of touch, that I've neglected my responsibilities. I feel guilty for being a recluse and not participating.

It's 5 PM and dark, everything closes in an hour, but actually that's plenty of time to see a lot of things. First, a group show at Murray Guy with a Matthew Buckingham video playing on a small monitor. There's almost nothing to look at: a nondescript

patch of sidewalk, grass, and fence; occasionally some bread crumbs get tossed into the frame and a few birds appear to peck at them. On the wall is a slot-shaped box containing a typeset printout with a text by Matthew. I take one of these to read later.

Robert Longo has massive graphite drawings of the cosmos and the moon, and a couple of sentimental photographs of beautiful blond children sleeping, all done totally straight-faced and earnest. This is the art world at its most absurd: Mount Rushmore–scale pieties, dwarfed only by the deafening ka-ching of the cash register.

A few days later I read Matthew's wonderful, vaguely Sebaldian text (printed in two columns of Times Roman with little documentary stills at the bottom) about the cultural history of house sparrows in Brooklyn. This is one of my favorite types of artwork, where the meaning of a work is deferred and completed, often over short distances of time and place, by the reading of a handout text.

Zoe Leonard

Head down to Dia for a lecture by Zoe Leonard on Agnes Martin. I get there just before 6, only to realize I've gotten the time wrong; the talk starts at 6:30, but Paula Cooper's bookstore is still open, so I spend the half hour reading a few pages of Annie Leibovitz's introduction to her book. Again, I am surprised—by the simplicity and directness of her writing. It's all about Susan, about how this doorstop of a book grew out of digging around for photos to give to friends at Sontag's memorial. The writing touches me.

Zoe gives her lecture on Agnes Martin, but doesn't show any paintings. With her characteristic flair for storytelling, she describes photographing the paintings over and over, and the difficulty of it: all she can see is the dust in her viewfinder. No paintings, no photographs; at the last minute Zoe substitutes a repetitive, structuralist film, the only film of any kind Martin ever made. Yet I leave the lecture with an incredibly vivid image of the absent, unseen photographs: classic, vintage B&W

Leonard, signature black frame line enclosing Martin's pale, gray, pencil-lined grids. Photographs of pencil marks.... But did Agnes Martin even use pencil? I realize, rereading this, that I don't actually know, and may have invented these pencil lines, fantasizing photographs to suit my own desire.

Jeff Wall

A big survey of Jeff Wall's light boxes is at MoMA. In his astute essay "'Marks of Indifference': Aspects of Photography in, or As, Conceptual Art," Wall makes the case that photography became modern and relevant (became "art") not with the f.64 school of Edward Weston and Ansel Adams (which Wall qualifies as still in the pictorial tradition), but with the crummy little snapshots of Robert Smithson, Ed Ruscha, and Dan Graham. Yet Wall's own photographic project exists in stark contrast to the modesty of that vernacular tradition: his massive transparencies want to be understood primarily in relation to nineteenth-century painting and its history.

As one of the ur-purveyors of large pictures in the late '70s, Wall was definitely attempting something new and radical in the presentation and reception of photographs, and he's historically important for that gesture of innovation, for giving the photograph a status as "constructed object" as opposed to "window on the world." I liked his sink pictures and the anemone-filled grave when I first saw them reproduced in magazines, but at MoMA even this work seems ultraflat and sterile in its effect, and I'd argue that it's not just a problem endemic to big, ossifying museum shows, but an issue with the grandiosity and ungainliness of the silver-boxed Duratrans themselves.

Wall is a smart guy and a good writer, and I always thought that one of the things he had going for him was his progressive politics: he could perform social documentary without the victimization. But as I think of it now, Sherrie Levine did pretty much the same thing with a vastly greater economy of means, i.e. appropriation and critique of the genre via her modest

re-presentations of Walker Evans and Edward Weston works in black-and-white 8 x 10s.

Kerry James Marshall

Lest I be accused of dismissing photographs simply because they are big, I want to register my love for Kerry James Marshall and his show of large inkjet prints at the Studio Museum in Harlem: a mural-size baobab tree; a Christmas tree with black nativity and lights; inky, blue-black figures and silhouettes, barely discernible invocations of Ellison's *Invisible Man* (Wall's version is a Macy's holiday window by comparison); the faces of the white women who stare out at the camera from an infamous 1930s lynching photograph. In this show there was a prodigious mixing of genres and textures: sculptural elements in the form of handmade, improvised furniture, and lounging areas mingled with photographs of all shapes and sizes, all manner of presentation. The corporate look of most museum shows was nowhere in evidence; what ruled instead was a breathtakingly inventive heterogeneity of formal invention and storytelling.

Bed

Early spring, 2007. Think back to July, sudden blindness in left eye and diagnosis of multiple sclerosis (a disease of accidents, "mistakes of the immune system"), leaving hospital with prednisone taper. For a few weeks I'd wake early each morning and with push from vitamin P, bring the computer to bed where I'd stretch out and make myself write. I'd asked some questions about photography and accident, about what it meant to my four writers; I'd laid down a gauntlet or two. And while the "decisive moment" metaphysics of accident might have been a red herring, it nonetheless pointed me to contemporary photographers whose work is compelling and vibrant. To those already mentioned (Peter Hujar, Zoe Leonard, Kerry James Marshall, David Wojnarowicz, Francesca Woodman) I'll take the opportunity to add here: Liz Deschenes, Jitka Hanslova, Hanna Liden, Claire Pentecost,

James Welling. In these artists I intuit, wholly from the gut, a love for "the aged and the yellowed," what Barthes, unabashed in his essentialism about photographs, identified in a 1979 lecture as the "real photography," unlike the glossy pictures in *Paris-Match*.

Finally, there is the accident of words: what wells up when we make space for such occurrence, when we lie on the bed in morning sunlight and bring laptop to lap. I've often heard it said, most recently by novelist Monica Ali, that as writers "we're not at liberty to choose the material, the material chooses us." Geoff Dyer has noted parallel statements by photographers: "It is the photo that takes you" (Henri Cartier-Bresson), "I don't press the shutter, the image does" (Arbus), and one from Paul Strand on choosing his subjects: "I don't.... They choose me." While I've always intuited this about pictures, I was skeptical when it came to words. But I now know it to be true, beyond any doubt, for writing as well.

Notes

I still haven't come across that lost reference to clocks. I did, however, begin to read Walter Benjamin's correspondence, and in a letter to Gershom Scholem dated December 20, 1931 (the same year "Little History" was published), he describes his study, a room with a panoramic view from which he can see the ice-skating rinks, as well as a clock: "as time goes by, it is especially this clock that becomes a luxury it is difficult to do without." Benjamin also tells Scholem: "I now write only while lying down." I think of Leibovitz's photograph of Sontag on her bed. I don't have the photo before me — it's another absent picture — but perhaps I can conjure it from memory: Susan in jeans, white shirt, and dirty white sneakers, reclining on the left, her hair thick and wiry, black with white stripe; and, spread out over more than half the bed, a complex patchwork of ruled pads with half their bulk folded over, typescript pages crossed out and annotated, and oddly shaped scraps of paper with handwritten notes.

(2008)

INDEX CARDS

FOR ALISON STRAYER

To have been driven all one's life by some poorly understood mechanism in one's body and then be asked to cut the speed by a half or two thirds is asking a great deal. I am trying to find a new way to work.

20 December. WB writes a letter to his friend GS in which he says he now writes only while lying down, the desk having become freighted with associations to other writing. From his divan he has a view of the filled-in bog, the ice-skating rinks, and a clock about which he says: "More and more I feel this is a luxury I cannot do without."

5 January. New York City. Gaze down upon Audubon Terrace and Trinity Cemetery. At this time of year it's a vast, hoary mound of earth, rocks, and naked trees in shades of gray and brown: so much is visible, in fact, that parts of it, the eroded, outer edges, resemble an archaeological dig. By summer the ground and stones will be obscured by giant puffs of green foliage, and not much will be distinguishable beyond the abundant flowering of huge old trees. In front of the cemetery is a building with this inscription:
WE ARE YOUNG
AND WE ARE
FRIENDS OF TIME

16 February. "Like a plant, in the mornings he wanted to live, by evening he wanted to die." (E. Leslie)

22 February. Think of three cemeteries: New Orleans (Paul Morphy); New York City (view from 790); Paris (Montparnasse, Père Lachaise, etc.). And Aldo Rossi's. This thought, of three cemeteries (plus Rossi's) in three cities in three moments in time gives a burst of optimism.

3 March. Andrea G. emails me Benjamin's "Surrealism" text with image of alarm clock at the end. I begin it but then read only the last sentence.

12 March. Buy tickets to New Orleans. Begin MS recovery diet. Spitzer resigns.

13 March. Waste two hours reading about Eliot Spitzer in the *New York Times*. Read instead: Paul Morphy, E. Bowen, Natalia G. Or: read and write nothing. What would I do instead?
 "In real life Sturgis was much more sanguine about giving up his writing career. His friend A.C. Benson said he thought Sturgis had all the makings of a great writer except the drive. Perhaps he was right. Though Sturgis ran through his fortune and fell on hard times toward the end of his life [...] he still seemed to be enjoying himself. He told Wharton after he underwent unsuccessful surgery for cancer, 'I'm enjoying dying very much.'" (Edmund White)

30 March. B. cannot say his own name without stuttering. Today he talked about the face and the vulnerability of the nose to being hit, and then more generally about the anatomy of the face. Amazed he knew this. And his own face is changing.

The Problem Of Paul Morphy

At the height of his career and prowess, chess prodigy Paul Morphy took himself to the Café de la Régence in Paris, where he'd arranged to play eight games simultaneously over ten hours, blindfolded. After defeating the last of his opponents he pushed his way out onto the streets through an ovation of cheering crowds; the next morning he dictated to his secretary every move of each of the eight matches, as well as multiple variations on those moves. Morphy was a consummate amateur so terrified of being thought otherwise he'd immediately give away any prize money won at chess. Triumphant in the chess world, there remained one Englishman named Staunton for Morphy to beat.

An analyst of chess and the author of several authoritative books on the game, one of which Morphy had owned since adolescence, Staunton had long been construed an "arch-imago father figure" by the younger player. Strategically, Staunton dodged all invitations to play, insinuating that his challenger was motivated by monetary gain. This was mortification to Paul Morphy, who stopped playing, became more and more reclusive and paranoid, and died suddenly of congestion of the brain at age forty-seven. (Adapted from the case study by Ernest Jones)

Cemeteries

Unable to make a decision about travel, about whether it would be good or bad for my health to travel, I woke one morning with the idea of a project rooted in travel, linked by three cemeteries in three cities in three moments in time. It made me happy to think I'd found a solution, and could accept the invitation to Mark and Dana's wedding in New Orleans, in a garden cemetery shaded by trees.

With me is a memory from the summer of 1988, of stumbling onto another of the city's little necropolises in blinding white sunlight and intense, nearly unbearable heat. The site is completely exposed and the white of the tombs draws and refracts even more light and heat. We look for but don't find the grave of 19th-century chess master Paul Morphy, known to us by way of Ernest Jones's essay in *The Psychology of Gambling*, a book with a smiling, ash-white grim reaper on the dust jacket.

25 April. Back in New York, sunlight is pouring in and bird sounds fill the room. Why am I sitting here tearing my hair out? It's a warm spring day, the cemetery is now almost obscured by soft green, yellow, and red bursts of leaves. Remember the *New York Times* article on Rossi: birth and death in his conception of the cemetery in Modena. Wonder how easily I might locate and photograph all four cemeteries (New York City, New Orleans, Paris, and San Cataldo in Modena) on Google Earth. Pull *Times* article from files to read later.

29 April. Aura tells me about the essay "Hashish in Marseilles," that in it someone wakes up from a hashish trance and sees a clock. I read the version in *Reflections*. There is no clock, but there is this:

Ball Of Thread

"What joy in the mere act of unrolling a ball of thread! And this joy is very deeply related to the joy of intoxication, just as it is to the joy of creation. We go forward; but in so doing, we not only discover the twists and turns of the cave, but also enjoy the pleasure of discovery against the background of the other, rhythmic bliss of unwinding the thread. The certainty of unwinding an artfully wound skein—isn't that the joy of all productivity, at least in prose? And under the influence of hashish, we are enraptured prose beings raised to the highest power." (Walter Benjamin)

How much easier to read Benjamin on drugs. Resolve to read only this kind of thing, or the short pieces on food and cities.

The certainty of the skein reminds me of Virginia Woolf's "net of words": her sureness that when she is writing an essay (not fiction), a net of words will eventually drop down on her. Google various phrases that I remember from the passage, but, unlike most searches undertaken in this manner, nothing turns up. This is what I remember:

"When writing an essay I have the certainty that within an hour or so a net of words will drop down upon me and allow me to compose my essay, but with fiction there is a great despair and it is as though I must sit and gaze at the words from the other side of a blue abyss."

Resolve to refrain from including long quotes, though I can't resist "Ball of Thread" and read it over and over. Refrain from quoting authors I've only read secondhand.

{"Myslovice-Braunschweig-Marseilles" is the story Aura meant, about a guy who takes hashish and misses his chance to become a millionaire: he keeps falling asleep and waking up to big clockfaces.}

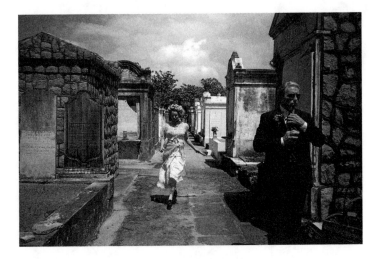

Story, Structure

What is the certainty Benjamin is talking about? Is it the assurance of having found a solution, the way out of an impasse? Ariadne's thread is literally a lifeline; for a writer, to hold the ball of string is to have the beginning and end of something, and all the twists and turns in between: to grasp the story, and know its unfolding.

Remember Jean-Pierre Gorin, who'd admit to a fundamental lack in his filmmaking: the subject of the film was the need of the maker to be making something, and the search for what that something could be. Disarming to have this lack so forthrightly acknowledged.

Malcolm: "The writer, like the murderer, needs a motive."

Genevieve: "[A]nd not just a story, but structure as well. Material is meaningless without: form, frame, container, thread."

But aren't confusion and drift truer to how lives get lived? Isn't structure a contrivance? Instead, why not just editing? As in Pasolini's "Observations on the Long Take," about how death imposes an immediate final edit, gives meaning to a life. Let story and structure unfold. But it takes so long. I sit and stare and I want to be an "enraptured prose being."

Aldo Rossi: "I felt that disorder, if limited and somehow honest, might best correspond to our state of mind."

Newspapers

In the middle of *The Heat of the Day* (E. Bowen, 1949), there is a long and tender ode to the newspaper. It is a passion shared by Connie, "a collector of newspapers of almost any age, either to look at again or wrap things up in," and Louie, who, "once [she] had taken to newspapers [...] found peace." The two women hoard the papers, savor their smells and textures, take pleasure in the brittle sounds of pages being turned and folded, empathize with their thinning bulk in war-rationed Britain and long to feed them, feel covetous at the sight of fried fish being wrapped in one of the precious broadsheets, and, having used a page to light a fire, "peer forward into the acrid smoke to read the last of the print till a flame [eats] it."

Rainer Werner Fassbinder: "What's needed is appetite. And if there is appetite, a story will unearth itself." In a filmed interview RWF says he can make a movie from reading an article in the newspaper.

"[M]y impressions on certain mornings when I read the newspaper." (Aldo Rossi)

"And I must read all the papers which I put into my closet week after week and never read." (Jane Bowles)

8 May. The fundamental pleasure of making something (with our hands especially). Wrapping and unwrapping the ball of thread [...]

At night: inducing sleep with stories (but only the boring, predictable ones: Tony Judt).

J. & language: transmutation of experience, lessening of pain.

Joan Didion: "We tell ourselves stories in order to live." Quoted over and over in David Rieff's memoir of Susan Sontag's illness and death.

"Talking so as not to die." (Jean Clair)

Jane Bowles

The book falls open to a boarding pass for a flight to Puerto Vallarta dated December 1986. I begin to read Jane's deliriously long and repetitive reflections on the minutiae of her life—money, ship schedules, the renting out of Paul's apartment and her anger at having to clean it, Paul's prolific writing, her own blockage. In one nine-page letter to him, she notes:

"I have waited to write because I have been in such a boiling rage with you having spent most of this week trying to make some order out of the havoc of your clothes and pure junk left around the apartment none of which I dare throw away [...] Unless I can get a friend to take [the apartment] everything in the closets will have to be packed away. I am willing to do this as best I can but I will take no responsibility about doing it wrong."

I found, and still find the letters oddly comforting for the way they translate thorny life problems into Gertrude Stein–like, droning-on prose. I've often thought that diaries and letters are the real modernism: stream of consciousness without the contrivance. Unable to work on fiction most of her life, the letters

are where Jane did her writing, and she wrote at great length about her inability to write. She called these dispatches "agonizers," and was capable of cycling over the same nagging problem, in slightly modified form, a dozen times or more in a single letter. I have to admit to some schadenfreude in reading the letters, of finding consolation in someone else's blockage.

I read from the beginning, but also flip forward to the page where I'd left the plane ticket, and where I'd possibly stopped reading in 1986. I'd forgotten that Bowles had had a stroke at age forty, and read some of the letters written shortly after in which she is struggling to spell common words and form sentences. Her vision is impaired and she cannot reread what she's written, yet she is still attempting the same sweeping representations of her psychic and material state as before her illness.

But it's quite a different thing to read Bowles at fifty than at twenty-eight, and this time, with less distance on her experience, both in terms of age and health, I am less seduced by her transformative prose powers, and much more confronted by the disabling neurosis that ended catastrophically.

In my notebook I have copied: "Inevitable that I would get this (stroke), no surprise (writer's block)," but I cannot find the exact source for this quote in *The Letters*, and must consider the possibility that it is partially my own invention.

In her introduction to the letters, Millicent Dillon writes: "It was Jane Bowles' custom never to date a letter." I find this awesome and try to think of reasons why:

The letters sometimes took days or weeks to write, therefore the practical problem of choosing one date over another.

Superstition. She will be safe if she cannot be placed in time.

The letters were more than epistolary communication pinned down by the calendar: this was writing by the yard—which again makes me think of Stein's extravagance.

Jane not wanting dates is the opposite of Benjamin needing the clock, of his finding stability and reassurance in its presence.

11 May. Patina of book covers: *The Psychology of Gambling, The Street of Crocodiles*.

20 May. Reading Rossi on Modena cemetery (bones) and thinking about my teeth. Reread *New York Times* article pulled from files:

"Rossi combined motifs of innocence and mortality in some projects [...] [made] efforts to reconcile the extremes of childhood and death [...] the womb and the grave [...] clocks appeared, totems of passing time."

Copy long quote from heavily marked-up library copy of Rossi's *A Scientific Autobiography*:

"In April 1971, on the road to Istanbul between Belgrade and Zagreb, I was involved in a serious auto accident. Perhaps as a result of this incident, the project for the cemetery at Modena was born in the little hospital at Slawonski Brod, and simultaneously, my youth reached its end. I lay in a small, groundfloor [*sic*] room near a window through which I looked at the sky and a little garden. Lying nearly immobile, I thought of the past, but sometimes I did not think: I merely gazed at the trees and the sky. This presence of things and of my separation from things—bound up also with the painful awareness of my own bones—brought me back to my childhood. During the following summer, in my study for the project, perhaps only this image and the pain in my bones remained with me: I saw the skeletal structure of the body as a series of fractures to be reassembled. At Slawonski Brod I had identified death with the morphology of the skeleton and the alterations it could undergo."

Reread *The Painter of Modern Life* and "On Being Ill" in order to extract the following citations:

"In the window of a coffee house there sits a convalescent, pleasurably absorbed in gazing at the crowd. But lately returned from the valley of the shadow of death, he is rapturously breathing in all the odours and essences of life." (Charles Baudelaire)

"[P]erhaps for the first time for years, to look around, to look up—to look, for example, at the sky. [...] This then has been going on without our knowing it! [...] Ought not someone to write to *The Times*?" (Virginia Woolf)

Sky

"When you lay in the grass you were under the azure map of clouds and sailing continents. You inhaled the whole geography of the sky." (Bruno Schulz, *The Street of Crocodiles*)

"I saw the sky, a few stars and a little greenery." (Jean-Jacques Rousseau, cited in *The Neutral*)

"How was it I did not see that sky before?" (Leo Tolstoy, ibid.)

23 May. *Silences*: small, yellowed paperback. Walk over bridge. Bittersweet aspect of B. on piano: loveliness of music but always his anger. Record his playing to have for Paris. Playing and crying. Buy him songs on iTunes.

Sunday. David Rieff at 6 AM. Onionskin paper: when you turn a page, you turn two, and have to pick them apart.

Jane Bowles on the subway: Happiness of reading the early letters and trying to reconstruct my passion for them.

24 May. Begin Arsenicum Album. Rain this morning, now sun and heat. Reading Rieff on Sontag: her terror of death terrifying. But also her conviction that she could outsmart death, and her hubris about it. No, this is unfair. Sontag's was the worst of situations. But Dennis Potter had the same fate and did not fear death.

Sontag in Italy, writing her second novel: "It was going well and she chose to ignore symptoms of second cancer." (David Rieff)

Thomas Mann quoted by David Rieff: "A writer is someone for whom writing is harder than it is for someone else."

27 May. Benjamin koan in *On Hashish*:
The little sheep reads.
Is the frame a writing song is it an image.
Sleep my little sheep sleep.
Write my little sheep write.
Sleep is the part I forgot and need to write about.
Put computer to sleep. Close eyes, rest. Open Benjamin's *On*

Hashish at random and read: "[U]nder the influence of hashish, we are enraptured prose beings raised to the highest power." Begin to understand: He was stoned, he could write anything.

28 May.　　　Strange sleep, no pill. Numbing sadness about Bella. Videotape B. on the Farfiza in the rain.

4 June.
　Sleep (pills)
　Shit (senna tea)
　Clean desk
　Weed shelves
　Nadine Gordimer quoted by David Rieff: "You must write as if you're already dead."

? June.　　　Walter Benjamin writes to his friend Gershom Scholem that his 2,000 books have arrived, and that he now writes only while lying down. From his study he has a panoramic view of the ice-skating rinks, Schramm Lake, and a clock. He calls the scene "almost *l'atelier qui chante et qui bavarde*." This cryptic letter is the starting point for a work about writing, illness, sleep, and the view from the window: Baudelaire, Woolf, Rossi, Potter all have described supine or convalescent views of clouds, patches of blue sky, blossoms, or the crowd seen with the innocence of a child. The look of the world altered by illness. For Ray Navarro, in 1989, it was the little red blinking light on his stereo. He wanted to make an artwork about it but never got the chance.

　What do we do when the part of us that could go "all out" is no longer available? When brainpower is addled by drugs? My lifelong supposition has been that to remain healthy I must work. Now I must close my eyes, sleep, breathe.

11 June.　　　"When I lost my sight I found I could think better. My head filled with ideas. Time passes differently. I let my memories flow. [. . .] Or I do nothing—I let myself live. I can remain sitting in an empty room, perfectly still, for three or four hours without discomfort." (David Hoon Kim)

"I was getting used to this strange semi-darkness in which I lived and almost began to like it [. . .] I stood on the threshold of reality and imagination." (Oliver Sacks)

"The fleeting and poignant desire to no longer hear, to no longer see, to stay silent and immobile." (*Un homme qui dort*)

"I had an accident and had to stay in bed for a long time, on my back, laying down [. . .] I remembered a long time ago looking at the jaguar, the South American tiger, at the zoo, and noticing that the marks on its skin resembled writing. So, I united the two ideas, myself, immobile, sick, almost dying, and the idea of the jaguar and this mysterious form of writing." (Jorge Luis Borges on *le tigre*)

"I watched my blood flow as I would have watched a brook flow [. . .] I felt a rapturous calm in my whole being; and each time I remember it, I find nothing comparable to it in all the activity of known pleasures." (Jean-Jacques Rousseau, *The Reveries of a Solitary Walker*, in RB, *The Neutral*)

"An illness without suffering is a great privilege." (Gilles Deleuze: "M pour Maladie," *L'abécédaire*)

Dreams

"Another system is to lie down and dream for one hour until one can go back to the writing table. This is about all I can take right now — Goodby [*sic*] I am going to dream." (Jane Bowles, July/August, 1966)

"Intense dreams of solitude." (GP)

"[C]rumpled and disordered from the weight of dreams." (*The Street of Crocodiles*)

"[S]ince failure follows me into my dreams." (Jane Bowles, facsimile letter)

12 June. Sleep and dream about desperately trying to find a pen that works in order to scribble a note on a tiny, crumpled pad of paper. Woke and shot trees in the cemetery. Too hot and light too hard.

{Montparnasse Cemetery, main gate on Boul. Edgar Quinet. Beauvoir on right, Beckett. Sontag 1933–2004. Cioran, Sartre, Raymond Aron, Baudelaire.}

25 June.　　But I have been sleeping, and putting the computer "to sleep." Thinking about doing nothing, about Sontag doing everything, "being driven all one's life." Sontag's chief regrets at the end: "not having done enough in the past, and not having been happier in the present."

"[T]he number of hours when I simply lie on the bed without reading or thinking would shock you." (JB, p. 34)

27 June.　　Wake this morning with the thought that the last thing we need is more product. This related to realization last night while looking at AF's new book, or at least the question it raises about: subsequent books motivated by need for advance income or the need to maintain identity; the writer's need to log the AM hours; the artist's need to be always thinking of or making things; the filmmaker's need to be already working on the next project. Stopping signals a breach of identity. Think of AR, who pointedly did not write second blockbuster novel but did activism instead. Think of JL, who gracefully dodged this

pressure as well, though I'm sure it caused her pain.

In month of nonwriting, and in growing anticipation of departure for Paris, I have been reading Gail Scott's *My Paris*. I made this list in her gerund-driven style:

 I writing
 I sleeping
 I needing drugs
 I having pain in hands
 I feeling afraid
 I missing B.
 I feeling sadness for Bella
 I shitting guts out all over floor
 J. mopping up
 I meeting Dr. Pain and getting new drugs
 I writing in little notebook today on subway

1 July. Wake at 6 AM. Beautiful light and air. Sit on bed with books and papers. Sleep again till 12 and dream. Attempt to pack, read instead old diaries. Day comes full circle. Cool breeze from window. 3 AM *The Soccer War* in B.'s room, and continue reading: essays about war and liberation in Africa.

5 July. Two days of hell following Cymbalta, when I thought I was dying. Thoughts of all my dying friends and tell J.: I love you more than anything. I have arrived at the truth: only health is important.

15 July. Ulrike reads Benjamin letter in the barn and signals "l'atelier qui chante et qui bavarde." It is from *Les fleurs du mal*. B.'s interpretation of the clock: "Time is valuable. I like to know if I am on time, or have time to kill. It comes down to this: It's better to know something than not to know something."

26 July. To Ben: "I am obsessed with the idea of artists and writers having a drive to produce, and the sometimes-conflict when the product may not deserve to exist."

Ben wrote back:

"Only connect [...]

That's why I make stuff, the above, by way of trying to make sense of me and the world around me. That's why I'm not making stuff no more either. A performance is a bit of a gamble but easy enough to avoid."

Later LT says to me: you should examine those words: "deserve to exist." Evidence of how judgmental I can be.

26 July. Woke this morning thinking about photographing the weed and the trees in the cemetery, the necessity of getting out early for the light. Leave the house weighted down, shaky. Begin to see that many people are out at this hour: a man holds a small child by the hand. Realize that I can slow down and look and feel, and not always be driven by the urgency to capture, but also think: all photography is about discipline over constancy of light and sky. Light is everything. And: all photography is easel painting.

Climb ramp on West Side Highway to get the weed, but quickly realize how dangerous it is: drivers swerve at 50mph, unnerved by the sight of a pedestrian on the ramp.

Finally, experience of being in the cemetery: Almost deafening chant of cicadas and crows; abundant tropical greenery, ivy, vines, and huge ancient trees. Heat and light, and the sound of cars whizzing by.

28 July. Back to the cemetery for a third time: it is "l'atelier qui chante et qui bavarde." I am working again. I am alive.

The act of going out. Of physical exertion, of climbing the mound, listening to those intense insect and bird sounds. And bringing something home. Except that in the cemetery it is also private, protected. There is no anxiety over the public encounter with strangers, as with street photography.

"All the crickets and bugs are singing outside." (Jane Bowles, p. 49)

To Have Been Driven

"To have been driven all one's life by some poorly understood

mechanism in one's body and then be asked to cut the speed by a half or two thirds is asking a great deal. Yet this adjustment is necessary for living an exacerbation-free life." (Swank)

How to reconcile this truth with the lifelong craving for the rise of spirits that comes with engagement? Addiction to fever, as in: The moment when you lock in and feel yourself drawn forward by something both certain and unknown? And what of the stamina needed to find out, eventually, perhaps, what that thing might be?

Then there is the part of the self that wants to be off the hook. To have once and for all made the thing that will end the need to make things (others have said this: Miranda July). How to make sense of these incongruent drives. A book grabbed in the middle of the night says: "Eros and death, anxiety and guilt."

Sontag: "To write is to spend oneself."

I am trying to find a new way to work.

6 August. Woken by crows. Think again of *l'atelier*. Beautiful light and sky. Deep sleep, no drugs. To see Louise Bourgeois yesterday at the Guggenheim: some works are autonomous, mute; others attached to language: these always shock, pierce. Then on a park bench with Julie: sun, wrinkles, fat.

12 August. 9:45 PM and I recall almost nothing of the day. Finish Elizabeth Bowen: woman with a baby and three swans.

16 August. Drive Bella to Montreal. Terrible depression absorbed in the night.

21 August. *The Soccer War*. Remember this model: journalism cut with "The Book that could have been" or "notes on [...]"

"Yet I have not written a dictionary or a book because whenever I start taking a deep breath and crossing myself as if getting ready to jump into deep water, a red light starts blinking on the map." (SW, p. 197)

23 August. Air India: swollen, whale of a plane. Pretty young women with babies. RER train to Gare du Nord with nine pieces of luggage.

25 August. B.: "I heard you pee last night for the longest time." J.: "We both lay there and listened to you pee."

27 August. Arrive in Paris and begin to walk. Walk through the Passage Jouffroy with J. & B. Big, broken clocks, and a date: 1846. Jetlag adding to bell-jar effect in head and ears, this, in turn, doubled by muffled, muted sounds of glassed-in arcade. For Aragon it is like being underwater: arcade as "human aquarium." Also: *passage* as "coffin."
 "[T]he same voice of the seashells, the whole ocean in the Passage de l'Opéra." (LA)

30 August. Johanna emails long, beautiful passage about cameras and clocks from *Camera Lucida*.

2 September. Dream about going to the Cité for first time and finding halls are smeared in dog shit. *Money + time.*

3 September. Inexorable tug of sleep on my body. Sleep as
the weight of gravity pulling me down, and not able to resist
until finally I hear myself say: "get up." And I do. And I wander
out and buy the papers. I can't shake Gail Scott's book, or any of
the other countless recitations of this place.

"A dead, a tranquil place." (GP, p. 165)

5 September. Angry at J. for throwing out papers, then find
them in the trash on the sidewalk. Awesome beauty of park be-
side Notre Dame. Pleasure of maps, figuring out where I have
been and where I will go.

8 September. Chiming bells every half hour. Powdery
clouds and soft sun. In the middle of the night, waiting for sleep:
recrimination; in the morning, in the metro: forgiveness. Feel
the tension of last months lift. And pain lifts.

Stock market crashing. Toss two Lyrica into my mouth. One
falls on floor. Half out of my mind with drugs and frozen fin-
gers. 5 PM: sleep, or rather observe myself sleeping and think
about how I will extract myself from it. She is not dead but
sleepeth.

17 September. Visit Sontag's grave, a black slab on which visitors have placed small stones and yellow Post-it notes. Someone has written a note on a metro ticket and weighted it with a chestnut. Shoot some mediocre video of the stone and surrounding trees, a fitting expression of my ambivalence about being here. I use the small map given to me by the custodian to locate Baudelaire's grave. It is covered with notes written on metro tickets; also flowers and a book wrapped in plastic.

19 September. Hungover. Sniffly. Sound of bells. Sound of singing. Crash of stocks. Reread Elizabeth Bowen chapter on Connie, Louie, and newspapers. Trying to read Baudelaire on beauty: beauty has an *eternal* and *circumstantial* element etc., but cannot get past two sentences without stopping to eat, drink, or note something. Sunlight and church bells. Trying to help B. with math in French, plunged back to my mother's situation forty-five years ago. *J'ai, tu as, il a, nous zavons, vous zavez, ils zont. Mon ton son, notre votre leur.* Returned to childhood.

22 September. J. loses wallet and we spend the rest of the day on the phone canceling cards. I am understanding because his disaster justifies my own excessive vigilance, paranoia.

26 September. *The artist K recommends Regulin as a laxative, a powdered seaweed that swells up in the bowels, shakes them up, and is thus effective mechanically in contrast to the unhealthy chemical effect of other laxatives which just tear through the excrement and leave it hanging on the walls of the bowels.* OCD behavior over duplicate debit wire of $16K from Walnut to Anita. Stupid to lose sleep over this, but I will never change unless I am forced to, i.e. by blindness. Finish *The Painter of Modern Life*. Read *Les fleurs du mal*, "The Man of the Crowd," *Le horla*.

29 September. Re. diaries: *A person who keeps none is in a false position in the face of a diary. When for example he reads in Goethe's diaries: "1/11/1797. All day at home busy with various affairs," then it seems to him that he himself had never done so little in one day.* Less pain in hands but now worried about thing on my nose. Serial anxiety. Sleep. Sleep of the dead. After years of wishing for sleep it is in fact frightening to sleep this much.

30 September. *All evening he spoke often and—in my opinion— entirely seriously about my constipation and his. [. . .] When we had already said good-bye he called to me again from the distance: "Regulin!"* Anxiety about "thing" on nose replaced by anxiety over money and Walnut in the wake of stock market crash.

2 October. *I fall asleep soundly but after an hour I wake up, as though I had laid my head in the wrong hole [. . .] I believe this sleeplessness comes only because I write.* J. is reading *The Psychology of Gambling* and on my way out, gray skies, I think "Does my father love me?" (from the book), and wonder: will I be lucky again today?

4 October. After a week of staring at thing on my nose and growing anxiety verging on hysteria that it is "something," visit plastic surgeon and have it removed. In my notebook he writes "Basocellular carcinoma (benign)."

Map of Paris

Brain, ball, spiral, maze, fractal, fist. What would it look like to pry open the fist of Paris? I will interrupt almost any activity with the excuse of consulting the blue book: finding my way in and around the labyrinth, retracing my steps. Study of the centrifugal *Métro*: calculating the shortest distance between points.

Aldo Rossi: "The emergence of relations among things, more than the things themselves, always gives rise to new meanings."

10 October. On the train, wedged between a woman doing a crossword puzzle and a stone-faced man staring unwaveringly ahead, a woman across the aisle weeps into her cell phone. With her free hand she staunches the flow from her nose with a big wad of tissues.

12 October. *Yesterday at Max's wrote in the Paris Diary.* Peel myself from bed at 8:30 AM: Ambien on top of Laroxyl. Last Jane Bowles letters: she is losing her mind. After twenty years I have finally read them all. This produces a slightly shocking feeling: like, now her life is really ended, as is a chapter of mine. Today pianist is playing Schumann and other Romantics.

15 October. *After nearly a fortnight of blockage I faint again in the WC. When I finally open my eyes I see curled up beside me the product of my unconscious labor, something so dense and compacted it leaves no trace on the tiles. I carefully wrap it in soft, white tissue, feel its weight and send it on its way into the twists and turns of subterranean Paris. Later I recount this episode to K., who is appalled that "I did not have myself evaluated," and reprimands me for ignoring his advice on Regulin.*

Jane Bowles

Why Jane Bowles now? I'd kept the Black Sparrow Press spine in my peripheral vision for 20 years. I was getting ready to uproot

(or so it felt to me), and this is what she did over and over. Wonder if I am beginning to overidentify with Jane. Instead copy passages where I've made a mark, often late at night:

"It was like going there after I died." (JB, p. 213)

"I was upset about the Leary scandal which Paul heard about from Susan Sontag, whom you've surely met or at least heard of." (JB, p. 282)

14 October. Burning fingers. *The Street of Crocodiles*: descriptions of sunlight and sun-soaked streets, memories of summer. I am like the father, stewing over bills and accounts. And I can't shit either. Neighbor pianist is playing Bach, now scales. My studio is also "l'atelier qui chante et qui bavarde."

A.: Move towards images rather than words.

Cuts

In a document labeled "Cuts," I find: "Rossi quotes Benjamin: 'Therefore I am deformed by connections with everything that surrounds me here.'" (p. 19)

I realize that I write about being deformed and remade by the things I read. And I am trying to write in the form of the things that I want to read: diaries, fragments, lists.

"Pointless, and therefore true." (Gene Youngblood)

16 October. Watch David Bowie documentary from the '70s in which he demonstrates cutting up his lyrics into strips and reordering them randomly as a means of accessing unconscious thoughts. About his characters and personas he asks: "Am I writing them or are they writing me?" Seeing Bowie and hearing the songs: more burrowing. Wishing my fingers to fly across the keyboard like the pianist somewhere in this building.

20 October. On the train: reading New York edition of the *International Herald Tribune* from October 15. Story about conflict over nonextradition to Italy by France of Marina Petrella, 54, former Red Brigade. Carla Bruni visits her in the hospital and assures

her she will be allowed to remain in France. Petrella is severely depressed and says she wants to die. Pianist is playing Bach.

Ann C. reads three to four newspapers a day: "I read what interests me." I learned from her to read what interests me. Arrive: eat, read newspaper. Talk on the phone to A.: one hour. 1 PM: eat, read newspaper. Still have not finished paper from Thursday. Think of sleep. Ache in my teeth too real to be phantom.

21 October. Neighbor pianist practicing same trills of ten notes over and over, making the same mistakes. Ennui, lassitude. Benjamin and extreme aggravation of piano below his study. Index fingertips frozen.

22 October. Reading Alison on Jane Bowles: "[JB] is still looking to develop in her work her ideas on salvation, and increasingly to attain salvation *through* her work." Her descriptions of Bowles's "salvation through renunciation," self-abasement etc., remind me of Simone Weil, whom Bowles mentions reading toward the end of her life in a letter to Paul, along with "a little of S[usan] Sontag [...] and you."

23 October. Stagger out of bed alarmed because it is 10 AM. See neon, glowing brain, Day-Glo colors and lights. Panic that now I've completely lost my sight. Fall over. Panic that now I've lost motor control. J. woken by noise: I am limp, but recover quickly.

24 October. Capture diary fragments like video captures, scenes recorded and forgotten. Because I want to include here words like: Arsenicum Album.

Yesterday, after the fall: Relief. And briefly: off the hook. Prolonged enjoyment in looking at books, looking at photographs, looking at anything. And "taking the sun" in the gardens with G.

Today: Sense of doom. I want only to be with J. and B. I would run to them now. Walk at night to rue Réamur for raucous dinner at L.'s. Evening is perfect antidote to day of gloom and stinging pain.

25 October. Walk with B. in Tuileries gardens. Beautiful light and smell of dried leaves. Thousands of people stroll and sit in green metal chairs, "taking the sun." I sit with B. Finally I am "with him," but at this moment I am terribly hungry and that is all I can think about.

27 October. JM comes to studio and reminds me of the "book about the book that never was," and I remember why I copied down long passage from *The Soccer War*: to be reminded of the book you write along the way to writing the book that never gets written.

28 October. Dream about a woman: tall, red hair, stout body, guileless. She tells me she is a 52-cigarette-a-day smoker. Asks me if I think she'll be okay. I interpret the number "52" (as in weeks), to be a warning about the ill-advised nature of this diary.
 "Perhaps the magnitude of the task is putting me off. To unravel the skein one more time, right to the end, to shut myself up for I don't know how many weeks, months or years [...] in the enclosed world of my memories, going over and over them until I'm both satiated and nauseated." (GP, p. 97)
 4 November. Force myself vertical, pour coffee down my throat. Sleep is a succubus.
 13 November. "J'ai horreur du passé. J'ai horreur du souvenir." Paul Claudel invoked by Pierre Boulez in *Télérama*. Read Baudelaire "Spleen" poems and think this is what I experienced at the flea markets on the weekend. Alison: CB pretty much said it all. You may as well get over it.

14 November. J.'s birthday. RIP dear little Bella.

25 November. *Little did I know I'd be the corpse that would arrest my own take*, but I stop myself: out of superstition never write such things, or spell out medical anxieties. Sweep studio. Peel hair + dust from broom, let fly out window. Pianist rehearses same repertoire of fragments, segueing from one to the other, over and over, like a tic.

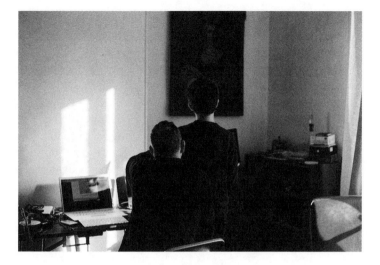

20 December. "Dear Gerhard, The Christmas season is
upon us once more [. . .] All of my books are here now and, even
given these times, their number has increased over time from
1,200 — although I certainly have not kept all of them by a long
shot — to 2,000. The study does have some peculiarities: first, it
has no desk; over the years, due to a series of circumstances — not
only because I have become used to working in the café a lot,
but also because of some notions related to the memory of what
I wrote at my old desk — I now write only while lying down. I
have a sofa inherited from my predecessor. It lends itself most
wonderfully as a place to work because of its qualities — it is quite
useless for sleeping. I once heard from her that it had been built
for an old woman who was crippled. This, therefore, is the first
peculiarity, and the second one is that it has a panoramic view
of the old, filled-in bog, or, as it is also called, Schramm Lake —
almost *l'atelier qui chante et qui bavarde* — and now that it is cold, a
view of the ice-skating rinks and a clock is in sight in all seasons;
as time goes by, it is especially this clock that becomes a luxury
it is difficult to do without. The rent for the apartment is unfor-
tunately such that it seems as if all of these optical furnishings
were included in the price.

"It is nothing short of an infernal irony that I had hardly written these lines when a piano, never heard before today [...] begins to make itself heard directly below my study. This is simply horrible. But disconcerted as I am, I can do nothing but continue to write."

26 December. Finish *The Street of Crocodiles*. In the final story, "The Comet," the whole town is waiting for the end of the world. Father crawls into the flue of the chimney and, through his microscope and some trick of refraction, catches sight of the comet. At first it looks like "a brother of the moon [...] scrofulous and pock-marked." Then Father realizes it is in fact "a human brain, deeply asleep, and blissfully smiling in its sleep [...] in the light of waters of amnion."

31 December. Visit the caves of Nerja near Málaga on B.'s birthday. This vast, quieted underworld reminds J. of *Voyage to Italy*: Bergman dissolving into tears at the Pompeii ruins, and the religious procession in which she gets separated from her husband. Another tourist hole is redeemed: anger at B. fades, tension lifts. Long hike up through the hills. New Year's Eve on the Balcón de Europa.
 Later, in "Cuts" I find: "JB died in a convent in Malaga." Search-engine this and immediately click on a detail of a map of that city with a blinking red dot on "Avenida Jane Bowles," and a photograph of her grave in San Miguel Cemetery, Málaga.

"I saw that the roses that had been next to the wall were a mass of dust and mildew." (*A Fairly Good Time*)

(2010)

EMPTIES

In an undated diary entry, probably from around 1949, John Cheever, drinker, dog owner, lover of cut flowers, writing on the waning days of summer, noted: "... by the Fourth of July, the green of the maples has begun to fade. The calendar of flowers, gin bottles, steak bones."

One day, about seventeen years ago, living in Hoboken, NJ, a blurred, partially cropped picture of an empty Johnnie Walker bottle turned up at the tail end of a contact sheet. It was a misfire, but I loved the way the prism of my lens rendered the oblong, chunky glass of JW Red, and how the faint capture of motion could invoke inebriation. And so I continued to take pictures of (amber) liquor bottles when they'd attained a state of depletion, hoping to reproduce something of the effect of the initial accident. Someone mentioned Morandi, I saw the totality of the images as a calendar, in the spirit of Cheever, a marker of time denoted by a particular type of consumption. The time span is 1996–2000; coincidence or not, it is synchronous with the first five years of my son's life.

Skipping ahead in Cheever's *Journals* to 1956, I find another dog-eared page with pencil marks beside this line:
"Took a secret slug of whiskey at eleven on Independence Day."
And:
"There is a world of difference between taking out a sailboat and filling in the pages of a journal and I would like to bring these worlds together. . . . Writing is . . . like most gifts, a paradox . . ."

My drinking days pretty much behind me, it is the later thought, the paradox of life lived versus the drive to reproduce it, that preoccupies me more, continues to fascinate.

(2013)

LES GODDESSES

A young English woman named Mary Wollstonecraft lived by her wits and her pen. At thirty-four, Mary did not expect to marry, but she soon met an American adventurer named Gilbert Imlay and believed she'd found her soul mate. In love, they moved to Paris where they had a daughter, named Fanny.

But Gilbert began to travel more and more, and soon it became apparent he had a wandering eye as well. Heartbroken over this desertion, Mary drank laudanum. She survived, but within a matter of months was despondent again and jumped from a bridge into the Thames.

Miraculously she was rescued and nursed back to health by William Godwin, like Mary a political radical, to whom she quickly developed a strong attachment. Later married and happy, they read Goethe's *The Sorrows of Young Werther* aloud together the night before she went into labor. Tragically, Mary died a few days after giving birth to a second daughter, also named Mary, who would be raised, along with Fanny, by William Godwin, who would remarry.

His new wife had a young child of her own, Claire, and the three girls grew up as sisters; they became known as Les Goddesses. When Mary was seventeen, a famous poet named Percy Bysshe Shelley came courting: he first paid favors to Fanny but quickly fell for Mary and the two eloped to the continent, taking Claire with them.

Fanny, crestfallen, stayed behind and like her mother, drank laudanum. The real story concerning the lives of these extraordinary women is filled with many paradoxes, and without a doubt it is more fantastic than any fiction.

Grey To Green

Sitting on the floor in sunlight and reading through eight small notebooks going back to 1998, looking for a phrase about Goethe: *The stars above, the plants below.* The thought is connected to

Goethe's mother and what she taught him about the natural world; more generally, it is about how people lived in constant relation to nature.

I never found the reference; it was something I had stumbled across on the Internet, but it led me to *The Flight to Italy*, Goethe's diary (recommended by Kafka, in *his* diary), in which G. abruptly takes leave of a turgid existence in Weimar and travels incognito to Italy for the first time in his life. He is thirty-seven years old, and the trip is a revelation and a creative renewal of mammoth proportions. He draws plants, collects rock samples, and begins to dress like the locals so as to pass and be better able to observe their customs. G. reports on the weather patterns (sublime clouds and sunsets); he develops a theory of precipitation involving the curious concept of "elasticity." He looks at architecture and writes of his worshipful love of Palladio; he has a deep appreciation for Italian painting but rails against the squandering of genius and talent on the "senseless . . . stupid subjects" of Christianity.

Because the diary is written quickly, informally, it feels uncannily contemporary. It is hard to believe this is a voice from the late eighteenth century. In addition to studying everything, G. takes a hard look at himself, and toward the end of the book there is a striking revelation: he confesses his "sickness and . . . foolishness," his secret shame that he had never before made the trip to Italy to see firsthand its art and architecture, the objects of his lifelong fascination. Two days after arriving in Rome, he no longer takes off his clothes to sleep so as to hasten his arrival, and on October 26, 1786, he writes, "Next Sunday [I]'ll be sleeping in Rome after 30 years of wishing and hoping."

The effusive diary abruptly goes silent: "I can say nothing now except I am here. . . . Only now do I begin to live." To his Weimar friends, he writes: "I'm here and at peace with myself, and, it seems, at peace with the whole of my life," and to his lover, Charlotte von Stein: "I could spend years here without saying much."

The Flight to Italy is filled with references to plants and crops; G. even has a theory of a "primal plant" form. The only star he mentions, though, is the sun.

The Real

Now it is a conflict between the idea of writing from the unknown versus working from notes and journals. Elsewhere, I have compared these different modes of writing to two genres in photography: the vérité approach of the street, seizing life and movement with little chance of reprise, and, in contrast, the controlled practice of the studio, where the artist is less exposed, the environment more forgiving, and time more malleable. And perhaps another iteration of this distinction between risk and control was intimated in something I heard a critic, quoting Godard, say on the radio when I lived in Paris in 2008: "Filmmakers who make installations instead of films are afraid of the real."

In his six-hour documentary *Phantom India*, Louis Malle travels all over the subcontinent filming, and later, in voiceover, he analyzes and reflects on the intrusion and indiscretion of the camera. Malle will never get over this feeling of impropriety, but he will keep on shooting, hour after hour, pushing up against the act of documentary in an attempt to understand something about India and something about himself. Much of *Phantom India* is straight-up documentary, but there are moments of intense self-scrutiny and questioning, for instance, when Malle describes his inability to be "present," to experience the "real" of what is taking place before the camera.

He lives in his head, sometimes thinking of the past but mostly caught up in a work whose meaning will only be locked in at a future moment. To every new situation, his first instinct is to invoke memory and analysis: a scene on a beach at daybreak reminds him of another, twenty years earlier when he was making his first film. "A tamer of time, a slave of time" is how Malle understands his predicament. At a certain point, he and his crew stop filming. Only then do they begin to experience the present tense, the slowness of time, and what Malle calls "the real."

The Wet

Another problem for me now is the welling up of the "Wet," the insistent preoccupation with narrating certain aspects of the

discredited past, things I may never be ready to tell.

Previously I have incited myself to write by beginning with the most pressing thing, but the problem now is that I can't face writing about the Wet. I think about giving it a masquerade, or perhaps the Wet will duly give way to something else.

This document parallels another one written from notes collected in diaries. That one is accompanied by the uneasy feeling of cannibalizing myself. *This* document, though not a book, is trying to begin according to a principle described by Marguerite Duras: "To be without a subject for a book, without any idea of a book, is to find yourself in front of a book. An immense void. An eventual book. In front of writing, live and naked, something terrible to surmount." I wanted to try, almost as an experiment, to write both ways, one alongside the other in tandem, but already I've begun to fold in notes from that other document . . .

Was Duras opening her veins? Yes and no. She was also opening the bottle. But she would go at it—writing and drinking—for days and nights. She had stamina, as Susan Sontag would say. And she was not afraid of the Wet.

Rainer Werner Fassbinder: "The more honestly you put yourself into the story, the more that story will concern others as well."

Mary

Mary Wollstonecraft, born in 1759, ten years after Goethe and two hundred years before my sister Claire, was Wet and Dry. She was a brilliant star in her firmament, a passionate, early advocate of women's, children's, and human rights and an enlightened defender of truth and justice: a radical. She went to Paris to witness the revolution and lived to tell of the bloody Terror of 1793–94. A woman with enormous intellectual capabilities and savoir faire, she supported herself, and at various times one or more of her largely hapless six siblings, by writing.

But she also suffered from depression, and broken-hearted over the rejection by Imlay, drank laudanum. In an attempt to revive her, he offered a mission of travel to Scandinavia to inves-

tigate a murky business affair of his. Mary accepted because she needed the money and hoped that this continued involvement with Imlay might ensure a positive romantic outcome.

In 1795, she set out on a dangerous ocean voyage with her infant daughter, Fanny, and a French maid. Like Goethe on his travels to Italy, Wollstonecraft wrote letters to Imlay chronicling her observations and emotional responses to the landscape and peoples of Sweden, Norway, and Denmark. Her heartbreak is softly intimated in the letters, but mostly she reflects and reports with a journalist's eye on the native customs: a featherbed so soft and deep it is like "sinking into the grave"; children swaddled in heavy, insalubrious layers of flannel; airless homes heated with stoves instead of fires — here, like Goethe, Mary invokes the odd concept of "elasticity" to talk about the air. Viewing the mummified remains of some nobles, she responds with characteristic indignation: "When I was shewn these human petrefactions, I shrunk back with disgust and horror. 'Ashes to ashes!' thought I—'Dust to dust!'"

After her return home to England, Wollstonecraft composed the letters into an extremely well-received book titled *Letters Written During a Short Residence in Sweden, Norway, and Denmark*. It was published in 1796, two hundred years before the birth of my son, Barney.

Alison

Soon after I arrived in Paris, shaky with jetlag and insomnia, I asked Alison, my oldest friend, if she'd help me brainstorm. Bless her, she is always willing, and she is a font of ideas and strategies. I was struggling and fearful, convinced I'd do nothing of value in this city: I took a pill and drank a glass of wine on a cold terrace on the rue de Rivoli, and told Alison this: "I came to Paris in 1976 just out of high school. I was lonely, depressed, bored, illiterate. I was thin, I was fat, with no control over any of it. I was a Francophile with a deep longing to be part of the culture, but I was clueless, infused with teenage ideas about 'the Romantic.' A French friend told me emphatically: 'The Romantic

is the nineteenth century. End of story.' I met the two Quebecois artists in the Cité Internationale des Arts studios. They were friendly but aloof. Thirty years later, I am back in Paris with a husband, a son, a life. I have one of those studios. I am thin. I have money. I have MS." Alison's eyes light up: "*That* is the perfect story." But I have no idea how to write a story. About telling certain episodes of your past, Norman Mailer said: "You must be ready." I may never be ready. Some excised paragraphs, the original motivation for this project, now reside in a separate document labeled "Pathography."

Why does everyone want to tell their story? Why do all of my students talk about "representing memory"? Why is Amy, in grad school, suddenly conscious of her working-class roots, destabilized, and obsessed with her childhood? Why is my sister Jane tormented by the past and asks Mom to talk to her shrink? Why did I spend so much time in Paris, agoraphobic, brooding, tunneling into realms of childhood where I found pockets of it illuminated with sudden, violent flashes?

Isak Dinesen: "The reward of storytelling is to be able to let go. . . . All sorrows can be borne if you put them into a story or tell a story about them."

Siblings

At the end of my copy of *Flight to Italy*, there are short bios of all the principals in Goethe's life. His mother, Catharina Elisabeth von Goethe, is described as a very supportive woman, and there is a citation from Freud about G. having been his mother's favorite and about how children singled out in this way retain a lifelong confidence and glow. This led me to Freud's brief essay "A Childhood Recollection," an analysis of an early memory G. recounts in his autobiography of throwing dishes out the window when he was a small child. The episode remained mysterious to Freud until, as is typical of his method, he began to hear similar stories from his patients and started to piece together a theory, namely that the throwing of objects out the window is typically linked to a child's fury and jealousy in response to the arrival of

a new baby. I strongly suspect I reacted just as violently or even more so to the births of my five younger siblings. A therapist explained this to me once and said I should practice self-forgiveness, but it took Freud's words to cement the notion that my behavior was not a murderous aberration of childhood. A description of one of these cruel episodes of "acting out" has been excised and relegated to the "Pathography."

Michael Haneke: "Artists don't need shrinks because they can work it out in their work."

But can we do without Freud?

Sharon & Gloria

I fell asleep in the afternoon and dreamed I was commiserating with Sharon Hayes about how a work, once finished, is "like a tombstone." Gloria Naylor said this about her book *The Women of Brewster Place*: "I had gotten a bound copy of the book—which I really call a tombstone because that's what it represents, at least for my part of the experience."

The thing is only alive (and, by extension, *I* am only alive) while it is in process, and I've never quite figured out how to keep it ignited, moving. Some stubborn gene always threatens to flood the engine just at the crucial moment of shifting gears.

Mary & Mary

Like Goethe's *Flight*, Wollstonecraft's *Letters*, a narrative moderated by a journey, has a special, self-generating momentum: a trip, with its displacements in time and space, can be the perfect way to frame a story. Combine this with an epistolary address, and it would appear to be the most easeful of forms. *Letters* was the only happy outcome of the Scandinavian trip. Five months after her first suicide attempt, on confirmation that Imlay had a lover, Mary jumped from a bridge in rain-soaked clothing to hasten her descent. She was saved by a boatman and briefly consoled by Imlay, who shortly thereafter disappeared for good from the lives of Mary and Fanny. But M.W. was lucky to find a friend

in the person of William Godwin, a sage man who, according to M.W. biographer Lyndall Gordon, counseled: "A disappointed woman should try to construct happiness 'out of a set of materials within her reach.'"

A year later, in 1797, in love with Godwin, married, and pregnant, Mary read Goethe's *The Sorrows of Young Werther* aloud with William. The following night, she went into labor and gave birth to a child who would grow up to be Mary Shelley, whom she would soon leave motherless. The delivery was botched: the placenta did not descend, and a doctor's unwashed hands reached into the womb to tear it out. Sepsis set in, the mother's milk became infected, and puppies were used to draw off lactation. Two hundred years later, in 1997, less than six months after giving birth, I flew across North America with an electric pump to suction the milk from my breasts. But I missed my connection and arrived at my destination twelve hours later, my breasts grotesquely engorged. I took a photo in the hotel room and some years later published it in *LTTR*, a minutely circulating, queer-feminist journal. Now that photo is all over the internet, completely out of my control.

Part of the tragic irony of M.W.'s death in childbirth was her own enlightened advocacy of simple hygiene and nonintervention in the care of infants and mothers; suspicious of doctors, she was a believer in wholesomeness and common sense in an age of superstition and quackery.

The Sun

Wollstonecraft and Goethe, both northerners from cold, rainy climates, enthuse repeatedly in their correspondences about the presence of sunshine. Goethe marveled to his friends about its perpetual abundance in Italy ("these skies, where all day long you don't have to give a thought to your body"), and for Wollstonecraft in Scandinavia its effects are central to her evocation of the sublime, which she experiences in her travels along the rocky coast and mountainous landscapes of Sweden and Norway.

The warm reach of the sun was also surely a factor in granting

each of them a measure of peace: for Goethe, when he arrives in Rome and no longer feels the need to double his life in writing ("I am here.... Only now do I begin to live"), and for Wollstonecraft, during countless moments when nature impresses itself on her as the salve and renewal of an exhausted, disillusioned spirit. Waking on a ship one morning, she greets daybreak with these words: "I opened my bosom to the embraces of nature; and my soul rose to its author." Two decades later, her daughter Mary Shelley would write from the banks of Lake Geneva: "When the sun bursts forth it is with a splendour and heat unknown in England."

In 2004, in Needville, Texas, an asteroid was named for Mary Wollstonecraft (Minor Planet Center designation 90481 Wollstonecraft).

"Les Goddesses"

Aaron Burr, visiting England from America in 1812, bestowed this epithet on Mary Wollstonecraft's daughters, Fanny and Mary, and their stepsister, Clara Mary Jane Clairmont, known then as Jane and later as Claire. Two years later, Mary, age seventeen, and Percy Bysshe Shelley eloped to France with Jane in tow; Fanny—with disastrous results—was not invited to join them. Lord Byron eventually formed part of the group, and together they lived an idyll of poetry, song, travel, and love, surviving on whatever money they could squeeze from Shelley's father. On foot, atop a donkey, and by boat, they journeyed through parts of France, Switzerland, and Germany, keeping a collective diary subsequently published under the title *History of a Six Weeks' Tour*. Nearly two hundred years later, I procured a facsimile edition of this book printed in New Delhi, no doubt downloaded from Google Books: the insides are a distant cousin of the original typeset, but the cover is a bright red design adorned with Islamic patterning. It is an utterly charming object, as is the prose it contains.

Eventually the Shelleys settled in Italy where they wrote, read the classics, Rousseau, and Goethe, and Jane, in particular, studied music and languages. About Rome, Mary proclaimed: "[It] has such an effect on me that my past life before I saw it appears a

blank & now I begin to live." They existed like this for eight years, short of money, outcasts living in defiance of the rigid matrimonial conventions of the early nineteenth century. The ménage was not without its tensions and jealousies: Mary, pregnant and ill for much of the time, quickly began to find Jane (now Claire) an irritant. Claire was vivacious and talented, and though she could sometimes be dispatched, she would remain a resolute fixture of the Shelley circle. Mary began to use a little sun symbol in her diary to indicate Claire's presence on any given day. ☉

Jane

Mary Wollstonecraft's parents, John Edward and Elizabeth, were married in 1756; their union produced seven children. Two hundred years later, my parents, James and Patricia, met in England and married in 1956. They also had seven children—six girls and one boy—beginning with Jane Elisabeth in 1957.

Prompted by a stay in rehab, my sister decided to write a memoir of her childhood and addiction. In an e-mail, she told me: "I am in the process of teasing out an ending, but I'm now edging up to a very respectable 60,000 words, plenty to qualify for a book.

Now, of course that the deed is nearing completion and *I have set down once and for all a true record of what has happened* (sorta, kinda), I am feeling somewhat uncertain."

M.W. wrote of "the healing balm of sympathy [as the] medicine of life," a concept Jane, an uncommonly sensitive and empathic person—always, since childhood—and now an amateur homeopath, would undoubtedly agree with. Jane reminds me of M.W. in some ways. A nurturing mother of three daughters, she is a strong and caring woman who, like M.W. at times, both keeps her distance from doctors and their drugs and is emotionally fragile, prone to depression and occasional rash behavior.

Fanny

Fanny, to whom Percy Shelley had first shown affection, was excluded from the Summer of Love. She had inherited her

mother's melancholic streak, and though she tried to combat the depressive feelings she was dogged by what she called: "Spleen. Indolence. Torpor. Ill-humour." Fannykin, of whom Mary Wollstonecraft wrote in the Scandinavian *Letters* when her child was a babe, "I dread lest she should be forced to sacrifice her heart to her principles, or her principles to her heart," succumbed to exactly that predicament of the nineteenth-century woman without means. Fearful of becoming a burden, Fanny drank laudanum as her mother had done, but unlike Mary, she was successful.

Young Mary's bliss with Shelley was short-lived, as death began to intrude with frightening regularity. Of her four pregnancies, only one child, Percy Florence, survived. Claire's daughter by Byron, Allegra, whom Byron callously separated from her mother, died at age five, alone in an Italian convent. Just prior, Claire had written heartbreakingly in her journal that recovering Allegra would be like "com[ing] back to the warm ease of life after the coldness and stiffness of the grave." Shelley's first wife, Harriet, in an advanced state of pregnancy, drowned herself in 1816, and, eight years into his relationship with Mary, Shelley himself drowned in a boating accident on the Gulf of La Spezia off the coast of Pisa with their close friend Edward Williams. Byron, who'd committed himself to a war of independence in Greece, died two years later in Missolonghi of fever.

James & Patricia

In 1975, my father, James, aged forty-five, fell from the roof of our house one Saturday morning in August and never regained consciousness. I had just turned seventeen, the same age as Mary Wollstonecraft Godwin when she eloped to France with Percy Bysshe Shelley and Jane Clairmont. My mother, Patricia, retreated to the top of our big box of a house and all hell broke loose below. The Davey girls were not writing poetry, studying Greek and Latin, and procreating; we were listening to David Bowie, Roxy Music, and the Clash, and ingesting too many drugs. Interviewed by a journalist friend about our active sex lives at the time, my mother responded ruefully: "I'd mind less if I thought they enjoyed it more." It was a different time and

different kind of rebellion; nonetheless, many thought of us as a female force — goddesses, no, but "Amazonian," yes, to be reckoned with. And that is what I tried to show in a series of portraits I took in Ottawa and Montreal beginning around 1980. "Les jeunes filles en fleur" was another expression used by the same journalist friend to describe some of us, but that came later, after we'd settled down a bit.

Claire & Kate

Claire Davey, small and taut, and the only one among us who did not regularly swell and shrink, never succumbed to intoxicants or liquor. And she never threw herself at men, as did some of her sisters, as did Claire Clairmont with Byron. Temperate, she traveled, she studied; now she teaches philosophy and yoga to high-school students in Toronto. Kate, born a year and a half after Claire, in 1961, two hundred years after Mary's brother Henry Wollstonecraft, was the fearless party girl, drinking and inhaling pills until she passed out. Kate never "recovered" into anything resembling normalcy. Multiple stays in rehab would eventually lead to a lifetime of AA, NA, OA. Intelligent, sensitive, she opted out. She read every novel on my mother's bookshelves and filled the house with rescued animals. Some of the original five cats and four dogs have passed on, but the smells linger to remind us of nineteen-year-old, blind, incontinent Candy and gentle, gormless, clubfooted Duke, found on a reservation.

Claire

Of the Shelley entourage, only Mary, her son Percy, and Claire Clairmont lived beyond their thirties. At the dissolution of their circle, Claire joined her brother in Vienna and began to work as a teacher, but she was hounded out of this employment by the lingering scandal of her youth and forced to migrate as far as Moscow, where she became a governess. Her journal, a penetrating literary document, was published a century later;

an old woman, she eventually settled in Florence with her niece Paola and became the model for Henry James's story "The Aspern Papers."

Mary & Percy

Widowed, Mary Shelley was at the mercy of her tyrannical and conservative father-in-law, a man who had never accepted his son's poetic gift, nor his marriage to Mary. After editing a posthumous collection of Shelley's work in 1824, Mary was forbidden by the patriarch from publishing any more of Shelley's poetry or even writing about him, lest it shame the family, thus forcing her into a conventional lifestyle for the sake of her son and his inheritance, small sums of which were parsed out to them while Shelley senior lived on and on, defying all expectations of his demise.

According to Muriel Spark, Percy Florence inherited none of his parents' literary or artistic talent and refused to visit art museums with his mother when they traveled in Europe. A disappointment to Mary, she later grew to appreciate what Spark termed his "phlegmatic qualities." Percy was "to remain loyally and negatively by [Mary's] side to sustain her old age." He married Jane Gibson, a sympathetic woman who became Mary's friend and caretaker during her final illness at age fifty-three. Percy and Jane did not have children.

Barney

Age thirteen, Barney does not like art museums either—he says they instantly make him feel sleepy. He told me, "An ideal way to spend the day would be to drive to an airport and watch the planes take off and land."

Tautology

I learned the meaning of this from Baudelaire via Barthes: "I take H [hashish] in order to be free. But in order to take H I must already be free." And from Alejandra Pizarnik: "To not eat

I must be happy. And I cannot be happy if I am fat." This comes close to summing up my adolescence.

Homeopathy

In November 2010, on the recommendation of my sister Jane, I traveled to Montreal to visit Dr. Saine, a famous homeopath, a man who, like his father before him, had treated thousands of people with MS. I sat with him in his Dickensian study, surrounded by stacks of paper and books, some framing white busts — no doubt Dr. Saine's predecessors, the discoverers of this strange and mystical science. He interviewed me for three and a half hours about symptoms, cravings, fears, and dreams.

He felt my frozen feet and lit a fire, burning a cube of oak. "How do you feel when you see a poor person? On a scale of one to ten, how much do you fear poverty? Cancer? Death?" "How do you feel when you are with your son and your husband enters the room?" And on and on. "Is there anything you haven't told me about yourself?" I told as much as I could, including some of the bad and shameful memories from the "Pathography" (because you have to), but the long interview was tiring, and my fragmented story came out rather flat and monotone. He received it all without judgment, indeed, with a high degree of curiosity, almost excitement.

He said my case was unusual — perhaps my parental influences were too strong, too dominant, neither one giving way — and this left him torn between two antidotes. I departed with two tiny glass vials, coincidently each substance related to photography: sepia, which is a dye used to tone photographic prints, and lycopodium, the spores of club mosses that were ground into combustible powder and ignited in the era before flashbulbs.

Being

"To do without people is for photography the most impossible of renunciations," wrote Walter Benjamin. Yet that abandonment is precisely what would begin to take place in my photographs over

the next ten years, beginning in 1984, until my subjects consti-
tuted little more than the dust on my bookshelves or the view
under the bed. The burden of image theft, as Louis Malle put it,
had something to do with my retreat, but also a gradual seeping
in of a kind of biographical reticence, perhaps connected to my
present reservations around telling my story ("Pathography").

I, too, ingested excessive substances in decades two and three,
and one result is that I can barely keep track of the analogies
I've posited, from Duras's "immense void" and the unscripted
of vérité, between rehearsed writing (from journals) and pho-
tographic mise-en-scène. And what is meant by "the real" in
the pronouncements of Malle and Godard ("Filmmakers who
make installations instead of films are afraid of the real")? For
Godard, the real is about confrontation and risk in time-based
media, the old-fashioned way, no props allowed. Malle uses the
term to describe a state of "being" to which he accedes when he
finally stops filming in India; it is about experiencing a kind of
existential peace, a freedom from the need to be making some-
thing. But he can only enjoy the feeling because he has worked
very hard for it.

The Green & the Wet

Over the years, I've brushed up against a peculiar sensation of
"being," usually in green places where water infuses the air: in a
marshy field in England crisscrossed by canals; on the tiny, nar-
row peninsula of pine-choked soil that is Provincetown, in fall or
winter. Something about the "elasticity" of the air infuses "the
elasticity of my spirits" and allows me to enter an unusual state of
weightlessness, an intense and rare feeling of well-being.

Displacement in space, and the attendant fatigue of travel,
must be contributing factors to this febrile state, not unrelated
to Stendhal syndrome, which had its origins in Florence in 1817.
Stendhal noted this phenomenon in Italy just one year before
Claire Clairmont and the Shelley party found themselves climb-
ing the ruins of the Coliseum on their nightly walks through
Rome. Goethe, Mary Wollstonecraft, and the Shelleys were all

weary travelers—M.W. had recently given birth, and Mary Shelley, her daughter, was more or less pregnant for five years. They both had very young children in tow; they were exhausted. In early 1997, sleep deprived, I walked through the snow-covered woods of Provincetown with infant Barney strapped to my chest. I needed to move at all costs; I craved something mind-altering.

Sepia Days

Mary Shelley died in 1851 and Claire Clairmont in 1879, but no photographs of them seem to exist, at least on the web; there is a photographic oval of Percy Florence Shelley as an older man—he looks a bit like Freud.

In his essay "A Little History of Photography," Walter Benjamin cites Goethe, apropos of August Sander: "There is a delicate empiricism which so intimately involves itself with the object that it becomes true theory." Mary Wollstonecraft and Goethe were just prephotography, Goethe by only seven years. Their travel writings have the vividness and spontaneity of snapshots, and Goethe's phrases and sketches, in particular, feel startlingly modern. It is not a stretch to imagine that Goethe, with his scientific mind, might have anticipated the nascent technology: it was "in the air," after all, long before 1839.

The close observation that Goethe championed and was his means to knowledge, to "true theory," was precisely the promise held out for photography for many, many decades, perhaps 130 years if we count up through the late 1970s. And that is when I started taking pictures, at the very moment when the truth claims of the photograph were being dismantled by theory. That moment of the "Discourse of Others" has passed or shifted, but it marked me, changed for good the way I work.

When I wrote about "being" four years ago, it was under the tapering effect of steroids. Now I take drugs that make me sleep. But this morning I woke early with precisely the idea of writing these lines and taking a picture of the rising sun reflected off the giant apartment building in the distance. Up at seven for the first time in . . . ? Photograph gleaming building—my old habit from when I'd wake with the sun.

<center>* * *</center>

Coda

On the subway downtown to the New York Public Library in search of Mary Shelley's diaries, I began to notice subway riders absorbed in writing of their own: a woman paying her bills, another marking pages on which the word *draft* is stamped in large letters. Some are standing, precariously balancing pads and pens on crowded trains; others look off into space, lost in concentration. There is a man folded over his crossword, whom I captured in the same pose on more than one day, and children doing their homework. A woman wearing orange velvet gloves clutches a small yellow pencil.

Just when I'd been writing about the disappearance of the figure from my photographs, I found myself taking street pictures again in the dim green light of the Manhattan subway. I experienced the same unease and doubt I've always had in taking pictures on the street, and I kept expecting to be asked what I was doing. But the writers themselves, eyes downcast, were unaware of my camera, and those looking on, over my own shoulder even, seem only mildly surprised by the small point and shoot, a note-taker itself, recording the underground writers as we ride.

The artist would like to thank Elizabeth Denlinger, curator of the Carl H. Pforzheimer Collection of Shelley and His Circle at the New York Public Library, for her kind permission to photograph in the archives.

<div align="right">(2011)</div>

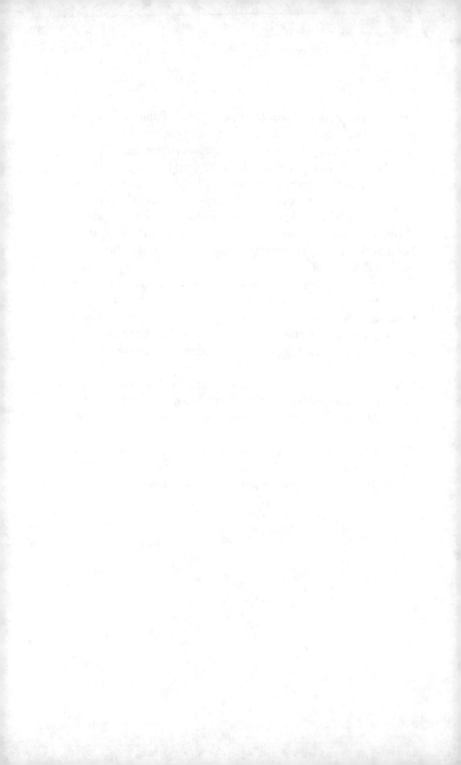

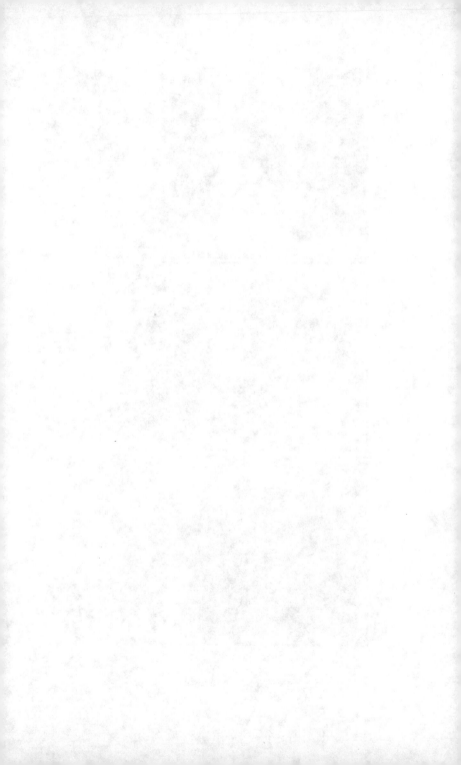

ONE YEAR

"I'd say the more you put yourself into the stories, that is, the more 'honestly' you put yourself into the story, the more that story will concern others as well."
Rainer Werner Fassbinder

August 18, 2012 (beginning of notebook)

No more clean, happy, tidy making of things.
Jane breaking down.
Mom confused.
Y. stays four hours.
Hands burning despite more than 0.25 Clona.

"Digital video is implacable and therefore violent. You have to trick it . . ."—Agnès Godard

Return to east side cemetery with Hasselblad and Scala film. Quickly shoot two rolls of film and leave without being apprehended, my whole being abuzz with that sensation of risk and thievery.

Awake at six. Look out at sky as I turn light on and off: blue sky/gray sky. Mauve-gray sky. Snow, fog, rain.

Wet, howling, drippy, snotty babes.

The bleaching, white light of vanity. Genet: I'm fifty and I don't mind that I look sixty.

"Everybody needs an angel, and here's this devil by my side."
Palace Music

Yoga. Living room lit up by big screen TV: Barney's devil.

Plunder archive of B&W negatives: pull something out, knowing it will never find its way back, and thus my "archive" frays, its contents migrating. Because nothing is dated, labeled or organized, it is all slowly becoming undone.

Sky and light at dusk: preternaturally white, almost the same as at dawn.

8:45 PM: powder blue sky.
8:52: sapphire blue.

'By transferring a fact into words and characters you create other facts that can never recreate the original one.'
Jean Genet, *Prisoner of Love*

The smell of sex and sexual desire are everywhere — Alison's slip about "the pack" entirely consistent with Genet's obsessions.

A. thinks I should keep a pleasure diary. Must examine why I find this idea so distasteful.

August 18, 2013

One year has passed since Y. came to dinner and stayed four hours talking about himself.

(2014)

> 'The page that was blank to begin with is now crossed from top to bottom with tiny black characters—letters, words, commas, exclamation marks ...'
> —Jean Genet, *Prisoner of Love*

Robert Walser obviously had a thing for paper. We know he loved his pen, and when it began to cramp his hand and his style, he learned to value pencils. About the tiny, filigreed hieroglyphs known as "microscripts," he said, "with the aid of my pencil I was better able to play, to write."

But he clearly was also a paper fetishist, and the recycled fragments—calendar pages, stained envelopes, brown postal wrappers, business cards, and on at least one occasion, "white paper used for art prints"—must have appealed to him for their graphics and textures, their odd shapes and sizes, their tactile qualities.

I couldn't quite fathom *The Assistant*—I kept thinking of Kafka and how the modernist style never persuasively seeped into my veins. I read a hundred pages expecting I'd stop there, but then I kept on reading, mostly in the middle of the night when I couldn't sleep, waiting for pills to kick in. I'd been thinking of this novel as a bourgeois satire but then began to be struck by its interludes of escape into the beauty and the "authenticity" of nature.

I could never find a pencil near the bed and shamelessly dog-eared pages from a library copy in order to remember certain passages, delirious accounts of protagonist Joseph's forays into the countryside, especially the enchanted, golden vale in the forest where his mother sits and for a rare moment is happy and at peace, thereby granting her children, normally guarded and attuned to her shifting moods, the giddy freedom to frolic in the paradisiacal, wooded playground, a fairy-tale space they've come upon by chance. *The Assistant*, for all its strangeness and alienation, is rich in long, drawn-out passages of delirious, intoxicated reveling in the loveliness of nature.

There is a deep gratification to projects—this essay, and the *Subway Writers*—connected to the experience of books read in the night. With their oneiric quality of improbability, of peculiar and inexplicable behaviors, Walser's novels seemed the perfect books to be reading when I was not far from dreams myself.

Reading *Jakob von Gunten* at 6 AM, again waiting for sleep, and thinking, *Why*, as per Genet (who finds his way in here by happenstance as will soon be explained), does everything need to be instrumentalized: read or looked at, consumed with a view as to how it might be made into something else? Even as I scribble this note at 6:15 AM. I feel the satisfaction/relief of productivity.

Jakob's abjection at the Benjamenta Institute (a boys' school for servants) reminds me of Genet's incarceration at the Mettray Penal Colony (ostensibly a school for sailors). My friend the artist Pradeep Dalal cited Genet at a public event—against efficiency and output and about how we should spend more time listening to music, for instance—and later told me the quote came from an interview he'd watched. I assumed it was the infamous 1985 BBC interview where Genet turns the camera on the crew and begins to interrogate them, but apparently not, I found out, after watching the few clips available on YouTube, and later by reading a complete transcript. The transcript did, however, reveal that Genet wrote his second novel, *Miracle of the Rose*, on scraps of brown paper bags, which of course reminded me of Walser. Genet's manuscript was found by the prison warden and destroyed, so he bought a notebook from the commissary and rewrote the whole thing from memory, hiding under the bedcovers.

In *Jakob von Gunten* the narrator says, "I must write a short and true account of my life. That means paper. So I have the added pleasure of walking into a stationer's." (Walser's father owned a toy and stationery shop.)

Happy for the excuse to keep on reading, I proceed in a desultory fashion, sometimes by day and still in the middle of the night, to read Walser's remarkably buoyant *Berlin Stories* and Carl Seelig's account of their walks together; and the Genet interviews and Edmund White's descriptions of Genet in the last

two decades of his life, when he connected with the Panthers and the PLO, and after a very long writing hiatus, worked on *Prisoner of Love*. Both Walser and Genet, in these later periods of their lives, lived marginally, owning one or two sets of clothing, no books, few possessions; a psychiatric hospice for Walser, cheap hotels by train stations for Genet. Both men had attempted suicide at least once, and for twenty years Genet took Nembutal every night to sleep, though it compromised his memory and his ability to write.

Asked about the defining moment at which he knew he'd be a writer, Genet described buying a postcard from the prison store to send to a German friend:

"The side I was supposed to write on had a sort of white, grainy texture, a little like snow, and it was this surface that led me to speak of a snow that was of course absent from prison, to speak of Christmas, and instead of writing just anything, I wrote to her about the quality of that thick paper. That was it, the trigger that allowed me to write."

Genet's anecdote about a small rectangle of card stock that inspired him to dilate upon the quality of the paper and its resemblance to snow is uncannily in the spirit of Robert Walser.

Genet often claimed that the happiest years of his life were those spent in the reformatory and in prison: "Prison isn't prison, it's escape, it's freedom. There you can escape the trivial and return to the essential." In *Walks with Walser*, the writer tells Carl Seelig, apropos of his arrival at Herisau: "I was very content in my sick person's room. To remain prone like a felled tree, without having to move one's little finger. All desires drift off to sleep, like children tired of playing. It's like being in a monastery, or in the anti-chamber of death." And invoking the last thirty years of Hölderin's life, in the care of others, Walser remarked, "To be able to dream quietly in a corner without constantly having tasks to fulfill is no martyrdom." He is also reputed to have said of his confinement at Herisau, "I am not here to write but to be mad."

Walser died on Christmas day, 1956, in the snow. At the end of the BBC interview, asked what he was doing with his life,

Genet responded, "I will answer, as per Saint Augustine: I am waiting for death."

A strange/familiar lassitude sets in. I've sent a first draft to Donald (the above paragraphs), thinking the piece is approaching completion, but he emails back and says "Please write more." And in order to write I must keep reading. I stumble across something about Genet and addiction, and find under "health" in the index of Edmund White's biography: *drug abuse, Nembutal*. On the weekend I see a production of *The Maids*.

There is a peculiar divide in my attention/appetite where I only want to read *about* Genet, and have now been drawn into White's giant doorstop of a biography, an almost overly stimulating book, but find the fiction too hardcore. The opposite is true with Walser: I am a convert and will now read anything by him. Also the Seelig book *Walks*.

There is no question Genet and Walser were very different writers, opposite ends of the spectrum in fact. But I nonetheless find the similarities in their philosophical outlooks and the circumstances of their final years compelling. Genet was an avowed partisan of the underclass, the marginalized, the poor. Notably American Blacks, and the Palestinians, of whom he wrote: "visible wretchedness is counterbalanced by a hidden glory." Genet disdained bourgeois pretension, as did Walser, who lived an almost Ghandian simplicity.

Walser was more diffident in his allegiances, reclusive, and withdrawn. A solitary walker, committed to "faithful, devoted self-effacement and self-surrender among objects." He had strong opinions but was not openly engaged politically, as Genet was.

Walks is filled with Walser's philosophy about leading a modest life, finding beauty in mundane things, getting by with less. He even goes so far as to imply that the misfortunes of war have a silver lining in that they force people to live more simply: "in my opinion, modern man has too many needs." Humility, divestment ... He never wanted a library of his own.

April 13: I learn of Donald's death and think of how much Walser must have been a comfort to him in his final months of life. I imagine that Donald gravitated to Walser because of his

writing but also because of his life—his stoicism and staunch asceticism, his acute powers of observation and transformative focus on the ordinary, his love of nature and walking. At the end of his life Walser was no longer writing, but, as Maroun Baghdadi put it in *Room 666*, "taking the time to live."

I finally finish *Walks*, which I'd begun at Donald's recommendation, after seeing his copy in which he'd underlined and translated many words and made comments in the margins. I read this small, inexpensive paperback sent to me by my friend Alison in Paris mostly on the subway, but also in the middle of the night, waiting for sleep.

(2013)

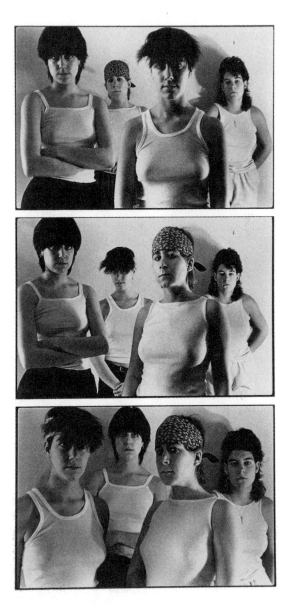

CARYATIDS & PROMISCUITY

A few years ago I set out to channel the sometimes troubled, sometimes ecstatic histories of Mary Wollstonecraft and her daughters, as a means to talk about episodes from my own errant youth in the company of five sisters.

The Wollstonecrafts, a large, mid-eighteenth-century family with a history of depression and rebellious behaviour — "born under the sign of Saturn" as Susan Sontag would say — figured in the ensuing video (*Les Goddesses*) as historical counterparts to my own siblings, a group of women bedeviled by similar genetic traits — the melancholia etc., but also, thankfully, some of the defiant nonconformism as well.

But in a development I did not anticipate, the content of the video soon shifted to encompass a narrative about photography. This thematic began to assert itself when I made a link between the honorific "Les Goddesses," an epithet conferred on Wollstonecraft's precocious teenage daughters, Mary Shelley, Fanny Imlay, and their stepsister Claire Clairmont by visiting American statesman Aaron Burr, and a photograph I'd taken of my teenage sisters in which they look a little like Greek caryatids. Here were my robust siblings dressed in white tank tops, assertively pushing up against the edges of a 35mm frame, and looking like they could indeed hold up the roof of a temple.

It might seem improbable, but, sparked by this image, I immediately connected my sisters to the Wollstonecraft daughters who, at around the same age, ran off to Europe to live exactly as they pleased in headstrong defiance of the cultural mores of their time. I should also mention that, in addition to this "caryatid" image, there were a whole series of (slightly engineered) coincidences of birth and marriage dates, and given names, that suggested a device for linking the two histories set almost exactly two hundred years apart.

I already had a script, but as I began to perform it for the camera the narrative about picture-taking became more and more insistent. I began to reflect on the ebb and flow of photography

in my life, my early, unschooled passion for the medium and the subsequent shocks that gave pause and made me vastly more cautious about the kinds of pictures I'd take—in particular, a prohibition I'd developed, starting in the mid-1980s, against taking pictures of people. The reminder was occasioned by George Baker quoting Walter Benjamin who said: "To do without people is for photography the most impossible of renunciations." I couldn't stop thinking about the truth of this statement, something I know first hand from the pleasure I take in looking at pictures of people—from Nadar to Lewis Hine to Robert Frank to Francesca Woodman to Zoe Strauss, to name a tiny few.

Strauss, a young, queer autodidact, has been photographing her community of friends and cohorts for ten years, and displaying the results under the vast, columned space of the I-95 overpass in downtown Philly. A monograph of this work, titled *Ten Years*, includes a personal text by Strauss—a jagged, passionate outpouring about her working method—along with an essay by photo historian Sally Stein. I knew Sally, a Marxist-feminist scholar, over twenty-five years ago in San Diego, and could not imagine her championing Zoe Strauss's mean streets back then when the correct, critical model was Martha Rosler's *Bowery* series. But Stein has written a very funny and utterly sanguine appreciation of Strauss's work, a telling indicator that the old ethos around representation has been radically upended.

The erasure of the human figure from my own photographs, had, over the years, become more or less a fait accompli. Newsstand vendors poke their heads out of their kiosks in a few shots from a series I made in NYC in 1994, but other than that, the focus of my work of the last twenty-five years has been on the inanimate, from money to books to cemeteries to the general squalor of the domestic scene, till eventually I found myself on hands and knees with a camera aimed at the dust under my bed.

And at an impasse. I began to feel boxed in by the very thing I craved: the privacy and stillness of the regulated, domestic environment. I'd long been familiar with the old-school narrative of photographers putting down their Leicas for Bolexes or Arris, and trading the still for the moving image felt persuasive, but

I also wanted to write, to make a video that would take root in words. I worked on a first video, *Fifty Minutes*, for three years, and put myself in it, more out of convenience, and so, without actually intending it, found myself working figuratively again for the first time in twenty years.

This style, of placing myself in the video as the performer of a written narration, persisted with *Les Goddesses*. And then a strange thing happened: just as I was reflecting (in the video itself) on the disappearance of the figure from my photographs I found myself, after decades of abstinence, taking pictures of people writing on the subway.

That type of situation was in the category of images I spent many hours pouring over but could never bring myself to participate in (Walker Evans's *Many Are Called* subway portraits from 1938–41, Bruce Davidson's visceral, color-saturated Kodachromes, Chantal Akerman's unforgettable, riveting NYC subway shot in *News From Home*, and most recently, Chris Marker's electric series *Passengers*, taken on the Paris Metro). Writer Lynne Sharon Schwartz once remarked that the types of novels she loves to read are not the ones she herself can write, and I'd pretty much identified that as my own fate with regards to the photograph.

An invitation came from the late gallerist Donald Young, to make a work in response to the writing of Robert Walser, the Swiss novelist and producer of artful, microscopic texts written in pencil on scraps of paper. These "microscripts" were the direct inspiration (as I hadn't yet read the fiction), the catalyst that forced me out the door and onto the subway with a small point-and-shoot camera to spy on subway scribes.

The critique of representation I'd absorbed as a student via John Berger, Laura Mulvey and Martha Rosler, to name a few, the position that was so dominant throughout the 1980s and early 1990s, is by now a historical footnote, largely ignored by younger generations who are having nothing of those withholding attitudes towards visual pleasure. The camera is everywhere, nudity is everywhere, from Vanessa Beecroft, K8 Hardy, and Ryan McGinley, to porn all over the internet. John Kelsey, writing

about McGinley's photographs, succinctly identified the phenomenon and placed it in time: "The fresh, streamlined bodies ... captured naked in a flash ... are the new mobile devices ... stripped down and live-streaming into New York between the Gulf War and 9/11, this is the same skin that showed up in *Vice* and the first American Apparel ads ... nakedness finally became whatever-naked, because by suddenly being everywhere it was suddenly also nowhere ..."

I took about one hundred of these subway-writer photos, and several of them appear as a coda with voice-over at the end of *Les Goddesses*. But I never scrutinized the original contract: stepping onto the subway and taking pictures without so much as a word of exchange with my subjects. Nor did I think through the fact that many of the photographs in the video show my sisters topless or naked, and have not been exhibited since 1985, the point at which my personal prohibition around this type of representation went into effect. I simply took the plunge, pushed aside my reservations and let myself get swept up in a narrative that seemed to be writing itself.

My own subway photographs are hybridized: they are in a twentieth-century idiom in a line with Walker Evans and Bruce Davidson, shot on film, scanned, and digitally C-printed. Folded into letters they get dropped into mailboxes where they sail off for a few days or weeks and have a secret life of their own before turning up at their destinations.

I consider Chris Marker's *Passengers*, taken on the Paris subways and photoshopped in spacey ways, to also be in the old idiom, but playing with it, digitally painting with it, so to speak, staking out something that could lay claim to a compassionate, even amorous street ethos, a new and original aesthetic that confronts but also dispatches some of the thorny, late-twentieth-century arguments around documentary.

In his introduction to the project Marker, citing a poem by Ezra Pound, writes: "Petals are for sure these visages I capture like a benevolent paparazzo. Stolen, yes, but by another trick of the mirror, here stealing means giving ... I try to give [my subjects] their best moment ... mak[ing] them truer to their

inner selves." Marker's first attempts were made with a camera hidden in a wristwatch, prompting him to privately name the series "Quelle heure est-elle?" (What time is she?)

And now, thinking back over my recent transgressions, I don't know that I can answer for what I've done. Obviously, there's a question of degree, the lengths an artist might go to produce a potentially prurient, intrusive image, and then the uses it gets put to, the circulation it receives. And then there is context: all of my still images in *Les Goddesses* are accompanied by a fairly relentless voice-over, anchoring the nudes and the clandestine subway shots in a very pointed narrative.

On a strictly personal level, the women and representation debate feels more and more like a tired relic of my formative years; I don't think its themes are unimportant by any means, but I no longer invest in it the same psychic energy I used to.

A more interesting and contemporary spin on the discussion came to me by way of an *e-flux* missive authored by Hito Steyerl around the question of digital image spam, the preposterous "photochopped" people that inhabit the internet, but are largely ignored. She writes: "If Jean Genet were still alive, he would have sung praise to the gorgeous hoodlums, tricksters, prostitutes, and fake dentists of image spam," the ones Steyerl goes on to say are "substituting for real people who are actively beginning to avoid the camera." Steyerl's analysis of image spam puts a whole new twist on some of the stagnant questions that have preoccupied me for so long. Commenting on the ubiquity of surveillance and social media, Steyerl turns Warhol's dictum on its head and says: "Now people want to be invisible for 15 minutes."

The morning after I wrote about Marker I learned of his death, and in one of the many online obituaries read something he'd said about his working method for the *Immemory* CD-ROM, about how "photos apparently taken by chance, postcards chosen according to a passing mood, begin to trace an itinerary, to map the imaginary country that stretches out before us."

Marker is describing a kind of montage effect of made and found images, of words and sounds. One of the ways I'd kept photography alive for myself was through writing. The word

could redeem a failed picture, text could invigorate and give new direction to a stalled practice. Annexing, hitching my work to writing and reading also became a way to circumvent some of the troubling questions around the digital takeover and the eclipse of analogue. I've many times turned to literary models for a new take on the photograph.

Lately I've been thinking a lot about Jean Genet's obsession with certain photographs, pictures of beautiful murderers and thieves, and snapshots of his loved ones. In prison he fashioned a secret montage on the back of the rules board posted in his cell, affixing photos culled from magazines and newspapers with chewed bread, and framing within this assemblage certain of the faces with colored beads and wire in the shape of stars. He could take this small placard under the blankets at night and live out his fantasies undetected. We learn of this montage in *Our Lady of the Flowers*, a novel that moves from diaristic, first-person chronicling of Genet in the present, in his cell, to the fictional characters of his imagination — Divine, for instance, who has the same photos as Genet on the wall of her Montmartre garret overlooking the cemetery.

Another resonant account of Genet's fixation, his passion for certain photographs is mentioned in a letter to a former lover, Java. Written in the monastic, later period of his life, Genet mentions being able to vacate his hotel room (usually located near a train station) in a matter of minutes as all he cares about are four photographs, one of which is of Java, and these, along with his clothes and papers, all fit easily into a small valise.

The day Marker died, on his birthday, walking on Blind Pond Road with Jason, I mention that it'd crossed my mind to try and find an antique rules board and make my own version of Genet's talismanic collage.

My description, of Genet flipping the rules board over, reminds Jason of one of his favourite Zoe Leonard installations, and mine too, from *DOCUMENTA IX* in 1992, where she removed all the portraits in a gallery of eighteenth-century painting except those of women, and replaced the missing works with

photos of "pussies" (as I once heard her call them in a lecture to high school students in Ithaca, NY).

And finally, because the literary connection to photography is so important to me, I want to mention a recent discovery, the French writer and photographer Hervé Guibert who published many books — novels, diaries, monographs, and at least one collection of writings on photography that came out in 1981, a year after *Camera Lucida*, titled *Ghost Image*.

There are some uncanny parallels to Barthes, for instance the first essay describes an elaborate mise-en-scène in which Guibert sets out to photograph his beautiful, reticent mother, just as she is on the cusp of aging, only to realize upon developing the film that it never advanced through the camera: it is completely clear.

In *Camera Lucida* and *Ghost Image* both authors are in search of an ideal image of the mother; Barthes finds his, but for Guibert the quest ends in crushing disappointment. On the other hand he has written a text about the failure, and in it he talks explicitly about the difference between photography and writing: if he takes a picture he will possess it as an object, but it will be "foreign" to him: the emotion he felt at the time of making it, the memory of the moment will be obliterated. Writing for him is "melancholic," and if he writes about a scene he didn't photograph, the sensation and memory of it will stay with him.

In another essay in the book titled *Photographic Writing*, Guibert characterizes the style of Goethe's Italian diary as proto-photographic.

A description of a landscape is "a travel photograph, a postcard"; Kafka's diary entries are like "snapshots of his inner being," and Guibert compares Peter Handke's journal to video, "a long, uninterrupted spool of film." My take on Goethe's diaries in *Les Goddesses*, completely unaware at the time of Hervé Guibert's writing, is an almost identical interpretation. In my essay, I write about how uncannily contemporary Goethe's eighteenth-century voice feels, about how his "travel writings have the vividness and spontaneity of snapshots," and I speculate that with his scientific mind he might have anticipated the nascent

technology—Goethe died in 1832, just seven years before the sanctioned discovery of photography.

As I think about concluding, I realize I've barely touched upon the digital divide. While I mourn the fading of analog technologies, especially the beautiful cameras—such incredible machines, almost unbreakable, their batteries lasting forever—I also don't want to look back. I truly only care about what I'm making in the present, and what I'll do next. I want film to continue, and I want to keep shooting it, but I also feel that the boundaries between the technologies are becoming increasingly blurred and harder to recognize. More important to me than fidelity and adherence to a medium is a kind of devotion to promiscuity (to lift that concept once again from the lexicon of Gregg Bordowitz), an embrace of materials, formats, histories and genres, and lastly but perhaps most importantly, an investment in language. I am a believer in heterogeneity as an enabler and enhancer of the story wanting to be told.

(2012)

BURN THE DIARIES

Blankness

In a volume of interviews, Jean Genet constructs the story of his life. The narrative differs in his various retellings, swayed by discrepancies of memory and the desire for an ever more perfect story. An editor has scrupulously corrected and reordered everything in endnotes, so that we have both versions: Genet freely spins his tales, and we possess the true record.

> *The white of the paper is an artifice that's replaced the translucency of parchment and the ochre surface of clay tablets; but the ochre and the translucency and the whiteness may all possess more reality than the signs that mar them.*[1]

The murkiness and ambiguities of a life take on weight and authority by virtue of the published document. Perhaps this is what Genet meant when he said there is more truth in the whiteness surrounding all those black characters than in the meticulously transcribed words themselves.

Snow

Asked about the defining moment in which he knew he'd be a writer, Genet told of buying a postcard in prison to send to a German friend:

> *The side I was supposed to write on had a sort of white, grainy texture, a little like snow, and it was this surface that led me to speak of a snow that was of course absent from prison, to speak of Christmas, and instead of writing just anything, I wrote to her*

1 Jean Genet, *Prisoner of Love*, trans. Barbara Bray (New York: New York Review Books, 2003), 5.

about the quality of that thick paper. That was it, the trigger that allowed me to write. [2]

Dream

I am about to give a talk on Douglas Crimp before a large audience, but my pages have become lost in a pile of recycled paper. I shuffle through the stack without success. Eventually I try to quickly recall some of the ideas and grab a little silver pen to record them, but it's out of ink. I scratch out a few barely legible words.

Keeping an eye on the fanned-out sheaf of papers in the hand of a boring speaker, I watch its volume diminish and wait for the last page to turn.

Music

I am hooked by accident, drawn in by my friend Pradeep quoting Genet at a public event. The record shows that this is what Pradeep said:

> *A part of me . . . wants to see . . . writing or reading, as personal and private and pleasurable without activating it in a strategic way. . . . Not everything we do is for art-making, not everything we write is for public consumption. I think back to an interview I heard with Jean Genet where he says that to deepen your practice, it's not by just studying writing, that it's actually the other bits—the music, the theater, the film, and other things that all interlock and move you up a notch or two.* [3]

My take on P.'s comment is that we tend to cannibalize experience and that we should consider spending more time just lis-

2 Genet, *The Declared Enemy: Texts and Interviews*, ed. Albert Dichy, trans. Jeff Fort (Stanford, CA: Stanford University Press, 2004), 9

3 Pradeep Dalal, quoted in "Moyra Davey, Zoe Leonard," in *Writing as Practice: Peripheral Continuity*, ed. Michi Jigarjian and Libby Pratt (New York: Secretary Press, 2012), 99.

tening to music, for instance, for its own sake, "taking the time to live," as Baghdadi put it in *Room 666*.[4]

P.'s critique of the drive to commodify lures me in and steers me to Genet, and eventually I will find myself reproducing the problem in the midst of soft green hills and the uninterrupted birdsong of rural Wyoming in a studio on a cattle ranch. At least I will have the doors wide-open.

> *I was amazed when I realized that my life ... was nothing but a blank sheet of paper which I'd managed to fold into something different.*[5]

Paper

Christopher Hitchens was brave in death (as was Dennis Potter) and said he had no regrets about the drinking and smoking that caused his illness: writing was the most important thing to him, and the late nights and the talk were part of it. Genet, Potter, Hervé Guibert, Hitchens, and David Rakoff wrote prolifically through terminal illness. Writing was all they cared about.

> *I had to work [time] almost in a blaze, and almost day and night.*[6]

On the endpapers of a notebook from 1988, a year before he died of AIDS complications, Mark Morrisroe wrote a litany of fuck-yous to all his friends, including Pat Hearn.

> *Still another thing: I don't have any more paper. . . . Would you try to procure some (preferably a very thick school exercise book, because I write on my knees since there's no table).*[7]

4 Maroun Baghdadi, in *Room 666*, directed by Wim Wenders, 1982.
5 Genet, *Prisoner of Love*, 171.
6 Genet, The Declared Enemy, 189.
7 Genet, quoted in Edmund White, *Genet: A Biography* (New York: Knopf, 1993), 232

Childhood

To create is always to speak about childhood. It's always nostalgic.[8]

The need to make things is directly related to childhood. Swimming in the chaos of a too-big family, this is how I strove to extricate myself. Everything compensated for my having been a monster-child.

Desultory day, but thinking I could make my own diary an object of study. Or simply begin with "burn the diaries."

> *A turnkey entered the cell, noticed the manuscript, took it away, and burned it. . . . Why? For whom? . . . Nothing in the world mattered to him except those sheets of brown paper which a match could reduce to ashes.*[9]

> *It was on that brown paper that I wrote the beginning of* Our Lady of the Flowers.[10]

Awake

M.'s dog Shadow is fucking another small animal. When he stops, his large, erect penis is detached from his body. Soon I realize that a huge chunk of his lower torso is also detached.

I associate this dream with a conversation I had the night before, when I introduced two former students: "Anus, meet Anus." One had made a video called *Colon Karaoke*; the other had based a performance on Georges Bataille's "Solar Anus."

155th Street

Pee behind a parked car on 155th Street and wonder why we can't

8 Ibid., 169
9 Jean-Paul Sartre, introduction to *Our Lady of the Flowers*, by Jean Genet, trans. Bernard Frechtman (New York: Grove Press, 1963), 9–10.
10 Genet, quoted in White, *Genet*, 210.

just piss in the park like the doggies or on the rocks by the Hudson, where I squat and think of Roni Horn. Read *NYT* article about sex offender Jerry Sandusky that mentions "rhythmic slapping sounds" coming from the shower. Begin to feel better and not care that I can't write anything. Enjoy the river. Wash the sheets. Eat grapefruits.

> *Under [H.'s] skirts, under the fur-edged coats . . . the bodies are performing their functions.*[11]

Fairground

On the way to the airport, blue of dawn, groggy. An inert fairground—its big wheels will not light up again till dusk—signals danger and excitement. I immediately think of childhood and the thrill of such places but also of the menace and seediness, the hours spent aimlessly wandering. I once saw a man cuffed and strong-armed out of the midway, a cigarette dangling from his mouth. It was around this time that I met my childhood friend Susan Kealey.

View from the plane: vast expanse; chalky, dusty patchwork of rectangles; perfect circles and squares; lozenges and other unnamable shapes. Listening to Bryan Ferry.

Genet

P.'s emphasis at the event is less about taking the time to live and more about privacy and discretion. But also about patience, knowing that we are sometimes unconscious of the ways in which we are being fed.

In the transcript of the interview, Genet is asked: "Is a reader changed by what he reads? Are there books that changed you?" His answer:

11 Jean Genet, "What Remains of a Rembrandt Torn into Four Equal Pieces and Flushed Down the Toilet," in *Rembrandt* (Madras and New York: Hanuman Books, 1988), 35.

In the end no. . . . Every person takes his nourishment from ev-
erything. He isn't transformed by reading a book, looking at a
painting, or hearing a piece of music; he is transformed gradually,
and from all these things he makes something that suits him.[12]

Sleep

Cut *Genet* in half to read on the subway. Then drop into em-
balmed sleep. B. comes home from school, and I talk to him
from my dreams. Walk Rosie and pee twice under the West Side
Highway. Think of Eileen Myles's image of *her* Rosie, "arching
about to dump a load." [13]

In *The Thief's Journal*, Genet has a similar description of a
dog shitting:

It squeezes, its gaze is fixed, its four paws are close together be-
neath its arched body; and it trembles from head to reeking turd.[14]

Diary

While reading Myles's *Inferno*, I wonder: how can one *not* write
like this? And I think, I could begin to write again about the
peeing, I could pee on the diaries . . . Astonished that this is all
I have done today.

Up at six. Sit in kitchen with lights off and watch dark-blue
sky turn pale blue, then white, now rose. Lights twinkle. Listen
to clock tick. Heat hiccuping through pipes.

Yesterday, simultaneously reading Marguerite Duras: "To be
without [a] subject for a book . . . is to find yourself, once again,
before a book."[15] And John McPhee: "You begin with a subject,

12 Genet, *The Declared Enemy*, 201.

13 Eileen Myles, *Inferno (A Poet's Novel)* (New York: O/R Books, 2010), 174.

14 Genet, *The Thief's Journal*, in *The Selected Writings of Jean Genet*, ed. Ed-
mund White (Hopewell, NJ: Ecco Press, 1993), 258.

15 Marguerite Duras, *Writing*, trans. Mark Polizzotti (Cambridge, MA: Lu-
men Editions, 1998), 7.

gather material, and work your way to structure from there. . . . Not the other way around."[16]

Addiction

I am drawn into Genet through the interviews. I also have the huge Edmund White biography from the library, even though I've decided not to read it. But I am hooked while browsing the index, where under "health" I find "drug addiction," then "Nembutal." I start reading from the end and read the last five chapters in reverse. I buy a paperback copy and cut it in half, and this time I start at the beginning. The book excites me, and I have trouble sleeping; it is way too stimulating to read in the middle of the night.

> *I managed to surprise them by swallowing eight capsules of Nembutal. . . . Fifteen or twenty terrorists peered in amazement . . . at the tranquil expression on my face.*[17]

Complete Works

I have Susan's Gallimard editions of the *Complete Works of Jean Genet*, many pages uncut. I take the books down from the shelf where they have lived untouched for over ten years, since Susan loaned them to me before she died. I dip in here and there, but Genet is way too hard to read in French. On the back flyleaf of volume one, I notice for the first time an inscription from our friend Alison, written in French.

> *I bought these volumes along the quays. I have very few books at my place because when I've read them I give them away or abandon them or throw them away, not wanting to keep literature written by other people.*[18]

16 John McPhee, "Progression," *New Yorker*, November 14, 2011, 36.
17 Genet, *Prisoner of Love*, 118.
18 Genet, quoted in White, *Genet*, 215.

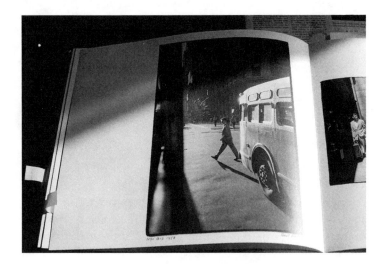

Jennifer

Drink coffee with Jennifer, then fall asleep bearing full weight of Rosie on my thighs and pelvis, her soft form draped over me like a large, coiled snake. She conforms her body to my body. Later I describe the Rosie/snake image to Jennifer.

And then, one morning on the street, out of the blue, a woman comes up to Rosie, looks at her large head, and pronounces: "Anaconda."

Discipline

> *When the ambulance arrived, [Larkin] looked up at Monica wildly, begging her to destroy his diaries.*[19]

The dross of the diary, the compulsion to scribble, the delusion that we can hold on to time. The inversion of this neurosis is the anxiety of being read, the fear of wounding, and, just as strong, the dread of being unmasked. William Godwin kept up a daily discipline and passed it on to his daughter, Mary Shelley. But Godwin's diary was the furthest thing from waste: he was cryptic, minimalist in the extreme, using dashes and dots to indicate sex. On the day Mary's mother, Mary Wollstonecraft, died, he simply recorded the time of death.

> *I put my papers in order.* (Dennis Potter)

> *Will you dispose of all my papers?* (V. Woolf, suicide note)

> *He destroyed his papers.* (Freud)

> *He burned his papers.* (?)

Towering pile of diaries on desk: the existential weight of years

19 Hermione Lee, "How to End It All," in *Virginia Woolf's Nose: Essays on Biography* (Princeton, NJ: Princeton University Press, 2005), 115.

of hoarding. The journal is a "good object" when it receives something that can be put to use (*exactly* what Pradeep cautioned against). Weighing this against the intermittent aimless drive to just run ink or soft lead across the page until a book, full, goes into a drawer and another one is started.

I think of burning, but I prefer the image of burial and water, as either of these seems slightly less absolute in the sense that the book might survive, albeit in an altered form: as per Genet, no words or letters, just the bluish white of the page.

> *Today I transmitted to Genet a packet of blank pages on which he can write.*[20]

Similarly, a strong fantasy of trashing mediocre negatives, paradoxically triggered by my recent meltdown over "lost" negatives, when I wept and wondered: am I losing my mind?

Later, look at a beautiful photograph by Hervé Guibert titled *Destruction des négatifs de jeunesse* (Destruction of Negatives from My Youth): on the floor are carefully arranged contact sheets, negatives in sleeves, and a pile of the same that are ripped and torn. Also, a small pair of scissors.

My ambivalence about the journal means that I now write only in microjournals. If I can't give up the practice altogether, I can at least shrink it.

WY

Except for a brief walk by the stream, I live on the couch with *Prisoner of Love*, Genet's last book. I also methodically read through the diary I began on April 2, 2011.

Deep sleep is abetted by sun and heat and long walks to the two-hundred-year-old teepee rings.

In an e-mail, Alison asks: "What is the connection *inside you* between Genet and the inhabited hills of Wyoming?"[21]

20 Maurice Toesca, quoted in White, *Genet*, 244–45.
21 Alison Strayer, e-mail to the author, June 1, 2012.

I instantly think: sun, heat, desert, bleaching white light. The white of the page. For Genet, it was the Middle East and North Africa, where he's buried in the sands of Larache, overlooking the sea. I hesitated before coming here, daunted by the remoteness, but ultimately made up my mind to travel because I wanted to see the landscape and knew it might unlock something in me.

A note scrawled in the dark while watching *Lawrence of Arabia*:

> *What do you like about the desert?*
> *It's clean.* [22]

From *Prisoner of Love*:

> *(Only now do I remember that Deraa was where Colonel Lawrence was raped by a pasha in the Turkish Army. I didn't remember it once while I was there.)* [23]

Circles

The "inhabited hills of Wyoming": I finally locate the evidence of settlement in the teepee circles after a failed attempt yesterday during which I was stopped at the pass by large bulls. With the cattle dispersed, I set out again, guided by a small map, and find the site, a promontory overlooking the valley. Looking closely, I make out the multiple rings of stones once used to hold down animal skins.

Certainly Genet's sympathies would have been with the beleaguered Lakota Sioux, Shoshone, Arapaho, and Crow who left their traces on these lush, green plains, only to be driven off and decimated by the American cavalry. Genet came to the US, sneaking in through Canada, at a day's notice to help the Black Panthers. It's likely he would have done the same for Native Americans had they asked.

22 Paraphrased from *Lawrence of Arabia*, 1962, directed by David Lean.
23 Genet, *Prisoner of Love*, 118.

To give me paper is as though a violin-maker's store in the street were to open to give a poor musician an instrument to play. Recently I've been making notes on flyleaves, on wrapping paper.[24]

Libido

Watch *Un chant d'amour*: extremely erotic, it vividly captures Genet's fetishes and fantasies. But, as with most porn, the guys beating off means less than nothing to me (except I am fascinated with the size of some of their members — which are like extra limbs between their legs). As per LB, sex has become sublimated.

The death of my libido is like a death between us. The loss goes nearly unspoken, except one day I asked why he could no longer come inside me. He mentioned new, compensatory habits born of not wanting to impose. As always in these situations, where I can say less than nothing about what I am thinking/feeling, his language, and his ability to articulate painful experience seduces and moves me, and it is why I love him.

This last image reminds me that a wake is a kind of fête.[25]

Susan

Somehow, through all of this, I am trying to connect with Susan, my friend with whom I was competitive from day one, whose close-knit Catholic family I both envied and feared. We shared books and dolls, before one day without a word she began having sex and was no longer a child, and not much of a friend. I was left in the dust, until the moment she said she hoped I would sleep with her boyfriend because he was so gentle, so caring, etc. I did, and I told her about it (a hasty, joyless affair at a drunken party), and she told me to fuck off.

From my diary, oddly, just below a mention of the Genet title *The Declared Enemy*:

24 Genet, quoted in White, *Genet*, 245.
25 Genet, *Prisoner of Love*, 421.

I knew Susan ages 10–18. After that we briefly shared an apartment in M. I was always out and she was lonely. Our positions had become reversed: now I enacted the dominant role she'd held with B. when we were teenagers. Later she became an artist, went blind, got very sick. And I was not really available to her as a friend anymore. I failed her.

Below that:

Reading Genet, and watching the interviews. Some disgust with the urge provocateur, especially talk of shit, piss, drool, spit, sperm, snot, blood, the crabs in his groin. Fascination with candid expression of his desire for incarceration, paradox of that.

Prisons I found rather motherly.[26]

Being there is like being between the legs of a woman, or perhaps in her belly. [27]

Susan would have recognized Genet's urge to provoke. It was her idea to initiate a tequila binge on a frigid winter day in O., circa 1972. With my sister Jane, we drained a large bottle in less than thirty minutes and then attempted to make our way downtown on snow that, having been rained on, turned the city into a giant ice rink. We could barely stand, let alone walk.

Alison

By high school, my relationship with Susan had become triangulated through Alison. Both were voracious readers, and from them I caught the bug. I asked Alison recently if she'd ever read Genet. No, she read Violette Leduc instead.

26 Genet, *Prisoner of Love*, 172.
27 Genet, *The Declared Enemy*, 364.

I gazed at the first page, at the words I could not see. She took the book from my hands and put out the light.[28]

Return

On the flight from Denver to New York, I watch Eric Rohmer's *My Night at Maud's*, the third of the *Six Moral Tales*. It opens with a scene in which an elderly priest recites the Mass in French. The parishioners are responding with the usual prayers, Lamb of God, Our Father, etc.

Memories of mind-numbing boredom of the Mass: prayers memorized in French, the priests with their ugly glasses and haircuts—eunuch-men swathed in gowns and collars and meticulously ironed ponchos—droning on in identical, portentous tones. Forming a curious little tent, a board and a thick cloth covered a chalice that contained a large, hard wafer cracked into bits. They'd make a big show of eating the crumbs and drinking wine, patting their lips with a white cloth.

I could never fathom the series of bizarre, cultish rites, though I recognized the segments that signaled the ordeal was nearing its conclusion: the recitation of the gospel, which meant the tedium would soon end. The doors would swing open, bells would ring: smiles and naked expressions of the freed.

My Night at Maud's is insufferable, but I keep watching Rohmer's *Moral Tales* because of their potential to unlock memories such as the above.

I saw the church stripped naked before me, teaching me that the stagnant water in the fonts came not from the Jordan but from the tap; ... that unclean teeth could crunch the host without producing some internal miracle, and so on.[29]

Dream about sex, then viscerally imagine Father fucking Mother

28 Violette Leduc, *La Bâtarde* (Champaign, IL: Dalkey Archive Press, 1964), 72.
29 Genet, *Prisoner of Love*, 415.

over and over, their sex life yoked to the church and a brood of wet, howling babes.

Susan

I didn't attend Susan's funeral. I couldn't face her mother, a Catholic service, or O. (the city where we grew up). And I couldn't imagine speaking at the memorial. Now I recall how Gregg Bordowitz began his remembrance at Ray Navarro's service: the first words out of his mouth were: "Ray and I were competitive." I think of Gregg's candor and his ability to get over a hump by immediately putting it out in the open: signs of his innate genius and morality. But at the time of Susan's death, I was nowhere close to acknowledging this same truth that lay at the core of our relationship.

Susan made a bonfire of all her diaries after B. broke up with her when she was only fourteen or fifteen; two years before she died, she shredded all her papers.

Our Lady

Reading *Our Lady of the Flowers*: in it, Genet mixes fiction and autobiography. He called the book one long daydream.

In public toilets, I hear women pissing like horses and dream of one long, uninterrupted piss. Think of Robert Frank in *True Story*, listing all the things his body will no longer do: "Can't take a piss."[30]

Having doubts about my impulse to write about Susan, guilt that I'm "activating ... in a strategic way" the memory of a friend who died young. Desperate again for a story and wondering if I am exploiting Susan as a means to this end.

As per Roland Barthes, reading to write and writing to read, I have a reading program and won't have to worry about what to read for a long time. In this manner, I am perhaps exploiting

30 Robert Frank, *True Story*, 2004/2008.

Genet as well. Realize that I find most of his fiction tough going, repellent. But I will argue that there is something to be learned in observing a clash of sensibilities.

> *The dead do become puppets when you try to talk about them and you yourself become a shadow-showman.*[31]

Vanity

The bleaching white light of vanity. To his former lover Java, Genet wrote:

> *How old are you? Thirty-six or thirty-seven? As for me, I'm not ashamed of being fifty and of appearing sixty; it's even rather restful.*[32]

Money

Watch *Suzanne's Career*, the second in the *Moral Tales* series. Suzanne, lying on a bed, reaches across her boyfriend and says: "Pass me *Thief's Journal*." The whole film is about the silly, mean-spirited seduction and manipulation of Suzanne by her caddish boyfriend and about money: paying for other people, borrowing from other people, and Suzanne going broke. Bertrand, the slightly less offensive of the two males, refuses to lend money either to Suzanne or to his close friend Guillaume. He hides the money in the uncut pages of a book and places it on the mantel. Later the money is discovered to be missing: the incredulous victim flips through the book, shakes it upside down, and improbably cuts several pages, hoping the money will materialize.

The scene makes me think of the passage in *The Thief's Journal* in which Genet robs a fellow soldier, then watches as the bewildered man rifles through his backpack over and over, searching for his money in the most unlikely places, his mess kit, etc.

31 Genet, *Prisoner of Love*, 352
32 Genet, "To Java," in *Selected Writings*, 442.

Genet takes pleasure in the contortions of his comrade's handsome face, in the utter disintegration of his composure, and in his dumb refusal to accept that the money is gone. He has the nerve to tell him: "You're funny to watch. You look as if you've got the runs. Go to the toilet and pull the chain."[33]

The soldier's embarrassment mirrors Bertrand's in Rohmer's film, when B. is unmasked for lying about not having money to lend. One of two friends has discovered and then taken the hidden stash, but Bertrand won't confront either. In this way, he suffers a triple blow: he's been robbed, tacitly exposed for his lying and malevolence, and outsmarted by one of his friends, never to know for sure which of them did it.

I later force myself to watch *Suzanne's Career* again to study more closely the money scene. Once again, I find Rohmer's 1963 portrayal of heterosexual student life in Paris infuriating and depressing in its misogyny and bourgeois conformity. But if I am honest, the feeling has as much to do with a colonial's jealousy that French culture was and never could be hers. The perfect accents and petulant nonchalance of the characters' speech and expressions remind me of the uncouth outsider-pretender I was in 1976. The stifling, bougie correctness of these pre-'68 characters reminds me of my friends at the time, Gracia, who was kind, and her boring, arrogant boyfriend, Guy, who was not. He was studying *gérance* (management), a term that was utterly baffling to me, even though Gracia went to great pains to explain it. I see that whole period of my life in black-and-white, like the film.

Reading an old, yellowed copy of *Saint Genet* on the bed. Smell of mildew. Sontag wrote that this book "is a cancer," but then went on to mostly praise Sartre.[34]

> *One thing a book tries to do is show, beneath the disguise of words and causes and clothes and even grief, the skeleton and the skeleton dust to come. The author too, like those he speaks of, is dead.*[35]

33 Genet, *The Thief's Journal*, in *Selected Writings*, 235.

34 Susan Sontag, "Sartre's Saint Genet," in *Against Interpretation* (New York: Farrar, Straus & Giroux, 1966), 93.

35 Genet, *Prisoner of Love*, 353.

Pieta

I read an excerpt from *Prisoner of Love* in Edmund White's biography. It is something about Hamza, his mother, and the Pietà. I read the passage in the middle of the night, and it calms me. So I buy the book and cut it in two and also read it at night. I come to the end of that first half, where coincidentally, I read the part about Hamza and the Pietà. In interviews, Genet talks about loving Monteverdi's *Vespro della Beata Vergine* and scoffs at the idea that one would have to be a Christian to find the music beautiful.

There are two Genets: in the first part of his life, the novelist and the thief; and in the second, the playwright, the political activist, and the renouncer of wealth and status. In the end, I don't finish much of Genet's fiction. I know I should read *Funeral Rites*, especially because of the theme about cannibalism and the dead, but Violette Leduc is vastly more compelling. And so the collision of sensibilities I speculated might take place is deferred.

I cut VL into three parts and read her on the subway. I can't get enough. I am enthralled by her delirious stream of consciousness and the sense that she is uploading all of her experiences and everything that crossed her brilliant mind. Memories, observations, snippets of conversation — every passing thought is recorded, producing something akin to the simultaneity and totalizing vision of the Borgesian Aleph. Non sequiturs abound, but they exist within a narrative, the story of her life. I am riveted.

Late one night on the train, well into the middle slice of the book, I decide I've had enough. I can't take any more of her depression and self-absorption, and I resolve to give it a break.

Pale-blue layers of sky and cityscape. A large marquee flashes like one of the mega light screens in Times Square.

Albums

A forgotten memory of Susan starts to seep into my consciousness through music. Listening to Roxy Music's first LP from 1972, I begin to remember the impact of those album covers, the chutzpah of Bryan Ferry brandishing his record jackets with photos of statuesque models and girlfriends, women with impos-

sibly broad shoulders and narrow, cut waists. This is hands down the best music Susan and I listened to together, and, perversely, these fetish women became the models of femininity that imprinted on our teenage brains: dream-suffused images of women lying together on a bed of ferns, connecting me to Susan. The first memory to displace survivor's guilt came from the depths of song and the glossy surface of an image.

This train of thought led to David Bowie's "Jean Genie," apparently inspired by Jean Genet. I begin thinking more honestly about my sadism and about money, how tight and fearful I was with money back when I had none. Talking on the phone with me when she was quite ill, Susan could detect a tension in my voice and said: "Why don't you come to T.? I'll pay for it. What good will IRAs do me now?" These memories of her reaching out pivot the uneasiness and doubt, my misgivings about "using" her . . .

Giacometti

In a concentrated manner, I imbibe "The Studio of Alberto Giacometti" while sitting in a doctor's office, waiting for test results. Picasso was right when he said it was the best piece of art criticism ever written.

In the essay, Genet notes the turpentine bottles, covered in dust, and the window ledge, never cleaned of its "thick carpet of dust." Giacometti's broken, dirty glasses "twisted around his face, [which has] assumed the color of dust."

If he could, [G.] would reduce himself to powder, to dust.[36]

The drawings, made with a pen or hard pencil, are riven through with holes, and look to be made up of "commas [&] typographical arrangements."[37]

It is not the line that is elegant, but the empty space.[38]

36 Genet, "The Studio of Alberto Giacometti," in Selected Writings, 326.
37 Ibid., 319, 323.
38 Ibid., 323.

Genet and Giacometti drink coffee in the rue d'Alesia, where leaves from the acacia trees "seem to powder the street with gold."[39]

The Bus

One day, Genet rides the bus: he is the Man with a Movie Camera, a solitary, isolated eye taking in the scene of "a downward sloping street"; the figures populating it are, he suggests, a "naked," wounded Humanity such as Rembrandt might have painted.

Hervé Guibert, whose writing is said to have been influenced by Genet's, rode the bus and imagined it a giant, ambulatory tripod, a multifaceted eye, a camera: its windows viewfinders; every red light, every stop, a click of the shutter. Violette Leduc:

I live the life of the bus.[40]

Guibert's novel *To the Friend Who Did Not Save My Life*, published the year before he died, is dark and unsentimental, yet Guibert manages to find beauty and tenderness in the world around him. On his weekly trips to the Spallanzani Clinic in Rome to have his blood drawn, he notes jowly nuns patiently assigned to look after junkies; palm trees casting their ocher shadows on the walls of the courtyard. All he cares about is finishing this book. He writes:

I care more for my book than for my life, I won't give up my book to save my life.[41]

And later, when confronted with the possibility of AZT, he debates whether he should take the drug in order to write one or two more books or whether he should kill himself.

39 Ibid., 318.
40 Leduc, *La Bâtarde*, 143.
41 Hervé Guibert, *To the Friend Who Did Not Save My Life* (New York: High Risk Books, 1994), 237.

It's when I'm writing that I feel most alive.[42]

Robert Frank's last photographs before he turned to film were shot from an NYC bus in 1958, the year Alison and I were born, a year before Susan entered the world.

My south-facing apartment on the eleventh floor is both a sundial and a camera. Like the bus, it moves, albeit with planetary slowness, absorbing a sequence of solar rays that light up each room in turn. This is the season, late fall/early winter, when I wait and watch the light, trap it, and later observe its subtle shifts as the days begin to lengthen.

Light

A certain quality of light emanates from Susan's photographs: small, mostly mundane objects placed on a light table acquire a strange plasticity but also a floating unreality. Looking at her monograph, *Ordinary Marvel*, I realize the series does not just depict banal, household items.[43] It is full of sex toys: a large dildo, anal beads, a black rubber hood.

A kind of stubbornness made me read *Funeral Rites* in its entirety. I both hate and love the book, and in a juvenile fashion made "good" and "bad" columns in my journal to keep track of my thoughts, not just about the novel, but about Genet himself. There is nothing surprising in the "bad" list ("bodily effluvia," "Sadean," "kills a cat, kills a child," etc., etc.). But on the other side of the page, there are many notes about the Genet character processing the loss of his friend, the twenty-year-old Jean Decarnin. Picturing his stiff body in the ground, JG comforts himself by clutching a matchbox in his pocket, imagining it a miniature coffin containing his friend. There is much in this book (recommended by Gregg) about "assimilating" and "digesting" the dead, words that confirm and illuminate my ambivalence in relation to writing about Susan. It was important that I read it.

42 Guibert, *The Compassion Protocol* (London: Quartet Books, 1993), 106.
43 Susan Kealey, *Ordinary Marvel* (Toronto: YYZ Books, 2006).

Light seeps in through the pages and cracked spine of a paperback, Susan's copy of Genet, which is now in urgent need of repair: I did not intentionally damage it.

When the 1 train goes elevated at 125th Street, sunlight from the east lights up an open book. For a brief moment, it is nearly impossible to look directly at the page; its surface is made blindingly white and radiant, all characters are blown out, erased.

(2014)

HEMLOCK FOREST

News

News from Home by Chantal Akerman comprises breathtaking views of Manhattan accompanied by the filmmaker's voice reading her mother's letters from Brussels. These are frequently melancholic, pleading, a mother desperate for news of an apparently unresponsive daughter living on her own in what was then a dangerous city. Shot on film, *News* is saturated with gorgeous color, and Babette Mangolte's camera work is a thing of beauty.

A third of the way into the film, there's a subway shot aimed straight down the 1 train. The camera is uncannily still, taking in the movements of passengers, some curious, most indifferent, and one man dressed in lime green, apparently annoyed. Taken aback, he lurches, scowls at the camera, then turns on his heel and walks quickly away through the open doors into the next car.

I have an urge to recreate the scene by asking cinematographers to film a contemporary version of the shot. But I immediately begin to feel anxious and depressed about the idea: this is not how I've worked, I've always done my own scenes, even if this type of unpredictable situation in public is where I am most challenged technically. The idea of filming this quasi-illegal scene both makes me sick with nerves and—if I can pull it off—is a huge rush. This scene is the opposite of "low-hanging fruit."

I do in fact go out and shoot the scene, first with Jason and then with a camerawoman, Liz Sales. I am on edge for a week before the shoot with Liz, even having dreams about it. But we do it. We get the shot, with the doors open between two cars on the 1 train. We do it without permission, and no one says a word except three rowdy girls who gently heckle from behind the camera.

Kudzu

In *Goodbye to Language*, we hear a male voice ask off camera: "To live one's life or to tell it?" Not long ago, I asked my son if

he kept a diary, and he answered: "I'd rather live my life than narrate it."

I'm piecing together fragments because I don't yet have a subject.

A French writer said apropos of fragments, "choosing is easier than inventing," and wondered how he might pass from notes and fragments to the novel. He speculated that he was breaking the ultimate rule of writers—speaking about a nascent work—and that his "work" might in the end be the notes on its making. In that same lecture, he mentioned how much he delighted in hearing *any* professional talk about their craft, in detail, and how rare this was.

I might in fact have a subject, but it feels raw and intractable. A part of me is leaving at the very moment he is becoming a person. He rides me on his bicycle so that I can film the Kudzu jungle in Riverside Park. I cling to his shoulder with one hand and hold the camera aloft with the other.

Death

The morning after the subway shot, I learn of Akerman's death. A friend tells me she was mourning the loss of her mother, who is also the subject of her last film. Apparently her mother's death was supposed to free Chantal, but it had the opposite effect. I remember Annette Michelson years ago publicly interviewing Akerman, who quietly wept over the misfortune of having made a perfect film at age twenty-five. That film is the epic *Jeanne Dielman*, about a housewife who lives alone with her son, imprisoned by her home and the routine of its maintenance.

I perform some lines from *A Doll's House*, another story about a woman, Nora, trapped in her home, subjugated to a condescending husband who treats her like a child, who talks to her as though she were his little pet: "Is that skylark chirping out there? Has little bird been frittering money again?" I narrate these and similar lines from the play four or five times before I realize they aren't working. The light is fading, but I persist, wearing myself out. And I squander the blue robin's egg in the process.

In the frame, just above the TV, there's a small paperback copy

of Tillie Olsen's *Silences*. I keep staring at it and eventually start to think of Käthe Kollwitz, whom Olsen includes in the collection, writing about working in her studio after her children have left home. I read the passage to J. over the phone: "I am gradually approaching the period in my life when work comes first.... No longer diverted by other emotions, I work the way a cow grazes ... and yet formerly, in my so wretchedly limited working time, I was more productive, because I was more sensual." I start to cry at the word *sensual*.

This passage, included in a book I edited eighteen years ago called *Mother Reader*, has stayed with me, a harbinger. And now Kollwitz's reality is upon me, as is the reality of Akerman's mother when Chantal moved to New York and didn't answer her letters.

Sound

Even more captivating than my laments from the journals are other writers' words, loosely transcribed, such as these from a Norwegian novelist. He said: "Sound is the present, ever-changing; silence is eternity." He said that in relation to the remote shores of Newfoundland, and the contrasting stillness as he retreated from the surf.

As a child, he is surrounded by forest, with its smells and rot, its filtered light and colors. The protective canopy of the woods is his giant playground and refuge.

Another of my notes cites an American composer and pianist discussing in the *Brooklyn Rail*, "the difference between seeing a tree and seeing/recording a tree through a view finder."

I set a camera on the dash, pointing at the trees and vines along the Palisades. As I steal glances at the tiny screen, the shots seem promising, but when I look at them later they are absolutely ordinary. I call this type of filming "low-hanging fruit," and it rarely adds up to much because so little is at stake.

Addicted

Addicted to work to forget that:
 I can't sleep.

I can't shit.
My stomach hurts.
My hands burn.
I piss in the saddle.
I miss my son.

In the days and weeks after your death, we all stream and watch your films and interviews. Elisabeth posts on her blog *Le Beau Vice* a heartbreaking tribute and describes loving the sound of your voice. You talked about using your body in your films, and how you could never get actors to adequately substitute for your clumsiness. I watch *Je tu il elle*, in which you shovel powdered sugar into your mouth while writing lying down. Eventually you disrobe and pad about the nearly empty room, naked. You look directly into the camera and smile.

You became a filmmaker because of Godard, but later turned against him, called him an anti-Semite.

I spend hours watching you online, listening to you talk about Proust, about Judaism and, always, about your mother, who "came out of the camps," as you put it. In Jerusalem, you school out film students, call them "spoiled children." You tell the young women not to be afraid of making things that aren't beautiful. I too cannot get enough of your raspy, smoker's voice. You're fearless and charismatic, and I could listen to you forever. I search for more. Eventually it sinks in that you're no longer here to give us more.

Mary

When Mary Wollstonecraft visited Sweden and Norway in 1795, she drank the landscape. Its beauty was a tonic to her depression and sadness, and she bore witness in her letters to the restorative effects of the rugged coastline, the giant trees, and the marvels of sunlight.

The love of her life, her soul mate, and the father of her small child had moved on. He was doing his best to get rid of her, and her desperation over unanswered letters sent from abroad is

conveyed in no uncertain terms. At the conclusion of the voyage by land and sea, after experiencing "the effusions of a sensibility wounded almost to madness," Mary tried to end her life. She was rescued from drowning, and then, while convalescing, proceeded to craft the letters into what would become her bestselling work, *Letters Written during a Short Residence in Sweden, Norway, and Denmark*. At this point, she was also in a new relationship with William Godwin, who offered this advice to Mary: "A disappointed woman should try to construct happiness out of a set of materials within her reach."

Derailed

I am now officially derailed by Chantal Akerman. I read Ivone Margulies, who loves Chantal and has written a thoughtful, analytical book on her, in the course of which it is necessary to mention terms and phrases familiar to me from the eighties and nineties, such as:

> *Cinematic praxis*
> *Freud's* Dora
> *Lacanian theory*
> *Reified allegory*
> *Reflexivity*
> *Split nature of subjectivity*
> *Strategies of distanciation*
> *Subject formation*
> *To-be-looked-at-ness*
> *Visibility*
> *Visuality*
> *Will to allegory*

I still don't know what some of these word combinations mean, and I feel the hairs go up on my back as I remember the policing and posturing that went on then, and certain boring films that got made by way of enacting these theories.

You shied away from most labels except "feminist," at least

when it came to *Jeanne Dielman*. You spoke about your films enigmatically, in an idiom that was completely your own. You said, in 1982, "I haven't tried to find a compromise between myself and others. I have thought that the more particular I am, the more I address the general."

Jane

William Godwin's phrase about a disappointed woman has engraved itself upon my psyche, and inevitably when I think of it, it is my sister Jane, one year older than me, who bore three children and lost one to an accidental overdose a few months before her twentieth birthday, who comes to mind. Days after Hannah died, Jane left her relationship of thirteen years and moved to my mother's house where she continues to write her memoir of addiction.

The manuscript has undergone countless revisions, but Jane has decided against writing about Hannah. She is taking care of my mother and taking care of herself, and whether or not happiness is a realistic goal, as Freud put it, she is trying to construct peace "out of a set of materials within her reach."

Yet here *I* am talking about Hannah, born in 1993, two hundred years (minus one) after Mary Wollstonecraft's first daughter, Fanny, who also died of an overdose of opiates at age twenty-two, though in her case it was deliberate.

Shame

I have been immersed in K. like a drug. The foreignness has something to do with it: I can more readily give myself over to contemporary fiction where the translator has left in traces of a Scandinavian accent.

K. goes in and out of aggression and soporific benevolence. At times, he is a cranky misanthrope, boldly calling out individuals who've crossed him. Then suddenly it's as though a bad mood lifts, and he is a different person: kind, even-keeled, pacific. He writes with tenderness about caring for his small children.

I have been trying to locate his shame in all of this, but so far I see it only in drunkenness. Add to this the fact that when transgressions figure in literature they've already been transformed.

In real life, I've judged my friends for their drinking, and my sister for being a party girl; to my shame, I even inwardly faulted her for falling off the wagon in the wake of Hannah. Jane wrote to me: "I can't stand life right now without being a little high."

This brings me to something important, of which I must constantly remind my judgmental self: take the good with the bad; otherwise you're a hypocrite.

Filming

In her letters, steeped in Kantian images of the sublime, Mary Wollstonecraft exults in the beauty and restorative powers of the natural world. She was briefly rescued, kept alive, by the lush forests of Scandinavia.

Mary's published book *Letters* is also firmly rooted in the social. Its author is a reporter, receiving a culture and its people with all her sensibilities heightened. Mary's radical principles and her recent memories of revolutionary France inflect all her writings.

I'm reliant on the words of others, and I glom on to the dead. In the car, driving north on the Palisades, I listen to music, much of it is Barney's, but then Bryan Ferry comes on singing Dylan, and it reminds me that we all sample, we all do covers, and that it's a way of expressing love and allegiance. Taking in but also giving back.

A woman rabbi gives the eulogy for you. She recounts an anecdote of you filming your last birthday party in the hospital before finally putting down the camera and saying: "Non, maintenant il me faut vivre et pas juste filmer." ("No, now I must live life and not just film it").

The trouble is you can only "live" once you've filmed. That feeling of freedom and release comes only after you've worked very hard for it. Years after making *Hotel Monterey*, you remembered the feeling: "I can breathe, I'm really a filmmaker."

A few years ago, Iman Issa wrote, "Watching Moyra Davey's film [*Les Goddesses*] I had the feeling that I was confronted with more than just the work of an artist, a photographer, or a woman reflecting on her life and profession. Her often repeated 'I' didn't come across as the 'I' of a therapeutic self-portrait, or the timid and humble 'I' of a self-reflexive gesture. Davey's 'I' felt more desperate, more like a last resort. Perhaps she has known for quite some time that this voice is one of the few, if not the only, with which it is still possible to speak."

When I read Issa's description, in particular her use of the word *desperate*, I feel she'd put her finger on it, and I am impressed by her forthrightness in calling me out. I am still trying to parse the "desperate 'I' of last resort" and why it felt to her like the only viable one. Perhaps it's because it signals a risk is being taken.

I was in fact frantic when I wrote parts of *Les Goddesses*. My body was breaking down. I peed in front of the ATM machine; the raking light in the morning, the cold, the pervasive frostiness of French teachers and the humiliation of mediocre report cards were being visited on Barney.

Desperate has evolved. Now there is the vanity of self-preservation, in the sense that if I push myself too hard I become depleted, gaunt. "What's the *use* of working oneself to death . . ." But like most in my situation I need to keep working to live, and not just materially, because, as Ibsen said, "I've come to realize [I'll never] find happiness in idle pleasure."

Love Letter

Les Goddesses was a love letter to my family. I linked my sisters to Mary and her siblings, my parents to hers. I forged a coincidence of dates two hundred years apart to make connections and enable a story. I've often wondered what it would mean to revisit that account, word for word, showing us as we are now, not via pictures taken thirty-five years ago when the Davey girls were

in their heyday and when my mother went on record saying, "I'd mind less [about the sex] if I thought they enjoyed it more." A lot has changed since then. Things didn't exactly work out for some of us. Intoxication lasted longer and played harder for some of us. We didn't come through those party days unscathed.

Excepting the occasional rueful aside, my mother made a point not to speak about her children, and like her I've been circumspect. But now the boy is suddenly a man with one foot out the door and plays his cards close to his chest. He relaxed and opened up once over a bottle of champagne; he sat and talked for an hour, and I could see the tension drain from his face. Then something a bit more innocent happened: he put his head in my lap like a living Pietà. He was slightly high. I'd been dying to hold him in my arms and squeeze his flesh like the chubby baby he'd once been. I said, "You're a nice guy to let me hold you like this."

Elisabeth

Elisabeth asked, apropos of my book from 2001, "If you were doing *Mother Reader* now, what would you include?" Inevitably I've also been queried about "empty nest," a tough one to consider because the advent of it is so clichéd, the emotions strong and real.

I hear, echoing in the public hallway, the wail of a child pleading for its mother. This type of anguish goes straight to my nerve center, spiriting me back to childhood, my own and Barney's. I remember my transgressions, the times when Barney was that unhappy child. But I'm also pretty sure, as per Winnicott, that I was "good enough."

You are riding your bike in the park at dusk, struck once again by the wild, jungle quality of the foliage on the other side of the train tracks. You are drenched in sweat from the courts, your hands are gray with dirt. The air is smoky and filled with the rise and fall of cicada sounds. From all that, I get the idea to do a traveling shot for *Hemlock Forest*. I hold your shoulder with one hand and the camera high with the other.

After making *Jeanne Dielman*, Chantal told Delphine Seyrig, the star of her film, that she thought she no longer had the spark. You said that you thought you'd never again feel the euphoria of filmmaking. And Seyrig said to you: "You have to make, make, make. You still have the passion. You're just not an adolescent anymore."

You talked about manic episodes, explosions, which you'd put to use with bursts of work and creativity. You would "make, make, make," until you were spent, and then you'd remain dazed ("hébétée") for weeks afterward.

The woman making this film is writing on the subway, on the uptown 1 train in fact, but thinking of you four—Barney, Eric, Euripides and Leo—in a house surrounded by woods and falling snow.

It was a brief encounter; she was meeting some of you for the first time.

You ate, you slept, you played ball, you got high, you stayed up all night.

The day before you left, she turned on the camera without asking. She's not adept; the picture goes in and out of focus.

She's fascinated by you, doesn't want to be a voyeur, knows she is doing just that, eavesdropping on you and your world. You are the opposite of low-hanging fruit.

She started filming, and you gave tacit permission. You were playful, funny. You performed. You were trusting. When she re-plays the footage, she's awed by your faces, your smiles, your jokes, your aliveness.

She feels alive when she's behind a camera, when she's shoot-ing her own scenes, when she is making something.

(2016)

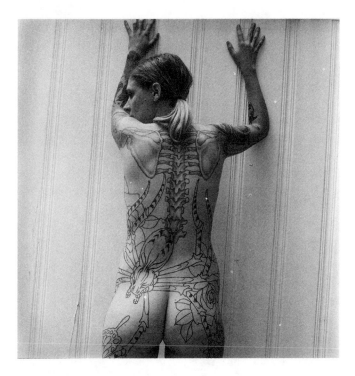

OPPOSITE OF LOW HANGING FRUIT

Low hanging fruit is a term I used recently to describe video footage or photographs that are too easily obtained. The stakes are low, and I'm not risking anything of myself; either not breaking rules (or laws even), or not putting myself on the line by getting up close to my subjects.

I harnessed the term quickly, thinking of it as a place-holder, and inserted it into a video narration I was writing. And there it remained, along with an even more awkward locution: "the opposite of low-hanging fruit." Those expressions are now part of a finished work, *Hemlock Forest*, completed in 2016. And then I doubled down by inserting those phrases into my film *Wedding Loop*, completed just a few months ago

The whole idea of having that belief—the need for an artwork to embody risk—as a barometer, is a little old-fashioned, and perhaps I impose it on myself in lieu of other challenges, such as thinking. I have always been a maker more than a thinker, though both making and writing give me a great deal of pleasure. Lately I have been transitioning to a different kind of writing, one where I don't feel the pressure of accountability so much.

Conceptual photography practices of the '60s and '70s foregrounded thinking, often of a quasi-robotic, "dumb" order. For example artists such as Vito Acconci and John Baldessari assigned themselves simple tasks and performed these in a rote, deskilled manner for the camera, later dropping the film off at a drugstore to be processed and printed. This work seems to me clever, but by and large it leaves me cold. Current evolutions of conceptual art, of which there are many, are often preceded by elaborate, byzantine trails of thought and research culminating in an object. But what does it mean to invest so much time in intricate excavations of genealogies and histories resulting in art about art and art institutions? There are some great works in this tradition, such as Hans Haacke's *Shapolsky et al ...* from 1971, which "chronicles the fraudulent activities of one of New York City's largest slumlords over the course of two decades," or

more recently Cameron Rowland's *91020000* shown at Artists Space in 2016, a powerful and succinct indictment of the American carceral system as an extension of slavery, and one where, by design, Artists Space itself is implicated. Here we sense real stakes. The clarity and accessibility of these works is quickly apprehended.

I ask myself why so much of what I encounter now in galleries and museums, especially in photography and video, appears coded and opaque, reflecting on how when I hear the back story to these projects, it strikes me as a lot of thought for slim rewards. Often I get to know the young artists who make this work, and I really like them. But it takes engaging with them to begin to appreciate aspects of what they do.

Here is a partial list of contemporary artists who've been important to me over the years. I knew almost nothing about them, but their work, sometimes experienced first in a book, lit me up almost instantaneously. While I was at UCSD, it was Chantal Akerman's very first film *Saute ma ville* and Chris Marker's *Sans soleil*; Just as I was getting ready to leave and drive across Texas in the dead of summer: Larry Clark's *Tulsa* and Nan Goldin's *The Ballad of Sexual Dependency*; When I reached NY and was in the Whitney Program: Sadie Benning's Pixel Vision videos made when she was a teenager; Peter Hujar's portraits of humans and animals; David Wojnarowicz, whose work I nearly stumbled over in a survey show at PPOW in 1989, and wanted to cry from the rooftops: *go see this show*, especially the *Sex Series*, masterful B&W montages performed in the dark room using diary fragments and found images. I often find it a challenge to read text embedded in a photograph or painting, but I stood glued to these works which are steeped in anger, pain and desire, and drank every word. And after the Whitney, having made my home in NY: David Hammons's *Flying Carpet* with Kentucky fried chicken wings pinned to a faded, Asian rug, and his sculptures made of cheap liquor bottles and piles of coal; Louise Bourgeois's *Cells*, self-contained environments made of old doors and steel that speak of the past, of things sexual, of disgust; Kerry James Marshall's show at the Studio Museum in Harlem where I first saw

his paintings and the incredible photographs for which he is less known; Lee Lozano's notebooks and giant tool paintings; Pope.L's eating/shitting the Wall Street Journal; Hervé Guibert's photographs, novels and diaries of which I've gobble up nearly everything; filmmaker Xavier Dolan's last three films dealing with motherhood and dysfunctional families, and his poignant inclusion of musical ballads to heighten emotional intensity; a performance choreographed by Sarah Michelson where the dancers do nothing but spin backwards and sweat until their costumes can no longer absorb the moisture and droplets fly off their bodies with ever increasing velocity; all of Frances Stark's writing; Dani Leventhal's and Sheilah Wilson's color saturated, semi-abstract films about queer sex, reproduction and what they call "feral domesticity." I felt pierced by these works, by the sex, the scatology, the audacity and desire on full display. Piecing together this list makes me think of countless other artists, a small number of whom I've developed friendships with. By and large, I didn't need the personal introduction to connect to the work.

Not unrelated to the thinking problem is the problem of reading, something that comes over me with predictable regularity. I need reading to produce writing, the latter a creative process that, as most people know, organizes and clarifies thought, unearths and generates new tangents and connections, and leads to other forms of making. Beginning a new phase of reading/writing can be mortifying, but when it takes on momentum, by which I mean it starts to become self-generating, it is one of the greatest highs I know of. I feel taken care of by my unconscious, "held" (in the Winnicottian sense) in a kind of suspended embrace. This is also perhaps where I most become a desiring subject, projecting my desire onto writing and writers and, invoking Roland Barthes, become a writerly reader. But periodically everything in this progression stalls, and I usually trace the problem back to a confusion around reading.

I read all the time: newspapers, magazines, fiction, nonfiction, but it's important for me to feel interpolated; to feel like the thing I am reading will lead to another and another, and become part of what I've referred to as a "generative, self-sustaining

process." I published an essay in 2003 called "The Problem Of Reading" which is largely about choice, a quandary I feel now with even more acuteness and regularity. Ten times a day I open an email with a link to something I'd like to read. I walk into my studio and am heartened by the sight of many books I'd love to plunge into, but nothing is giving permission and I feel a weird lassitude, even paralysis. This happens with music as well—its profuse digital availability serving to cloud and even annihilate my desire to tune in.

To return to low-hanging fruit and its opposite, and why I said just now my fixation was a little old-school. As a young artist I made a lot of portraits, starting with my punky, rebellious sisters. I ran reams of celluloid through my cameras for undergraduate assignments; later for bands and authors in need of publicity shots.

In 1984, two years after I finished art school, I received a grant to travel to Europe east and west to take pictures for some project I'd concocted. It was something we all did when applying for those grants.

This funded trip began in London where big anti-Apartheid protests were taking place. In an outdoor market in Brixton, a little Rasta boy sitting by himself smiled at me, and I took two photos of him with my clunky Hasselblad camera. Immediately following, his father was upon me demanding the film, and reprimanding me: "What do you think this is, a third world country?" I felt I had no choice but to open the camera-back and hand over the spool of film, which he unfurled and threw to the ground.

That was the second shock I had received behind the camera. The first came when I read Craig Owens's essay "Feminists and Post-Modernism" a year or two earlier, and immediately felt stung by the feeling that everything I'd done till then—making a small name for myself by photographing my five sisters and exhibiting the portraits, some of them "nakeds"—was hopelessly backward and wrong. In that essay Owens champions the work of "Pictures" artists Silvia Kolbowski, Barbara Kruger, Cindy Sherman, Sherri Levine and Laurie Simmons, all of whom steadfastly refused the un-manipulated photograph and appropriated

their images of women from advertising, cinema, pre-existing photographs or commercial toys. Add to Craig Owens's essay, John Berger's *Ways of Seeing* and Laura Mulvey's "Visual Pleasure and Narrative Cinema," and a pretty damning picture formed—at least in my eye—of the photographs I'd made till then.

After diverting my practice away from the figure for over 20 years I find myself once again pulled in that direction, making work that goes against some long-held prohibitions against photographic representation, but also that puts the "transgressions" into context through writing. Perhaps what I'm doing now is revisiting the site of trauma, and trying to bring about a different outcome.

At a conference in Chicago (Photography As Model) I read a short paper called "Caryatids and Promiscuity," where I talked about some of these ideas in relation to a video I'd made called *Les Goddesses*, in which I revisit my early practice of photographing my sisters. I show close-ups of the B&W photos—some depicting naked flesh, and even use these images to drive the narrative. In the paper I talk about my misgivings and ambivalences, but I never actually resolve the issue for myself—is the work exploitative, voyeuristic? Have I transgressed, perhaps even more so by projecting the nudes/nakeds onto the large screen?

Art historian Maria Gough, in the audience, asked a very germane question, something to the effect of: could I speak to the conflict as it's played out over nearly three decades, and come to any kind of new understanding or interpretation. The problem is, she used the word "dialectic," which, even after reading Walter Benjamin for years, I still don't understand. I have a mental block when it comes to that word.

Instead of asking Maria to rephrase her question using a different word, I tried to disguise my ignorance and rambled on at length before asking tentatively if I'd answered her. No, I had not.

I did, however, address the issue partially in the "Caryatids" essay by saying that perhaps the heavy cloak of language, the narrative framing of the photos, undercut some of the prurience. I back this up by citing Walter Benjamin, who famously said that photographs need words to ground their meaning. This rationale

was also a major thrust of the image-text work of the '70s and '80s. Martha Rosler's *Bowery* project is a good example of this type of work. In that series Rosler refused to appropriate the faces of the downtrodden and represents them instead by their absence.

I am still trying, in my haphazard way, to unpack some of this, but, like many artists, it interests me more to frame the question than to try and answer it. I'm curious about it, but also impatient and a bit bored. I crave forward momentum and dislike looking back, unless of course it's for the purpose of generating something new.

Aveek Sen, who wrote recently about my video *Hemlock Forest*, came up with the beautiful, Winnicottian image of "holding" to describe the balancing act I perform in that work and in *Les Goddesses*. Here is a passage from his essay:

"*Hemlock Forest* and *Les Goddesses*, together and individually, seem to move restlessly between two unresolved anxieties: the fear of low-hanging fruit, and the fear of the opposite of low-hanging fruit; between risking what is too easy and risking what is too difficult; between getting something too effortlessly and losing something through too much effort; between immediate access and the denial of access."

He then cites me citing Walter Benjamin who wrote in his essay "Little History of Photography:" "To do without people is for photography the most impossible of renunciations" followed by another citation, this one from Isak Dinesen: "The reward of storytelling is to be able to let go." Holding on to something in the first instance (the figure in photography), versus letting go of inhibitions and pent up memories to experience a kind of freedom, even ecstasy of expression. One might even say to experience forgiveness.

In fact there is an explicit image of holding in the narration of *Hemlock Forest*, a work in which I want to talk about missing my son but find the subject "raw and intractable." Nonetheless I do find ways to talk about him, such as a moment of intimacy when he was slightly high, when "I could see the tension drain from his face ... and he put his head in my lap like a living Pietà."

It was Aveek singling out that passage, stressing the give and take of a scene where I let go, permit myself an image of the "raw and intractable of motherhood," but only in writing, not as a visual representation, that made me understand the centrality of "holding" in my work, the mechanism that allows me to be analytical AND to transgress. For instance the scene in *Hemlock Forest* where I get naked while discussing shame, addiction, literature, loss and hypocrisy; or the subway shots with straphangers looking on, which I describe lusting after with anxiety and ambivalence in the opening segment of my narration. And that is precisely where I locate my desire in relation to making images, risking being called out for exhibitionism, risking treading on a consent that is not my own. I don't do it to shock I do it because shooting these scenes is an opportunity to engage an evolving discourse that is part of my history as an artist.

But does everything one makes or writes have to be "the opposite of low-hanging fruit"? Must everything entail risking something?

I also started to wonder if I was being judgmental and harsh by dismissing so much contemporary art simply because it frames its quest differently from mine, understands risk in a different way.

* * *

As it happened I was meeting a friend at the Whitney Biennial the next day.

I was seduced by much of what I saw and thought to myself: several of these artists will get added to my aforementioned, incomplete pantheon. I was also struck hard by the realization that in contrast to the chutzpah and edgy-ness evident in these artists' works, part of me is stuck on a weird treadmill, bound by a fixation with a stale binary (compliance vs. transgression), a burden that most of these Biennial Millennials seem enviably free of.

I spent five hours in the museum, an unheard of amount of time for someone who, like her son, is now more often than not,

made sleepy by art museums. This show actually gave me energy.

I felt especially interpolated by one work, essentially a 1:40 minute slide show by Oto Gillen. You stand or sit in a shoe-box shaped room with a high ceiling, walls painted black and the projector is flipped 90 degrees to accommodate the portrait orientation of the photos. I sat and watched for a long time, seduced by this montage of polyglot New York, a kaleidoscope of color-saturated images taken on the city's streets over a two year period: eerie, misty night shots of skyscrapers and rain soaked streets, portraits, and abstracted close-ups of nature. The colors are electric, and the sequencing and pacing via video projection is perfectly timed.

It did cross my mind at one point that many of Gilen's photographs of street people (the ones Martha Rosler elected to absent from her Bowery series) would fall into the "prohibited categories" taught in photo-documentary classes in college in the 1980s. Later I read in the catalogue that Gillen used a telephoto lens, another forbidden tool from the playbook of critical or engaged photography from back in the day.

But despite these revelations, the work did not strike me as voyeuristic. For the most part I was absorbed in Gillen's soulful montage of uncensored witnessing, a project that feels slightly epic and succeeds in part because it is abstracted through so many different passing genres.

When I mentioned the shocks I'd experienced in the early '80s (reading Craig Owens and the incident in the Brixton market in London) I could have included shocks incurred a few years later at the Whitney ISP where ideological lines quickly formed amongst my group, a factionalism that translated into a habit of ganging up on visiting artists and writers who'd present their work and research to us each week. More than a few of these invited guests were blindsided by the reception they had received.

I wonder if the climate at the Whitney program has mellowed, or if participants are as strident as we were in the late 1980s. In the larger world of art education I know critical discourse is still being taught, but there is also a not-so-new zeitgeist of "anything goes." Clearly a huge art market expansion has also been instrumental,

its insatiable appetite demanding an acceleration of production.

As I've noted elsewhere, the new ethos on representation and nakedness is artfully summed up by John Kelsey writing about the photographs of Ryan McGinley. Describing the many images of young, naked bodies, Kelsey links them to: ". . . the new mobile devices . . . Stripped down and live streaming into New York [when] . . . nakedness finally became whatever-naked, because by suddenly being everywhere it was suddenly also nowhere . . ."[1] In essence, no one cared.

McGinley was a phenom in the first decade of the second millennium, the youngest artist ever to have a solo show at the Whitney museum.

As predicted, I've left most of my dilemmas unresolved. But in doing so I hope to have given a picture of how I was formed as an artist and the psychic patterns and preoccupations that still impact the ways I work—the little "traumas" and idées fixes that underpin what I do, generate thought, and are the irritant-motor behind the pursuit of "the opposite of low-hanging fruit."

(2017)

1 John Kelsey, "Mobile Devices," *Ryan McGinley: Whistle for the Wind* (New York: Rizzoli, 2012), p. 8.

WEDDING LOOP

On a guided tour of a Colonial cemetery in Kolkata I stumble upon the grave of a Thomas Prinsep and immediately remember his name's connection to nineteenth century photographer, Julia Margaret Cameron. Related to her by marriage, the Prinseps would figure amongst Cameron's favorite models, in particular, Julia Prinsep Jackson, who was Cameron's niece, and the future mother of Virginia Woolf. It's been years since I've looked at Cameron's portraits, the Victorian men, women and children who sat for her in her converted chicken coop studio, her glass house, on the Isle of Wight. But at the end of her life, ill and impoverished, she had little choice but to return to this hot, humid sub-continent of her birth, where she settled on her husband's coffee plantation and continued, with the same, unwieldy view camera, to make portraits. By then she had given up on the commercial potential of her portfolios. She focused instead on what was at hand.

I photograph Jane in her wedding dress in the backyard and Claire in her T-shirt dress posing with Emma in front of the white brick wall; Addie, to my surprise, joins the group and allows me to take her picture.

Jane, unwisely, has been at the hair and makeup party since morning. She is beginning to unravel.

My mother's sense of foreboding in the build up to the event was not misplaced. Her house is packed with visitors and dogs. Addie is more "sauvage" than ever; Annie is boycotting because Claire is attending; Kate implodes at the last minute and refuses to get into a cab that will take us to the celebration in the suburbs.

The demand to be public and social over an afternoon and an evening, at a ceremony and a dinner, with 150 people, most of them drinking, is too much for this group of women, my sisters and their daughters, who are worn out physically and emotionally, are reticent by nature, and are trying to abstain.

Caitlin and her spouse, Antoine, give vows that are funny and original. They are straight-shooters—not a single cliché is spoken. Addie dances. She is a beautiful girl and a beautiful dancer. But when she's not on the dance floor she sits by herself and stares into space. I'm sure the pictures I've taken earlier with a Hasselblad are mediocre. The light was flat, my subjects were posed, I have no business hauling out this difficult-to-focus camera, and trying to revisit something I did, also only passably-well, thirty-five years ago.

The dinner is a raucous affair with a barker rousing the guests to make speeches and sing love songs. People put themselves out, risk looking foolish. Antoine and Caitlin take to the stage to greet and thank their guests, then Caitlin, with difficulty, begins to talk about her sister Hannah. Many people in the room are weeping, including Caitlin and her half-brother, Luca, age 15, with his forehead on the table. Jane tries to console him, but is too drunk to not make things worse and Luca's parents intervene.

I think of Yvon, the Quebecois writer of auto-fiction attuned to his circle of fragile women, shaping their lives into books but also taking care of them, materially and emotionally. I am no different, except for the taking-care-of part.

The next day Claire is cooking dinner for all of us, and can't stop talking about the dozen or so nonfiction books she's reading. I'm trying to decide what to do about Jane's pills. She's been drinking for two days and says to me: Part of me wants to be dead. She can't remember what she said to Luca the night before, though in my opinion it has more to do with the uncomplicated quality of a fifteen-year old boy's outpouring of grief over the death of his half-sister, and Jane's claim that she can't cry or properly mourn. We manage to remove liquor bottles stashed in her purse and from under her pillow. She either doesn't notice or pretends not to. She also willingly gives me her pills.

My mother's house smells permanently of animals and is fraying at the edges. I wipe dust off the leaves of the rubber plant in the hallway, acquired in 1966, the year my youngest sister was born.

I bathe in the English-style tub, a solid comfort with elaborate chromed faucets that creak.

The night before I returned to NY I wrote in a notebook:

> *In the midst of all the tears, angst, anger, drunkenness, I've arrived with my camera and performed the same role as in 1980: the one who watches and waits and corrals people into the light. My despondent feeling the night of the wedding is as much about my own fear of failure. Now all I care about is getting back to NY and getting my film to the lab.*

Improbably, I try to read the Iliad, a story of men kidnapping women, and going to war to get them back, to take revenge, to murder and maim till each and all, victor and vanquished are reduced to "things," as Simone Weil puts it.

In her essay "The Iliad, or the Poem of Force" Weil cites the passage about Hector's wife preparing a hot bath in anticipation of his return from battle. But what Andromache does not know is that Hector's already been slain:

> *Already he lay, far from hot baths*

> *Far from hot baths he was indeed, poor man. And not he alone. Nearly all the Iliad takes place far from hot baths. Nearly all of human life, then and now, takes place far from hot baths*, wrote Simone Weil.

Jane, Kate, Annie and Addie all live on the edge to one degree or another, in a cold-climate city. With age they anticipate winter with increasing dread: the deep snow and ice, the leather-corroding slush, the diminished light. It is especially hard on Kate who walks dogs for a living. In a dark, agitated mood she said: I can't bear the idea of another winter.

Far from hot baths. Far from toilets I could add. Kate, who has been self-destructive and caring of others in equal measure, her

whole life, once told me she'd helped homeless people clean shit off themselves. In a very untutored way that grows out of 12-step immersion, she is living a life philosophically close to Simone Weil's idea that "We participate in the creation of the world by decreating ourselves."

In a different notebook I wrote:

> *Meanwhile I was getting more and more depressed about my pictures. Old feelings of fraudery and worthlessness. Mixed up with this are moods of sadness for my derelict family in the midst of all the apparent robust mental health and wedding happiness. Though of course much of this is illusory.*

* * *

I don't care where I end a piece of writing. What I have a problem with is writing more, once I've secreted. I reach a point where I'm done, and then my mind shuts down and refuses to generate more. In this way I almost always short myself, barely meet the word count. I listen to late Tolstoy, read the fat books of Ferrante, Knausgaard and Hervé Guibert's diaries and fantasize they are simultaneously writing and living their lives. They are long-take writers. They circle back over the material again and again each time refracted through a slightly altered prism. There is comfort in their repetition.

These last three, and perhaps Tolstoy as well, are writing about their very complex lives, some further complicated by having children. It's a rather curious effect to be reading these reams of words that burrow into lives "termite" fashion and find that the "writing life" is not often discussed. So that when it is talked about the effect can be electric.

These breaks in the stories to talk about the writing itself are thrilling and always incite me to grab pen or laptop so that I can record passages such as this one from Ferrante:

"Perhaps Lila was right: my book . . . was really bad, and this was because it was well organized . . . written with obsessive care,

because I hadn't been able to imitate the disjointed, unaesthetic, illogical, shapeless banality of things. . . .

"I should write the way she speaks, leave abysses, construct bridges and not finish them, force the reader to establish the flow."

I'm embarrassed to admit it, but I am at the end of Ferrante and now we are the same age: almost sixty. I've gobbled up the books like comics, but in them a cherished child has been lost and I think of Hannah and feel gutted. I've read the books so fast I didn't even register the title of this one: *The Story Of the Lost Child*. I can barely finish it.

On the subway a young man with firm arms and shoulders falls asleep and leans into me. I could move but don't. I support the upright part of his sleeping body with my body. I don't look to see who he is, I don't want to call attention, I don't meet anyone's gaze to see if passengers are aware of him tilting into me. Not till it's my stop do I look down and see a red hard hat on the floor between his feet and realize he's a construction worker.

I read Jacqueline Rose on my phone writing about mothers, Medea, Winnicott, and maternal aggression. I wonder where the time's gone, then I remember I watched over two hours of *Jeanne Dielman* in the morning. I'd forgotten so much of this film: the baby that gets dropped off, the son's bedtime monologue about his father's penis-knife hurting his mother. This is his one moment of breaking out of the box, the oppressive conformity imposed on him by his mother. Jeanne says to him "you shouldn't have worried yourself over that" and turns off the light.

I woke in a panic that I'd never meet my commitments, but instead of hitting the keyboard I texted my friend who'd just had a baby to see if she needed help with her infant while she packed for a trip. I held the little guy and was overcome with my usual remorse that I hadn't been a tender enough mother to my own; I gave Fairfield a bottle, I walked him around the park for an hour observing squirrels and birds and people of all shapes and sizes walking tiny dogs; also kids playing basketball

at the court where Barney had been a regular. I walked till I was exhausted, then I brought the miniscule creature home and gave him another bottle.

Eric, Euripides, and Leo come to my studio.

I struggle massively with the 4x5 camera, my light meter's broken, clouds block the sun just as I'm about to release the shudder. I flail around like an amateur and shout at J & B to help me. But I stick with it. I push through my awkwardness and ineptitude, endure my small panic despite my conviction that the pictures will be failures. I've referred to this urge elsewhere as the pursuit of "the opposite of low-hanging fruit," meaning pushing myself to do the thing that is not easy, scares me, even. I put in a day's work and sleep the sleep of the just.

The portraits I take at the wedding and in the studio are mostly of Barney and his generation, inspired by Julia Margaret Cameron.

(2017)

THE PROBLEM OF READING

"What to read?" is a recurring dilemma in my life. The question always conjures up an image: a woman at home, half-dressed, moving restlessly from room to room, picking up a book, reading a page or two and no sooner feeling her mind drift, telling herself, "You should be reading something else, you should be doing something else." The image also has a mise-en-scène: overstuffed, disorderly shelves of dusty and yellowing books, many of them unread; books in piles around the bed or faced down on a table; work prints of photographs, also with a faint covering of dust, taped to the walls of the studio; a pile of bills; a sink full of dishes. She is trying to concentrate on the page in front of her but a distracting blip in her head travels from one desultory scene to the next, each one competing for her attention. It is not just a question of which book will absorb her, for there are plenty that will do that, but rather, which book, in a nearly cosmic sense, will choose her, redeem her. Often what is at stake, should she want to spell it out, is the idea that something is missing, as in: what is the crucial bit of urgently needed knowledge that will save her, at least for this day? She has the idea that if she can simply plug into the right book then all will be calm, still, and right with the world.

About a year ago I wrote to a friend, the Canadian writer Alison Strayer, and asked rhetorically, since I found it hard to imagine that she might share my dilemma: Do you ever get this frantic feeling about what to read? Alison wrote back:

> It is a big ongoing Issue in my life. One is in a state of temporary grace while working hard on a single project, for a deadline— reading doesn't quite come up as an immediate issue. It seems that when one has answered the question "what to read?" one has solved all the problems of restlessness, unfocus, and hunger of a certain sort, for a good long while. Because one [single] reading, if one is in a centered reading state, always contains the seeds of future readings. There is a true state of bliss one arrives at when

one always knows what to read next. (And conversely, always a
cause for concern when one doesn't know what to read.)

Alison's two-part answer started me thinking about the nature of reading and the nature of reading as work, specifically reading as creative work. The state of grace she refers to is produced by the writer's engrossment in a piece of writing (an essay that necessitates reading as research in her case). There is no time for self-doubt. One must simply absorb the material necessary to write the piece. Even if the writing project is not an essay but a story or novel, a writer must still read. She must ingest literature just as a car needs fuel. Stephen King in a recent memoir on writing wrote: "If you don't have time to read you don't have the time (or tools) to write." So reading in this manner is tied to productivity, to making something. Reading becomes part of a generative, creative cycle of taking in and putting out, with all of the rewards — the sense of balance, the sense of release — this process entails.

Georges Perec, the brilliantly inventive French novelist and essayist, wrote in his 1978 essay, "Brief Notes on the Art and Manner of Arranging One's Books":

> *Like the librarians of Babel in Borges's story, who are looking for the book that will provide them with the key to all the others, we oscillate between the illusion of perfection and the vertigo of the unattainable. In the name of completeness, we would like to believe that a unique order exists that would enable us to accede to knowledge all in one go.*

In the interest of approaching this utopian wish, so beautifully articulated by Perec, how are we to order and prioritize our reading, to figure out the key? In school, bibliographies and reading lists get generated easily enough. And there are times when we will simply drop everything to pick up a new book or article by a favorite author. But outside of these two circumstances, how do we choose what to read? Where do we locate value in reading and how do we define its pleasure? Is it in losing all sense of time and self to a page-turner, like the solitary novel reader ominously

described by Walter Benjamin, who "swallows up the material as the fire devours logs in the fireplace"? Or is the real value of reading to be found in confrontation and in challenge, as Kafka famously said, as an "axe [to shatter] the frozen sea within us"?

Must reading be tied to productivity to be truly satisfying, as my friend Alison suggests? Or is it the opposite, that it can only really gratify if it is a total escape? What is it that gives us a sense of sustenance and completion? Are we on some level always striving to attain that blissful state of un-agendaed reading remembered from childhood? What does it mean to spend a good part of one's life absorbed in books? Given that our time is limited, the problem of reading becomes one of exclusion. Why pick one book over the hundreds, perhaps thousands on our bookshelves, the further millions in libraries and stores? For in settling on any book we are implicitly saying no to countless others. This conflict is aptly conjured up by essayist Lynne Sharon Schwartz as she reflects on "the many books (the many acts) I cannot in all decency leave unread (undone)—or can I?"

Italo Calvino, Italian novelist and author, in his labyrinthine meta-novel *If On a Winter's Night a Traveler*, a veritable catalogue of the art of reading, gives a hilarious account of a hapless reader making his way through a bookstore. Intent on getting his hands on the latest offering by a favored author, he is nonetheless full of misgivings as to the legitimacy of his choice. Here is an excerpt from the protagonist's litany of doubts:

> [*What of all*] the Books You've Been Planning To Read For Ages ... the Books Dealing With Something You're Working On At The Moment ... [*the ones*] That Fill You With Sudden Inexplicable Curiosity, Not Easily Justified ... the Books Read Long Ago Which It's Now Time To Reread and the Books You've Always Pretended To Have Read And Now It's Time To Sit Down And Really Read Them[*?*]

I began my research into all these questions and doubts in the usual way, by making lists and querying friends, by mining footnotes and following hunches, and, I will admit it, by taking

recommendations from amazon.com. New piles grew up around the bedside and a reading program was launched, consisting of primarily essays, a small amount of fiction, and several books in a category that is clearly a genre of its own: the memoir of a life with books. And so it is no small irony that this essay, originating in the anxious question "What to read?" might possibly propel me into exactly that state of undoubting purposefulness, that state of grace and bliss that my friend Alison described.

This state of grace is at its height while reading a Virginia Woolf essay in the early morning with a first cup of coffee when no one else is awake, or, when seated before the computer, the muddle in my head manages to find a clear shape on the screen. But what about the day spent pouring over Harold Bloom, laboriously ticking off passages and transcribing them to my yellow pad along with page numbers, and feeling my own sense of agency dwindling under the weight of his relentless erudition. What pleasure is there in reading when the price to be paid is an axe hanging over your head, an essay to be produced? How to escape the little voice that says you cannot do this, you will fail? Where is the middle ground between absorption and anxiety, gratification and toil? Or is it simply that any creative project, especially writing, will always exact this price? Are the rewards of achievement always to be kept company by struggle and self-doubt? Now it's clear I'm not even talking about reading anymore. I'm talking about writing.

During the time I was preparing this essay I often made a slip and said that I was working on an essay about writing rather than my true topic, reading. Obviously reading and writing are connected. Jean-Paul Sartre and many other writers have said reading is writing, by which I understand that as readers we are always piecing together meaning and, in a sense, writing our own texts by weaving the threads and associations of previous readings and experiences. But by this I don't mean to suggest that reading and writing are one and the same—writing is infinitely harder. The central question I mean to pose is, what if the most gratifying reading is the one that also entails the risks of producing a text of one's own?

In her book *Reading Chekhov: A Critical Journey*, Janet Malcolm tells of Anton Chekhov, a man who wrote steadily and prolifically ("he was ... writing something in his head all the time"), and whose published stories brought him celebrity and financial independence, saying poignantly towards the end of his life, cut short by tuberculosis at age forty-four: "If life is given only once it shouldn't be spent writing." He also began to intimate that "idleness [and fishing] are the only form[s] of happiness." Virginia Woolf would seem to conjure up a similar ambivalence about reading in her many essays on the subject. Several times in these essays, she situates her fictional reader by an open window, with her gaze shifting from open book to the idealized, pastoral scenes taking place outside, implicitly contrasting but also longingly connecting the solitariness of reading with the pull and engagement of the outside world. Walter Benjamin underlines this kind of isolation in his essay "The Storyteller," in which he contrasts the alienation of the novel reader with the conviviality of storytelling, the latter an activity rooted in the social, in an oral tradition. Benjamin writes: "The reader of a novel ... is isolated, more so than any other reader. (For even the reader of a poem is ready to utter the words, for the benefit of a listener.)" Further, he adds this damning pronouncement: "What draws the reader to the novel is the hope of warming his shivering life with the death he reads about."

Writing demands detachment, seclusion. Following this, I wonder if the doubtful question that Chekhov raises of a life spent in solitude writing, might also be asked of reading: What does it mean to spend a good part of one's life alone in front of a book? And if this is our choice, how are we to go about it?

I will address the opinions, suggestions, advice, or, in certain cases the refusal to give advice, of a half dozen or so authors on the subject of reading: what, how, and why should we read? I began with a few favorite writers and a handful of essays, and I dutifully consulted the canonical voices on the subject. But beyond that, I feel it was not so much a question of myself making choices as books choosing me. This last comment speaks to a sense that I have, one that crops up frequently in the literature

on reading, about the roles of randomness and chance in an individual's reading process. It is an idea that fascinates me and one I will come back to later on.

In many ways *how to read, what to read*, and *why read* are one and the same question, and there are writers who have made a career of addressing it, notably Harold Bloom, author of *The Western Canon, How to Read and Why*, and dozens of other books of literary criticism and commentary. A controversial figure, Bloom has spent a lifetime reading and is a passionate advocate of a program that places William Shakespeare at the center of the canon. For Bloom, all of life, including "the Freudian map of the mind," is contained and mirrored in Shakespeare. If we wish to understand ourselves and the world, to confront mortality, to experience the sublime no less, we need look no further than the sixteenth-century playwright and poet to find that his words illuminate our modern dilemmas and preoccupations with accurate and prescient wisdom. All of this is hard to disagree with, especially Bloom's insistence on reading the classics not to mold oneself into a better citizen but self-indulgently because these books are "strange, uncanny [and] weird."

Consistent with Bloom, Italo Calvino, in his inspiring collection titled *Why Read the Classics?*, writes: "A classic is a book which even when we read it for the first time gives the sense of rereading something we have read before." Like Bloom, Calvino is a proponent of difficult and demanding reading. But unlike Bloom, who reminds me a little of those psychoanalysts who still insist on at least four-days-a-week treatment schedules, Calvino has a sense of proportion and modulation. He acknowledges that the stresses of modern life may not exactly afford us those daily parcels of unhindered headspace conducive to hours of free association and disciplined reading. One can be "impatient ... constantly irritated and dissatisfied," Calvino writes, and still find a place in one's life for Shakespeare, Beckett, and Conrad. Calvino recommends that we alternate reading contemporary works that "give us an understanding of our own times" with the classics, and further that we come to our own definition of what constitutes a classic. For Calvino, a classic is any book that

"represent[s] the whole universe ... on a par with ancient talismans ... a book to which you cannot remain indifferent." Perhaps there is hope for a fidgety reader like myself who finds her most sustained reading is done in subway cars shooting through tunnels on the express track.

Years before Bloom and Calvino were publishing their philosophies on reading, Virginia Woolf, in her essays and diaries, had already laid much of the groundwork for the thoughts they would later popularize. Reading constituted a huge part of Woolf's life. It was her greatest pleasure. It was also how she earned a living (partially, since she also had an inheritance), reviewing books for the *Times Literary Supplement* and other publications. In two important essays, "Hours in a Library," written in 1916, and the well-known "How Should One Read a Book?" from 1926, Woolf laid out some of her core ideas about books and reading. A great proponent of voracious, indiscriminate reading, everything from "bad" contemporary novels to the forgotten memoirs and letters one discovers buried in secondhand bookstores, Woolf would concur with Calvino that to really appreciate the classics one must come at them from the vantage point of contemporary literature. It is only then that one can experience "a complete finality about [the classics] ... a consecration [that] ... we return to life, feeling it more keenly and understanding it more deeply than before."

Woolf famously said of reading: "The only advice ... is to take no advice, ... follow your instincts, ... use your reason." A similar thought was voiced by her elder contemporary Oscar Wilde, who did not believe in recommending books, only in de-recommending them. Later, Jorge Luis Borges echoed the same sentiment by discouraging "systematic bibliographies" in favor of "adulterous" reading. More recently, Gregg Bordowitz has promoted "promiscuous" reading in which you impulsively allow an "imposter" book to overrule any reading trajectory you might have set for yourself, simply because, for instance, a friend tells you in conversation that he is reading it and is excited by it. This evokes for me that most potent kind of reading—reading as flirtation with or eavesdropping on someone you love or desire, someone who figures in your fantasy life.

But getting back to Virginia Woolf. Despite her interdiction ("take no advice"), she does in fact have advice to offer. Noting "all the books jostle.... And outside the donkey brays," she asks: "How are we to bring order into this multitudinous chaos and so get the ... widest pleasure from what we read?" Woolf begins "How Should One Read a Book?" by delineating various genres: fiction, biography, poetry, and a category dear to her that she names "rubbish reading." She proceeds in her inimitable way, conjuring up images of walks down city streets and through the byways of literary history, outlining the genres, their pleasures and virtues, and giving the most idiosyncratic advice for ways of savoring each category. For instance, she claims the best way to understand what a novelist is doing is not to read but to write: recall a scene from your life that has struck you in some way, she suggests, and put it to paper. See how easily the feelings you meant to transmit evade you. Now turn from your muddle (and here she is referring as much to her own hypothetical product as the reader's) and read the opening pages of Austen, Defoe, or Hardy, and you will be in no doubt as to their mastery, each conjuring up a world uncommonly vivid and unique.

"To read a novel is a difficult and complex art," Woolf goes on to say, and we can sometimes be aided in our perceptions by all those books that are not great art and that, in fact, take up most of the space on library shelves—biographies and memoirs. Then Woolf again circles back to the reader as writer and suggests that the biography we have been reading with the aim of better understanding literature may actually stimulate our own creative powers, our own urge to record something of our lives. Put the biography down, she recommends, and look out the window. Try your hand at recording the scene, "stimulating ... in its unself-consciousness, its irrelevance, its perpetual movement."

Woolf had a passion for the letters, diaries, and travel journals of ordinary men and women of bygone days. In "Street Haunting," her 1930 *flâneuse's* account of a twilight walk through the streets of London for the purpose of buying a pencil, she recounts stepping into a secondhand bookshop, the home of all the "wild" and undomesticated books, and pulling off of an

upper shelf a faded little volume, a wool-merchant's chronicle of a business trip through Wales, written and self-published a hundred years prior. In an almost Proustian evocation of the serendipitous, sensory retrieval of memory—the idea that something buried and forgotten may be summoned to life once again through chance encounter—she describes how the chronicler "let flow . . . [into his account] the very scent of hollyhocks and the hay together with such a portrait of himself as gives him forever a seat in the warm corner of the mind's inglenook." These "relics of human life" constitute the "rubbish reading" to which Woolf is so devoted: "it may be one letter—but what a vision it gives! It may be a few sentences—but what vistas they suggest!" It is the "matter-of-factness," the unpremeditated quality of these writings that is key to Woolf's delectation of them. Like the Surrealists who seized on the evocative, hallucinatory power of the found-object, Woolf prized her chance literary finds and wrote of the paroxysms of pleasure they elicited with an intensity and craving of a gourmet.

(Roland Barthes, in his book *The Pleasure of the Text*, expresses a similar appetite when reading biography for accounts of mundane things, such as the fluctuations of weather and other "petty details of daily life: schedules, habits, meals, lodging, clothing." Speculating on why he finds himself drawn in by these passages, Barthes proposes that it is because factual details, unlike someone's "insipid moral musings," retain their immediacy and relevance to our lives. Recorded in an almost unconscious manner, these passages allow us to insert ourselves into the scene, to feel interpolated by the text, perhaps a little in the way we are hooked by the *punctum* of a photograph.)

When Woolf is finally able to tear herself away from the rubbish heap of old letters and diaries, it is to read poetry, and, again invoking the writerly reader, she says, "the time to read poetry is when we are almost able to write it." (Elsewhere, in her diary, she inverts this statement to similar ends: "The most successful reading leaves me with the impulse to write it all over again," which reminds me again of Barthes. In another beautiful passage in *The Pleasure of the Text*, he says that his best ideas come to him

in a sideways manner while in the presence of someone he loves, and that his most creative reading is oblique or distracted, when he is led to "look up often, to listen to something else." One could argue this is a doubtful sort of reading since the reader perhaps failed to connect with the writer. On the other hand, how can we object to a reading that is so generative, so capable of spawning the seeds of future texts? I might add, this oblique mode of reading is often how I read Barthes himself, with a sort of free-floating attentiveness to the page and a diffusion of consciousness that tends to set me thinking about my own work and ideas as much as his.)

Woolf concludes "How Should One Read a Book?" by exhorting her readers, who heretofore have been told to be simply porous sponges and at one with the writer, to now conceptualize the book as a whole and to pass judgment upon it. As Woolf wrote in her memoir *Moments of Being* of her need to "make whole" the shocks of her life, the moments that stung her with intimations of consciousness and mortality, we must now do something similar with the book we have been reading. We must take its "multitudinous impressions [and] fleeting shapes" and make of them something whole, something "hard and lasting," a tool, a block of knowledge and understanding that can be compared to other such texts and judged as either good or bad.

This is a task Woolf considers of the utmost importance, one that should not be left to experts but assumed by the Common Reader. This reader must use her own tastes and sensitivities as her chief sources of discrimination and articulation. Woolf is asking us to become writers in our own right and to trust our instincts in setting down our thoughts and opinions on books. But what she is also saying is that these thoughts and judgments of the Common Reader, as opposed to those of the expert or professional, are of the utmost importance to an author. These opinions become part of the air an author "breathes," feeding her work and making the reader complicit in her writing.

In "Hours in a Library," an essay written ten years before "How Should One Read a Book?," Woolf distinguishes between "the man who loves learning and the man who loves reading . . .

and there is no connection whatever between the two." The man who loves learning is the pale "bookish" fellow who can't even boil water for tea, who sits wrapped in his dressing gown, searching for truth. "The true reader," writes Woolf, is "essentially young." He is active, tireless, moving through the world hungrily and impatiently, taking it all in. She warns, "if knowledge sticks to [the reader] well and good, but to go in pursuit of it, to read on a system, to become a specialist or an authority, is very apt to kill . . . the passion for pure, disinterested reading." What Woolf is describing positively here is the greedy, unfettered reading of childhood and young adulthood, the relationship to books that brings on the "disembodied, trance-like intense rapture that used to seize [us] and comes back now and again." She is referring to those books of childhood devoured without program or academic oversight.

What are we to make of Woolf's wide-ranging statements in these two essays? On the one hand, she proffers advice on how to read and exhorts the reader to fill herself up with books so as to become a responsible citizen with strong opinions, one who can contribute to the cultural climate of her world. On the other hand, she claims that to read with a purpose in search of knowledge is a betrayal of the true nature of reading. Of the two types of reading, youthful and mature, Harold Bloom says: "The sorrow of professional reading is that you recapture only rarely the pleasure of reading you knew in youth, when books were a Hazlittian gusto." (William Hazlitt, the early nineteenth-century English essayist and literary critic, wrote an essay titled "On Reading Old Books." It is a love letter to the books of his youth.)

One of the ways I came to identify this mode of youthful reading was via a genre of book, often elegiac in tone, the bibliophilic memoir that begins by recounting the memory of a childhood spent dreamily lost in books. Several writers describe their early, precocious reading, often pinpointing the Aha! moment when it became clear to them that the abstract signs on the page or blackboard signified a thing or a sound. Alberto Manguel, for instance, author of *A History of Reading*, describes a feeling of omniscience that came with the realization that he could read

at around age four. Lynne Sharon Schwartz, author of the pithy, insightful memoir *Ruined by Reading: A Life in Books* learned to read at three and a half. She was the prodigy reader, the baby plunked down in front of the *New York Times* and made to read the news for all who walked in the room. Both Manguel and Schwartz write of their early love of reading, of the long idylls of absorption in children's literature.

(I have always found these accounts of precocious reading a little grating. No doubt I am jealous, having come to reading late in life, and having had my first experiences of language fraught with the misapprehension and confusion of bilingualism. But that is another story. Suffice it to say that unlike Schwartz and Manguel, who were reading to themselves as children, I didn't take possession of books until considerably later.)

In *Ruined by Reading*, Schwartz conjures up a childhood of reading "behind closed doors . . . on my bed in the fading light," blissfully "bask[ing] in the everlasting present." For Woolf this youthful reading involves moments in which the ego is completely eliminated. Marcel Proust, in his little book *On Reading*, memorably figures this state of total absorption in the child alone in an empty house, mesmerized by a book, oblivious of mealtimes and schedules, resentful of every intrusion. The reading of childhood is always posited as pure and disinterested, voracious and undiscriminating, an existential moment of peace. I had this experience as a teenager, but lost it and didn't fully encounter it again until I was thirty-eight and very pregnant. I felt that only this, the weight of my gestating body, gave me permission to sit in one place and read exactly as I pleased.

I am not alone in feeling this guilt occasioned by reading. Schwartz writes:

"[Reading] was what I used to do through long evenings. Never mornings — even to one so self-indulgent, it seems slightly sinful to wake up and immediately sit down with a book. . . . In daylight I would pay what I owed the world. Reading was the reward."

(You may be wondering how this writer-reader, so conflicted about reading, was able to savor Virginia Woolf's essays at dawn. Those are the stolen hours before the routines of daily life set

in—the clock hasn't started to tick on them yet. Anything is possible at that hour, the time of day which Sylvia Plath, getting up at 4 AM to write her final, *Ariel* poems before her children awoke, called the "blue hour.")

Schwartz goes on to say, apropos of choice and obligation:

> *Children generally read what they please, but addictive adults (writers especially) can get tangled in the toils of choice.... At times the ramifications of choice verge on the metaphysical, the moral, even the absurd. To read the dead or the living, the famous or the ignored, the kindred spirits or the bracingly unfamiliar? And how to go about it—systematically or at random?*
>
> *At bottom, of course, the issue in choosing what to read (and what to do and how to live) is the old conflict, dating from the Garden, of pleasure versus duty: what we want to read versus what we think we ought to read....*

Schwartz's keen observations about pleasure and duty bring me to the crux of my deliberation, so perhaps this is the right moment to quote Kafka in full, as his statement on reading, written in 1904, sums up the most extreme, nihilistic position on duty:

> *I think we ought to read only the books that bite and sting us. If the book we are reading doesn't shake us awake like a blow on the skull, why bother reading it in the first place? ...What we need are books that hit us like a most painful misfortune, like the death of someone we loved more than we love ourselves, that make us feel as though we had been banished to the woods, far from any human presence, like a suicide. A book must be the axe for the frozen sea within us.*

Harold Bloom has referred to this kind of reading as "a difficult pleasure, [but one that is also] a plausible definition of the Sublime ... a reader's Sublime." Roland Barthes refers to it as the "Text of bliss: the text that imposes a state of loss, the text that discomforts, ... unsettles, ... brings to a crisis [the reader's] relation to language."

So far several models of reading have been posited. There is Bloom's model of the reader who chooses the classics because they are the books that mirror our souls and help us to confront mortality. There is Calvino's and Woolf's model of alternating the classics with contemporary and minor works so as to better understand and appreciate the virtues of each. There is the youthful, voracious, and promiscuous reading of Proust, Schwartz, and Woolf, in which we feed and feast and are at one with the writer. And finally, there is Kafka's model that says we should not waste a second on anything but the most demanding and challenging books. (Interestingly, Kafka's movie-going habits, as revealed in a recently published book, were the opposite of his reading habits: trashy films were his favorites.)

I think it has been fairly obvious from the beginning of this essay (and I have the wisdom and acuity of perception of my friend Alison Strayer to thank for articulating it in her letter), that the most compelling vision of reading for me is the one done, as Virginia Woolf put it, with "pen & notebook," the one that implies a relation to writing, to work.

In the course of my research, I came upon a striking statement by Woolf about work in her diary (cited in Hermione Lee's biography of the writer). Woolf wrote in 1921, somewhat self-deprecatingly but also with the utmost seriousness: "One ought to work—never to take one's eyes from one's work; & then if death should interrupt, well it is merely that one must get up & leave one's stitching—one won't have wasted a thought on death." And this reminded me of something Dennis Potter, the British television writer and director who dreamt up *The Singing Detective* and other fabulous musical dramas, said in his extraordinary final days before succumbing to cancer of the pancreas. Potter chose to spend his last few months of life finishing two plays, and he did this with the help of doses of morphine delicately calibrated to manage his pain while allowing for maximum lucidity. Potter was euphoric about his work and about this moment in his life. In an unforgettable BBC interview conducted shortly before he died, he told his host: "The fact is that if you see the present tense—boy do you see it! And, boy, can you

celebrate it. . . . When I go flat out, I go flat out, and with a passion I've never felt. I feel I can write anything at the moment." Again, I realize I have strayed into talking about writing rather than reading, but if reading can be connected to work that is this passionate and life-sustaining, then this is the reading I want.

So how are we to draw up those reading lists finally? I have been fascinated to note how many writers invoke chance and randomness as guiding principles in choosing their books. I am talking about Lynne Sharon Schwartz, who, citing "the John Cagean principle that if randomness determines the universe it might as well determine my reading too," spent a winter reading the Greek tragedies because she happened to find a discounted set in a mail order catalogue. I'm talking about the serendipitous findings of Virginia Woolf, the little pamphlet from a hundred years ago that she comes across in a secondhand bookshop that stops her in her tracks. I am talking about the happenstance of Georges Perec, who, while engaged in the tedious task of arranging his bookshelves, comes upon a book he'd lost sight of and writes: "putting off until tomorrow what you won't do today, you finally re-devour [it] lying face down on your bed." He further speculates that in our pursuit of knowledge, "order and disorder are in fact the same word, denoting pure chance." And finally, I am talking about the passionate book collector uncrating his treasures after a two-year hiatus, as portrayed by Walter Benjamin in his autobiographical essay "Unpacking My Library," for whom "chance and fate . . . are conspicuously present in the accustomed confusion of these books."

Just as a bookcase full of read and unread books conjures up a portrait of the owner over time ("joggers of the memory," Perec calls them), so the books that arrest us in the present constitute a reflection of "what we are, or what we are becoming or desire" (Schwartz). There is nothing random about that, or about any of these other seemingly random ways of coming to books, and it is from this notion that the oddly apt idea of books choosing us, rather than the other way around, seems to make sense. The idea of a book choosing the reader has to do with a privilege granted. A book gives permission when it uncovers a want or a need, and

in doing so asserts itself above all the hundreds of others jockeying to be read. In this way a book can become a sort of uncanny mirror held up to the reader, one that concretizes a desire in the process of becoming.

Virginia Woolf writes: "[feed] greedily and lavishly upon books of all sorts ... follow your own instincts ... use your own reason ... come to your own conclusions." I think the truest method, as Woolf suggests, is to be open and sensitized, creative, always on the lookout for the thing that will nourish a known or intuited desire or inkling. At Vermont College, where I teach in the MFA in Visual Art Program, there is a strong emphasis on reading and research. Vera Jacyk, a recent graduate once told me: "One of the problems with the Vermont program, and talking to so many people about so many books, is that everything begins to sound interesting. How do you decide what is for you?" My advice is to store up all the recommendations but be discriminating. Be attuned to your own hunches, appetites, and longings, your own creative urges. And from there, be like a diviner, with passing mentions, quotes, footnotes, and possibly even just an evocative dust jacket, as your guideposts.

And so, getting back to my original mise-en-scène: where is that half-clad, distracted reader now? In the course of writing this essay, she read a great deal, and yes, she was in a state of "temporary grace" while doing it. But on the day she completed a first draft, the state of grace came to an abrupt halt, and she was taken aback by the speed with which that postpartum feeling, an acquaintance now for over thirty years, came back to take its place, and along with it, the familiar misgivings about what to read. She has not solved "the problems of restlessness, unfocus and hunger." However, she *has* made a few discoveries about herself and reading, ones that will at least mitigate the inevitable malaise when it returns.

She may never read Cervantes or the Bible, but she also recognizes with certainty that Virginal Woolf, whose writing feels more prescient than ever, is her classic. She has Italo Calvino, a new discovery, to thank for that understanding. In the course of her recent reading, she read Woolf's essay on Michel de Mon-

taigne, and that led her to finally pick up a fat book that had been in her peripheral vision for many years: *The Complete Works of Montaigne*. In his essays, composed over four hundred years ago, he writes of idleness, calling it on the one hand the scourge of the mind, to be remedied only by writing, and on the other, man's ultimate goal: "[To live] is the most illustrious of your occupations.... To compose our character is our duty, not to compose books." On reading this, she sighed deeply and thought to herself: I have only just scratched the surface of the problems of reading, writing, pleasure, and duty. Clearly, it is a project to be continued.

On a more prosaic note, she opens and reads most of what fate tosses in her path. For instance, not so long ago, her friend Ellen McMahon mentioned that she'd been reading an essay by Foucault in which he describes reading and writing as among his "technologies of the self," one of his core themes. That night, she took a biography of Foucault off the shelf and opened it to the page where she'd left off reading three years before. There is something superstitiously primitive about this need to have someone else grant "permission" in order to pick up a book (again). But it is also a deeply pleasurable way to read because it is rooted in dialogue and in friendship, in the social. And it is not the only way to come to books, but one of many threads and lines that get cast out and pulled in to form the great connective tissue that makes up our reading.

Recently, on a frigid winter day, she found herself in her studio surrounded by layers of books and papers. From this mass of paper strewn all over the sunlit floor, she began to conjure up an image of it all coming together, the parts knitting themselves into a web or net capable of holding her in a sort of blissful suspension. This fantasy obviously points to metaphors of maternal holding and other more phenomenological aspects of reading than those covered in this essay. That is another reading and writing trajectory, an offshoot sown from the seeds of this current project, a possible thread to be pursued. But before taking up that thread and beginning new lists and stacking up new piles, she has promised herself a day to put in order those desperately

chaotic and dust-covered bookshelves. Wish her luck. Better yet, and with a nod to Georges Perec, wish that she may abandon the project midway and succumb to something forgotten, something irresistible.

(2003)

...Alexander. ... must and will manage something. Keep me off ... 10.32. please. By then I may know something of Venice ...

... explained ... had meet with difficulty. I long for the country ...
... in a garden.

... you know that our dear friend Bernard Fay has been pardoned —
... will be tickled to see you again.

So very much love

Alice

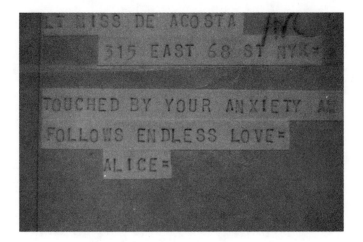

LT MISS DE ACOSTA
315 EAST 68 ST NYK=

TOUCHED BY YOUR ANXIETY AS

FOLLOWS ENDLESS LOVE=

ALICE=

I CONFESS

James Baldwin

She'd been in one of those restless states, casting about, picking up and putting down books with growing impatience. The last one in this category of rejects, an account by Emmanuel Carrère of his conversion to Catholicism, highly recommended by her sister, Claire, had seriously depressed her. Then J showed up with one of his thrift store hauls that included a stack of vintage James Baldwin pocketbooks with the page edges tinted turquoise and carmine.

She began to read *Another Country*, very beautiful as an object, but brittle with age, its yellowed pages crumbling. The first few sentences, a description of Rufus, a musician down on his luck, wandering through Times Square at midnight, were exhilarating. One chapter in, however, she begins to have doubts about this book as well, about the dated jargon, the shallowness of some of the characters, the battering of one of the women characters. But she persists and becomes more and more seduced by Baldwin's prose, by ever-longer passages of pure, gorgeous description and by an ever-deepening complexity in the characters: gentle Vivaldo, who'd been capable of intense, homophobic cruelty in his youth; and once-innocent Ida, who becomes hard-bitten and vengeful, abuses the man who is devoted to her. These are contradictions she can identify with. And the queerness and the muted invocations of gay sex.

For the first time in a long while they'd had real sex. Fucking, licking, biting, 69. She would be 60 in less than two years. After feeling nothing for so long, her fantasies used up, something in her psyche had switched back on. And she attributed it to Baldwin's book.

In *Another Country* there is every kind of sex: straight, queer, interracial, sex between a gay man and a straight woman, a gay man and a straight man. *Another Country* is full of beauty and prescience and hatred. It is a novel that mirrors our times.

I wake at 5:30 and finish reading *Another Country*. In the

penultimate scene, long-suffering Vivaldo (white, straight man who's just spent the night with his gay friend, Eric) hears the brutal, humiliating confession of infidelity by his girlfriend, Ida (black, straight woman). When it's all over and he waits for her to emerge from the bathroom, where she's gone to wash her face, an idea comes to him for the novel he's been struggling to write. Baldwin: "He thought ... to make a note of it now; he started toward his work table."

Fort Da

I'm reminded of the phrase "desiring machine," from the 1980s. I contemplate revisiting my attempts to read theory. I read about Guy Hocquenghem and *Screwball Asses*, a slim volume with a purple cover, which I buy and promptly lose.

I confess to writing the last sentence only after wasting a good hour searching for the book. These restless hunts are a form of procrastination, a fort/da game I play with myself: if I find the book my mother loves me, if I don't then I've been abandoned by fortune. I link this to a vivid memory from childhood, of losing a pencil given to me by my mother. Thinking it had been stolen I began to sob. To this day, and this was over 50 years ago, I remember the teacher's exact words: "Pourquoi as-tu tant de peine pour un crayon?" (Why so much grief over a pencil?) I made up a story about how my mother had just had another baby and that we were poor and could not afford to lose a pencil. The pencil was my mother, birthing baby after baby, seven in nine years.

Hubert Aquin

A nearsighted woman is folded over her desk writing. Next to her an iPhone is playing a movie, a documentary about Hubert Aquin, the iconic Quebecois novelist, actor, producer and revolutionary. She listens to the sound track, a narration in proper French, while occasionally shifting her glance to the small screen.

Her friend Alison sent the link and added a note. She wrote: "I'm trying to recall why and when all this trouble started, wanting to 'live in French ...' It's intriguing to try to figure out the magic I saw in Aquin, because he was my siren call to Quebec, though I was a unilingual girl from the Prairies, and the pull for Francophiles was definitely to go to France, not Quebec."

I read the English translation of Hubert Aquin's breakout first novel, *Prochain épisode*, the book that so gripped my friend Alison and cemented Aquin as a heroic figure for Quebecois nationalists. I was surprised by how Eurocentric *Prochain épisode* feels. I wrote to Alison and asked how it was that the book, even though it does contain a revolutionary thread, became so important to Quebecois readers. Queried, her friend, the writer, Yvon Rivard, sent this beautiful reply:

> *The short answer: because he was handsome, intelligent, and theatrical. Even men couldn't resist him! He wrote* Next Episode *being a revolutionary nationalist, but with a European sensibility—the exact opposite of how Trudeau described the nationalists.*
>
> *The long answer: because he profoundly expressed French Canada's "cultural fatigue" in a text that countered Trudeau. It was a two-part desire to assume independence and take hold of its future while also wanting to disappear and to end unwinnable conflicts. Forces of life and forces of death antagonized him, and we know how it ended (in suicide).*
>
> *An anti-French sentiment has long existed in Quebec. France abandoned us! But Aquin was a subject that could challenge his colonizer, whether French or English. This is also why the French never embraced him—they preferred more provincial Quebecois writers.*

Pierre Vallières

In the wake of Raoul Peck's film *I Am Not Your Negro* many of us were reading Baldwin. I'd finished three of his books and was about to begin a fourth when I started to remember a political

memoir from 1968 that I'd known about for decades but had never read called *Nègres blancs d'Amérique,* by the Quebecois writer Pierre Vallières. The title, translated into English, makes use of the N-word, and Vallières was often called upon to justify his use of the offending word, but he stood by it. He believed the Quebecois were also "the wretched of the earth." Later, Vallières would embrace and champion the cause of First Nations peoples, the original, colonized populations of what would become a doubly colonized land.

My Montreal friends would often refer to themselves as a colonized people and I knew from elementary school history of the pivotal defeat of the French on the Plains of Abraham in 1759. But my knowledge of politics stopped there, with Benjamin West's giant, arresting tableau of a dying man in a blood-red tunic and a kneeling, tattooed Mohawk (a Delaware warrior). That famous, neo-classical painting lives in the National Gallery in Ottawa, the city where I spent my teenage years. It is an iconic image signaling the start of centuries of colonization of the French by English Canadians, in cahoots with the Roman Catholic Church and American business interests.

Another strong memory from those years: wandering around the nearly empty National Gallery, age 12 or 13, taking in Joyce Wieland's retrospective exhibition *True Patriot Love,* with its signature quilt, *Reason Over Passion*, a riposte to then-Prime Minister, Pierre Elliot Trudeau.

I ordered *Nègres blancs d'Amérique*, and read most of it in nonchronological order starting with the chapter on Vallières's childhood in Montreal lived under the iron-fisted yoke of medieval Catholicism and the corrupt regime of Quebec's premiere, Maurice Duplessis whose grip on power lasted decades. Pierre Vallières is a precocious kid who sees from the cardboard walls of his ghetto home the extent of the church's hypocrisy and collusion with English Canada and American big business, a triumvirate that had conspired for centuries to keep the Quebecois docile and submissive.

Vallières reads history and philosophy and tries to rally his

parents to his dawning conviction about the exploitation of Quebec's working class and farmers. His mother is pious and disparages her son's growing disaffection. She wants him to quit high school and get a job in a bank. "Be a slave in a white shirt . . . I'd rather starve," he says. His father is more open but ultimately too beaten down by the grave-yard shift he's been working for decades at the rail yard.

The writing in this chapter is sublime. Vallières is a tormented soul, searching for answers to existential questions via philosophy, literature and theology.

Reading the memoir I'm reminded of many expressions I used to know: The great darkness; the white dust of winter; the Quiet Revolution.

When I hear a strong Quebecois accent on the sidewalks of New York I wince and I feel implicated. I went to school with French kids in Montreal, I squirmed alongside them in the incense-choked church that adjoined the school and the presbytery. These buildings plus a fourth called "Le Manoir" stood like chess pieces—king, queen, bishop, rook—on a rise that dominated the neighborhood. Even at a young age I was embarrassed by my parents' faith and dreamt of going to a secular, English school where I'd be spared the stigma of religion and the bullying that came with being part of a disliked, Anglo minority. Catholicism scared the shit out of me, as it did pretty much everyone in Quebec, by design.

Colonized, oppressed populations usually have accents deemed inferior.

James Baldwin

James Baldwin was a child preacher. It was a way to evade the violence of the streets and a form of protection against an abusive father. Like Pierre Vallières, he embraced religion as a means to salvation, only to later recognize its hypocrisy and vehemently repudiate it. Baldwin said: "I really mean that there was no love in the church. It was a mask for hatred and self-hatred and despair."

Pierre Vallières

In Joyce Wieland's film *Pierre Vallières*, the camera tightly frames her subject's lips, teeth, and mustache. In the shadowy, high-contrast image, the lips and teeth glisten, the mustache is coarse and bristly and the skin below the bottom lip is beginning to show five o'clock shadow. Vallières speaks three distinct monologues, each one the length of a 400 foot 16mm film reel.

In section two of the Wieland film, Vallières states that one of his principal goals as an organizer and activist is to "maximize jouissance and joy in the limited time humans have on earth."

Sometime around 1980 I met Pierre Vallières. My ex-boyfriend, Louis, had moved to Vallières's house in the country and was likely in a relationship with him. The house was something of a commune, in fact the whole area was a bit of a post-hippy refuge for people fleeing the city. I remember Vallières as a distinctly gentle, soft-spoken man and even though I represented an obstacle to his feelings for Louis he was kind to me. One exchange in particular sticks in my mind because I felt shamed by it, though I doubt Vallières intended it. I thought it was a joke and started to laugh when he said they were serving hot dogs for supper, and he simply said: "On essaye de vivre le mieux qu'on peut." (We try to live as best we can.) I took many pictures of Vallières, including nudes on the beach with members of the household.

As I was shooting the final scenes for this film, a new biography of Vallières was published. I found myself reading it in the middle of the night and piecing together the timeline of Vallières's life; his years in prison as a political prisoner wrongly convicted of murder and charged with sedition for his book "Nègres Blancs," his court appearances where he defended himself without a lawyer and dueled brilliantly with a judge to applause and cheers from a packed courtroom. There is a photo in the book of Vallières in a farmhouse that is likely the one where I found myself in that troubled summer of 1980. I don't think Louis and I slept together on that visit. I remember sobbing unashamedly on his bed and Vallières's anxious, watchful gaze.

Six months or a year later, Louis would contact me—I was by then in a new relationship—and offer the gift of a hand-carved mirror with an inscription on the back that read: *À Mo, a qui j'ai pensé parmis les montaignes*. (To Mo, whom I thought about among the mountains.)

Dalie Giroux

Vincent in Montreal sends me a text by the political philosopher, Dalie Giroux, titled "Les langages de la colonization: Quelques éléments de réflexion sur le régime linguistic subaltern en Amérique du Nord." ("The Languages of Colonization: A Few Elements of Reflection on the Subaltern Linguistic Regime in North America.") It contains a list of disparaging terms for North American French, words such as: *baraguoin, langue batarde, déchirée, partielle, contaminée, disseminée, voilée, mélangée, illetrée, vagabonde*. You almost don't need a translation to understand the denigration implied in these terms. In contemporary Quebec there is also an acute, urgent recognition of a duel identity, of being both colonized and colonizer, and so the question of language is not just about the Quebecois accent or American French, as Giroux calls it, but all the languages and creoles of first nations populations.

I went on to watch YouTube videos of Dalie Giroux in French and in English: she is artful and elliptical in her thought, some of which gets diagrammed in elaborate schemas on a chalkboard. She's invested in repetition, and the idea that repetition is not dumb or rote but a legitimate form of thinking.

Her manner of speech in the lecture "Repetition and Ruins," her body language, her facial expressions, the way she paces the room and broods over the stack of papers on the lectern, is mesmerizing. She is charismatic and shamanistic and moves easily from abstraction to the concrete

One could hypothesize that Dalie Giroux, with her anarchic and iconoclastic professions, is the heir to Pierre Vallières's utopian project. In her lecture "Repetition and Ruins" she says provocatively: "Give the whole planet a one-year sabbatical . . ."

and dares us to imagine what that would be like. An echo of Vallières can be heard here—his desire for a society where all people, during their time on earth, could be free to experience their "maximum joy and jouissance."

Ann Charney

Writers chase stories because they serve as containers for the raw material. Part of her thinks that words should pour from the writer and if this is not happening then the thing is not meant to be. She agrees with the French author who said: "I can't ever imagine writing in the third person." Yet some things are only imaginable in the third person.

In Montreal, I grew up next door to the journalist and writer Ann Charney. An atheist intellectual, Ann quite sensibly had only one child and likely was horrified by her Catholic, breeder neighbors. I can't help but think of the Monty Python skit in *The Meaning of Life* where the prim, protestant couple, alone in their tidy home, look on disapprovingly as their bloated Catholic neighbor, a mother of 64 children, stands at the sink scrubbing while babies drop from her crotch.

Many years later, in 2007, my mother and I paid a social visit to Ann, during which, out of the blue, she accused my father, an advisor to Pierre Trudeau in the late 1960's and early 70's, of having been on the wrong side, perhaps even of having been an architect of the War Measures Act in 1970. This was the time of the FLQ kidnappings when Trudeau responded by sending in the troops to Quebec. Almost five hundred "suspected terrorists" or sympathizers were rounded up and jailed, including Pierre Vallières. I wrote to my uncle, a historian, to ask if he knew anything about my father's involvement in the October crisis. He wrote back and said: "I think the very few references that do speak to his involvement are so sparse, for a very good reason. Few, if any, subjects are still as politically sensitive as this one."

Knowing Ann's researcher credentials, there's a good chance she was right about my father, nonetheless I was so annoyed by

her outburst, which struck me as displaced anger, that I didn't speak to her for over ten years.

Recently, I reread her very sympathetic portrait of Pierre Vallières in her book *Defiance in Their Eyes*. And then I continued to read everything in the collection, including the piece on Paul Rose, one of the FLQ kidnappers, and I became so engrossed by her essay on the Kanawake Mohawks that I missed my stop on the train. All of Ann's profiles of the FLQ members describe idealistic young men who sacrificed for a cause; some escaped to Cuba and France, some did time. One, Jean Castongay, in protest, drank gasoline and self-immolated on the top of Mount-Royal in Montreal.

Ann is mercurial, snobbish, and quick to judge and express anger. But she is also capable of being open-hearted and generous and I'm indebted to her for shared wisdom and friendship, fraught as it was.

I decided to contact Ann after a decade-long hiatus, to ask how she'd known about my father's role in the October Crisis. She said he'd attacked her at a dinner party for having published an article in support of the student movement, who jubilantly chanted its solidarity at a public rally. Ann also confirmed my Monty Python analogy. I asked her when it was she'd moved to our street, and she said, laughing: "It was 1966, the year your youngest sister was born. I thought you were hillbillies. Your father was always under the car fixing something, kids were running around everywhere, your mother was unkempt."

Alison Strayer

I wrote again to my friend Alison, the one-time prairie girl who'd heeded the siren call to live in French and to live in Quebec and not in France. Eventually she married a French man and moved to Paris. Her French is perfect.

I asked her: Do you code-switch when you speak French? Do you speak differently when you are in Quebec and in Paris?

Alison answered: I speak neutral French in Paris and people

say I have an accent (English) and in Montreal I swing into a Quebec lilt like I had when I lived there.

James Baldwin was accused of affecting a British accent when he debated William F. Buckley at Cambridge University in 1965. Buckley, whose own speech was famously mannered and arrogant, lobbed the insult right off the bat in an effort to discredit Baldwin. One year later Pierre Vallières would find himself detained in the Tombs in Manhattan writing his memoir and using uncannily similar words to Baldwin's in the debate.

Dalie Giroux

I met with Dalie in a café in the Plateau in Montreal. She was a bit late and a bit tired from walking, and immediately took off her shoes and socks. To my surprise she agreed without hesitation to do a recording and so we walked to my sister's apartment nearby and set up on the terrace under a large umbrella. As usual I struggled with the equipment. The miniature tripod I'd brought was like a Rubik's cube in its complexity to assemble, and just barely served; Dalie's face goes in and out of focus and I fail to correct the mistake.

She reads aloud Yvon's text about Hubert Aquin and then begins to talk about Pierre Vallières, taking long pauses to think before speaking. She speaks of him with passion and empathy, but also with a deep criticality of his willful, racial blind spots, and the unconscious misogyny directed primarily at his mother.

The man I had sanctified as a revolutionary and a renouncer, and whose photographs I printed for the first time and turned into votives, came under harsh critique from Dalie for his appropriation of the black struggle and his treatment of women. I had read *Nègres blancs* through the lens of literary and biographical themes, whereas Dalie employed the tools of political theory and philosophy to construct another, at times damning, interpretation of the book.

After about ten minutes it began to rain, and though Dalie didn't mind, the umbrella was not enough to protect the camera, so we moved inside to a couch in the living room where we sat

and talked, off camera, for hours, about her work, her writing and about ourselves, our early lives separated by almost twenty years. Dalie was born in 1974, a year before my father died, the year I turned 16. I could plausibly be her mother but at that moment instead I felt mothered, the object of her generosity.

The downpour continued. When it was time to leave for the train station, Dalie wanted to walk. She said she welcomed the rain.

(2019)

ACKNOWLEDGMENTS

Moyra Davey thanks:

Barbara Epler, who planted the idea for this book; Tynan Kogane for his vital support of my work and his incisive contributions to the publication; Nicolas Linnert for his inspired editing of the texts and photographs; and Alison Strayer for decades of friendship and encouragement. *Index Cards* is dedicated to Jason Simon and Barney Simon-Davey.

Nicolas Linnert thanks:

Moyra Davey and Tynan Kogane, both for their kindhearted generosity and cherished spirit of collaboration.